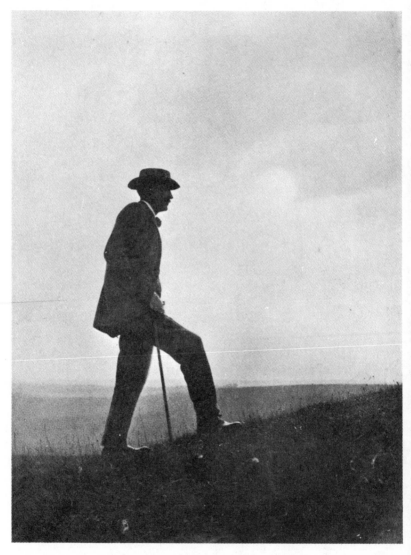

THE LATE EARL OF CARNARVON.

From a Photograph by F. J. Mortimer, F.R.P.S.

THE DISCOVERY OF
THE TOMB OF
TUTANKHAMEN

BY HOWARD CARTER
AND A.C. MACE

WITH A NEW INTRODUCTION BY
JON MANCHIP WHITE

DOVER PUBLICATIONS, INC., NEW YORK

This Dover edition, first published in 1977, is
an unabridged republication of Volume I of the
work *The Tomb of Tut·Ankh·Amen Discovered
by the Late Earl of Carnarvon and Howard
Carter,* originally published by Cassell and Com-
pany, Ltd, London, 1923 (subsequent volumes
were published in 1927 and 1933). A new In-
troduction has been specially written for the
present edition by Jon Manchip White.

International Standard Book Number:
0-486-23500-9
Library of Congress Catalog Card Number:
77-71042

Manufactured in the United States of America
Dover Publications, Inc.
180 Varick Street
New York, N.Y. 10014

Dedication

With the full sympathy of my collaborator, Mr. Mace, I dedicate this account of the discovery of the tomb of Tut·ankh·Amen to the memory of my beloved friend and colleague

LORD CARNARVON

who died in the hour of his triumph.

But for his untiring generosity and constant encouragement our labours could never have been crowned with success. His judgment in ancient art has rarely been equalled. His efforts, which have done so much to extend our knowledge of Egyptology, will ever be honoured in history, and by me his memory will always be cherished.

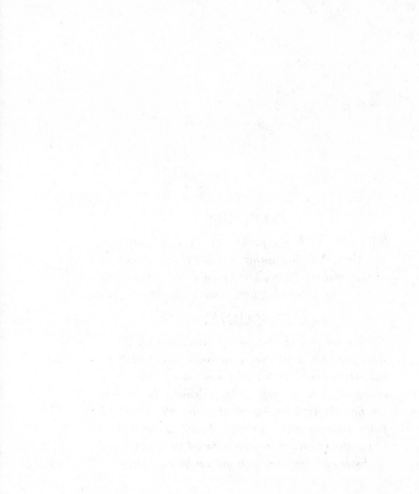

INTRODUCTION
TO THE DOVER EDITION

WHEN Howard Carter's workmen pointed out to him the first step beneath the debris of a workman's hut, on November 4, 1922, he was on the threshold of the most spectacular discovery ever recorded in the annals of archaeology.

A professional excavator like Carter spends most of his life on dusty sites, in ungrateful corners of the world, clearing away mountains of earth and rubbish, trying to unravel the meaning of the broken and battered relics that come to light. This patient work is of absorbing interest to the excavator and to the specialists who will read his report in a learned journal, but it is of little interest to the public at large. Yet sometimes, capriciously, Fate elects to reward one of this persevering band with a discovery so glorious, so glittering, so apocalyptic, that our neglected ancestors suddenly spring to life in their full grandeur, and the whole world sits up and takes notice. This is what happened to Carter: he received a privilege, a blessing, a supernatural benediction, a crown of immortality—but also, as we shall see, a blessing not unmixed with frustration and woe.

Splendid discoveries had been made in Egypt for a full century before Carter's exploit—which was why the country had long been the happy hunting ground of archaeologists and treasure-seekers. Statues, friezes and beautiful minor antiquities had emerged in plenty, and single discoveries had been interspersed with rich caches that had attracted the attention of educated people all over the globe. Mariette, the doyen of Egyptologists, had

brought back to his newly established Cairo Museum impressive assemblages of objects; Brugsch and Loret had retrieved the actual bodies of some of the greatest pharaohs from pathetic hiding places at Kurna and Luxor; Petrie and Brunton had recovered an exquisite collection of Middle Kingdom jewellery at Lahun. In our own century, even after Carter's stunning activities, wonderful though less heralded discoveries continued to be made. In 1925 Reisner stumbled on the only intact tomb chamber of the Old Kingdom, containing the personal furniture and adornments of Queen Hetep-heres, mother of Cheops and wife of Snofru; and as recently as 1940 Montet unearthed at Tanis, in the Delta, the mummy and funerary equipment of King Psusennes I of the Twenty-first Dynasty, which included a gold mask almost as striking as those of Tutankhamun.

These discoveries, exciting as they were, have been dimmed in popular imagination by Carter's achievement, which recreated not merely a tiny fragment but an entire panorama of a vanished society. One speaks of ''Carter's achievement,'' but, of course, other persons deserve their share of the credit. First, perhaps, we should recall how royalty and aristocracy are placed at the head of the cast list in Shakespeare, and begin with the figure of Carter's patron, the fifth Earl of Carnarvon. It was the financial and moral support provided by this amiable nobleman that made the whole astonishing course of events possible.

The memoir of ''Porchy'' (he was Lord Porchester before succeeding to his father's title of Carnarvon) by Lady Burghclere in the present work is an engaging example of British upper-class hagiography. It paints a portrait of a typical gentleman of the era, who emerges from her pages as a cross between Max Beerbohm's Duke of Dorset and P. G. Wodehouse's Bertie Wooster. It might be interesting to add a few details to Lady Burgh-

clere's account. To begin with, "Porchy's" father was by no means an enlightened amateur, like his heir, but a figure of weight and consequence, an important politician at the noon of Empire, a man whose strong shadow must have caused some uneasiness to his son, who never came within measuring distance of his achievements. The fourth Earl bequeathed to his successor not only the blood of the Herberts and the Molyneux, but also three enormous estates. The fifth Earl was therefore one of the most substantial landowners in England, referring vaguely to his holdings in *Who's Who* as "about 36,000 acres"—a large area even in America, and absolutely staggering in the context of the tiny British Isles.

Lady Burghclere tells us that he first began to winter in Egypt in 1903; Egypt, like Switzerland and Colorado, was then a favourite place of residence for wealthy Europeans suffering from chest ailments. To while away the time, he followed the example of many other English noblemen, of whom Lord Amherst of Hackney was the most prominent, and became an enthusiastic, or rather over-enthusiastic, Egyptologist. Lady Burghclere writes that after his first dig "it became clear to him that he needed expert aid"; actually, he had made such a hash of the business that Sir Gaston Maspero told him he could only proceed if he enrolled a qualified assistant, a provision that Carnarvon accepted with his usual good grace. Thus began the 16-year association of this easygoing man with the very different personality of Howard Carter, a man of moody, sometimes hostile and occasionally violent, temper, aggravated by a chronic stomach ailment contracted during his long residence in the hottest and most remote parts of Egypt.

Carter was an unusual and fascinating character, with a background diametrically opposed to Carnarvon's. His grandfather had been a gamekeeper on the Norfolk estate of Lord Amherst of Hackney. When Carter's

father showed talent in the typically Victorian métier of animal painting, it was Lord Amherst who provided the means to give him a formal training. However, it was a very poorly paid profession, and Howard Carter, who was born in 1873 into a family of nine children, was unable to receive any education beyond that furnished by the local village school. Like his father, he showed unusual artistic talent, and in 1891, at the tender age of 17, he was introduced by Lady Amherst to the distinguished Egyptologist P. E. Newberry, who needed help in inking over the tracings he had made of tomb scenes at Beni Hasan. Carter was in fact a very fine draughtsman and watercolourist, and it is a significant clue to the manner in which he viewed himself that when at the age of 50 his biography was included in *Who's Who* he listed himself first as a painter and second as an archaeologist.

While still only 17, he was sent out to Tell el-Amarna in Egypt to assist Flinders Petrie, one of the greatest of all British archaeologists and, with Pitt-Rivers, the founder of the modern method of excavation. He was actually entrusted with the supervision, under Petrie's guidance, of a certain amount of the digging, and if any man can be said to have found his vocation early, and to have been apprenticed to the most eminent masters, that man was Carter. For a further six years he worked with the illustrious Naville as a draughtsman and illustrator at the temple of Queen Hatshepsut. Then, in 1900, the young eagle of 27, who already had almost a decade in Egypt behind him, and who spoke several dialects of Arabic fluently, was appointed by Gaston Maspero to the extremely important post of Inspector-in-Chief of the Monuments of Upper Egypt and Nubia, with headquarters at Thebes. In three extraordinary years, Carter did much clearing and restoration at Thebes, and at distant Edfu and Kom Ombo, and undertook a great deal of original excavation of the highest importance. He discovered

the tombs of Queen Hatshepsut and Tuthmosis IV of the Eighteenth Dynasty; he located the huge cenotaph tomb of Mentuhotep I of the Eleventh Dynasty, which yielded one of the most haunting and impressive royal statues ever found in Egypt. One of his minor tasks, if such difficult enterprises at that time and place can be called minor, was to install iron doors and electric lights in many tombs of the Valley of the Kings, and also far upriver at the massive temple of Abu Simbel. Thus we find that at this early stage in his career he was already equipped for the giant task that would eventually fall to his lot: he spoke Arabic; he knew how to handle Egyptian workmen; he was a thoroughly trained excavator; he had worked at Tell el-Amarna and knew almost every yard of sand in the Valley of the Kings; and he united the conscience and craftsmanship of the artist with the practical skills of the engineer. There have been few men of such calibre in world archaeology.

In 1903 Carter was transferred to the Inspectorate of Lower and Middle Egypt. Further triumphs were anticipated. Instead, his career received a severe setback, as a result of a curious yet typical incident. He became involved in a scuffle with a band of drunken French tourists who were demanding admission to the Serapeum after hours; one of the Frenchmen struck a guard, Carter arrived and told the other guards to defend themselves, and in the ensuing free fight the Frenchmen got the worst of it. The latter lodged a complaint, and Sir Gaston Maspero indicated to Carter that a few brief and tactful words of apology would be in order. Carter refused. The matter was taken to the exalted Lord Cromer, the High Commissioner. Cromer ordered Carter to apologize. Again, Carter refused. Such diplomatic gestures were not in his nature. A distressed Maspero and his friends implored him to mumble the few required phrases. Stubborn as ever, certain that he was right, he stood firm, and

was dismissed from his post. He retired into private life in Cairo, where he lived precariously by painting and selling his watercolours of Egyptian scenes.

For four years Carter remained in the wilderness, and he would have remained there longer had the Earl of Carnarvon not required the services of a seasoned excavator. Their association began in 1907, and continued until Carnarvon's death in 1923—indeed, beyond it, for it was Carnarvon's widow who kept the work going for a further six years. Lady Burghclere says that the two men were "united not more by their common aim than by their mutual regard and affection." Carter, of course, was accustomed to the system of aristocratic patronage, which had played such a part in his family's life, but with his touchy, suspicious temperament he was a hard man to patronize. Nevertheless the relationship held firm, and was productive of outstanding results quite apart from its crowning achievement. Between 1907 and 1911, as he describes in their joint *Five Years' Explorations at Thebes* (1912), written with some assistance from Newberry, Carter discovered many important tombs of noblemen and functionaries. Then, in 1914, he unearthed the long-sought-for tomb of King Amenhotep I of the Eighteenth Dynasty; cleared the interior of the tomb of Amenophis III of the same dynasty in 1915; and in 1916 discovered the extraordinary cliff tomb of Queen Hatshepsut (see Plate VIII). For a time, after the outbreak of hostilities in 1914, he performed war service as King's Messenger or official courier in the Middle East, but some trouble seems to have cropped up that was rather similar in type to the painful episode of 1903. A dispute over regulations arose; Carter stood firm in his usual self-assertive way, and he was dismissed.

He was now free to return to Thebes to embark on his quest for Tutankhamun. How he came to the conclusion that he must dig in the area between the tombs of

Ramesses VI and Ramesses IX, and how he was eventually proved right, must rank as one of the most phenomenal of all real-life detective stories. The discovery was the joint victory of a superb intuition allied to a nerve of steel, and could only have been accomplished by a very exceptional man. In Chapter IV he relates how his interest in the tomb had been aroused by the excavations of Theodore Davis as early as 1908. The tombs of all the other rulers of the great Eighteenth and Nineteenth Dynasties in the Valley had been accounted for—several of them, as we have seen, by himself—and only Tutankhamun's still remained to trace. He was also encouraged by the fact that no antiquities from that tomb had ever come on the market, a sure hint that they might still be underground.

Ignoring Davis' warning, "I fear that the Valley of the Kings is now exhausted," Carter set to work in earnest in the autumn of 1917 and, as he tells us, toiled for six full seasons without any result whatever. His many enemies were delighted to watch him making a fool of himself. Carnarvon himself grew restless with this seemingly obsessed and demented pursuit. The Great War had shaken society to its roots, and even a magnate who owned "about 36,000 acres" now considered it prudent to start trimming his budget. Further, these seasons were barren of those attractive objets d'art which Carnarvon sought for his celebrated private collection; he was not entirely the disinterested devotee of knowledge, but was also the proud owner of what used to be called a "cabinet of antiquities." He was seriously debating whether he could any longer afford the luxury of his Egyptian activities. However, as Guy Brunton put it laconically in his obituary of Carter in the *Annales du Service des Antiquités de l'Egypte*, the latter, "with his characteristic belief in his own infallibility, was able to induce Lord Carnarvon to finance the excavations, though he was

thinking that enough money had been thrown away.''

As Carter writes in Chapter V, "season after season had drawn a blank; we had worked for months at a stretch and found nothing, and only an excavator knows how desperately depressing that can be; we had almost made up our minds that we were beaten, and were preparing to leave the Valley" With incredible tenacity, he came back for a final season, and that magnificent sense of infallibility was finally and abundantly justified. It is interesting to reflect that he had been in the same boat as Schliemann, before him, at Troy. Schliemann too had been at his last gasp, after several empty seasons, and it was only at the final moment, when thoughts of retreat were in his mind, that a chance spade struck through to the royal treasure.

Carter chronicles in a vivid and incisive style what happened after those 16 stone steps were cleared and he found that the clay seals of the outer door were intact. In addition to his other gifts—and he was a man who, unlike his fellow Egyptologists, had not had the benefits of an expensive education—he possessed marked literary ability; there are passages in the present work that rise to sustained heights of intensity. He does not merely describe what he found: he also communicates the wonder and excitement of finding it with an emotion that is rare in the annals of archaeology. One has only to read his description of the opening of the sealed doorway, on pages 95 and 96, or the account of his first examination of the sepulchral chamber, on pages 185 and 186, ending: "when, three hours later, hot, dusty, and dishevelled, we came out once more into the light of day, the very Valley seemed to have changed for us and taken on a more personal aspect. We have been given the Freedom."

Finding the tomb was a triumph in itself. It was only afterwards, however, that Carter showed his real stature. Consider what might have happened to that unique treas-

ure trove if some lesser man had been in charge. True, during the previous half-century the habit of ripping the contents out of tombs, almost in the manner of the ancient tomb robbers, had been superseded by scrupulous scientific methods. However, the tomb of Tutankhamun was an altogether special case. The pressures on Carter to tear the guts out of it, to drag its marvels into the light without delay, were tremendous. Not only Carnarvon, with the prospect of matchless additions to his collection, but even responsible archaeologists were afire with impatience. Carter himself felt for a moment the tug of temptation: "Our natural impulse was to break down the door, and get to the bottom of the matter at once." He needed every ounce of the scientific scrupulosity that had been drilled into him since his days with Flinders Petrie. His decision to record all the objects in the tomb and remove them one at a time, with painstaking and meticulous thoroughness, was almost universally unpopular. Never has the credo of the excavator been more brilliantly expressed than in the paragraph beginning "It was slow work," on pages 124 and 125. It was fortunate for archaeology and for later generations that in this man with his fierce expression, great beak of a nose and imperious moustaches, the right person, for once, happened to be on the right spot and at the right time.

In Chapter IX, "Visitors and the Press," he discusses, quite temperately, the difficulties and restrictions which these alien influences placed on the work. In a later volume he revealed that, after three years, applications to view the tomb were still arriving at the rate of over a thousand a week; and those who have seen the tomb will know how small it is, and how cramped its facilities. It is a wonder that he and his colleagues kept their sanity. Every newspaper of consequence throughout the world sent a representative to Luxor, and for many months these correspondents behaved in a manner little short of

hysterical. It was at this time that stories were written, pandering to popular ignorance and superstition, about the "Curse of Tutankhamun." In the popular imagination, ancient Egypt had always been associated with tinsel mummery and weird rites and customs; probably the mumbo jumbo of *The Magic Flute* and *Aïda* had helped to reinforce this impression, which was not dispelled even when archaeologists had demonstrated the sound, sensible and pragmatic elements in the life of ancient Egypt. Now the curse of the pharaoh on those who disturbed his bones was invoked to explain the deaths of Carnarvon, Mace and Bénédit, who succumbed within a relatively short space of time after the opening of the tomb. Readers of the more sensational papers were told how the lights of Cairo had unaccountably failed at the exact moment of Carnarvon's death, and how his favourite dog in England had begun to howl inconsolably at the same moment. Carnarvon, of course, had been a sick man for years, and Mace was not strong, and it may well be that the intense excitement of the discovery hastened their end. However, the fact remains that Carter himself and most of those associated with him in emptying the tomb lived into their sixties, at least, while several of them survived into their eighties and beyond.

Carter was an exacting man to work for. In the perceptive but grudging obituary already referred to, Brunton says: "Naturally generous and good-natured, he was so afraid of being taken advantage of that he deliberately stifled many of his good qualities. He was extremely capable and clear-headed and an excellent organizer, but was inclined to lay down the law not only for the work but also the lives of others. He could not bear to be contradicted, and expected not only obedience from his assistants but also servitude." Yet he was able, martinet as he was, to inspire the loyalty of the exceptionally capable team whom he gathered round him—his right-hand man,

A. R. Callender; his photographer, Harry Burton; and his chemist and technician, A. Lucas. Like a good general, he knew how to pick his men well, and between them they carried out a piece of work which will always remain a model of its kind. It took from November 1922 until February 1932 before the arduous task could be said to be finally concluded. Think of it: ten full seasons of unremitting anxiety and back-breaking toil. A century before, at the time when Belzoni, Salt and Burchardt were blasting their way into royal tombs with gunpowder and battering rams, the job would have taken ten days—or ten hours.

It is now time to discuss briefly the role of the third and most important of the main characters in the drama, King Tutankhamun himself. Carter opens the present volume and the subsequent third volume of 1933 with historical surveys of the facts relating to the king's career, as known at that date; and he concludes his briefer chapter on the king in the second volume of 1927 with the words: "The mystery of his life still eludes us—the shadows move but the dark is never quite uplifted." After another half-century of speculation and publication, these shadows are, if anything, even darker. The arguments surrounding every phase of the king's existence—parentage, upbringing, adolescence and death—are more vehement than ever; ironically, in many respects the picture seemed far clearer in the 1920s and 1930s than it does today (Carter's historical chapters are densely packed and well argued, and still remain valuable).

One of the principal causes of confusion, of course, was the condition of the tomb itself. It yielded so much, yet to the deep disappointment of all concerned it provided no written clue to the history of its owner's career —no significant inscriptions, and absolutely no documentary evidence of any kind (the tantalizing absence of documentary evidence has persisted during the past half-century). The king had been introduced into a makeshift,

perhaps a temporary tomb, with inexplicable haste. The objects themselves were magnificent, the proper rituals had been duly carried out, but the tomb itself was a paltry place in comparison with the sumptuous royal tombs nearby, and it looked as if the poor little king had been thrust beneath the ground with the express intention of forgetting his existence as quickly as possible. It was a minor burial, by royal Egyptian standards, and a very puzzling one.

To begin at the beginning, with regard to Tutankhamun's parentage, we find Carter in 1923 stating circumspectly that he may have been of the blood royal or may have been a mere commoner. In 1933, when the king's remains had been examined and Carter and his colleagues had noted his "remarkable structural resemblance" to Akhenaton, he was inclined to believe that the latter was his father by an "unofficial wife." In later years various scholars have declared the king to be the son of Amenophis III, or of his vizier, the "Divine Father" Ay, who was to succeed Tutankhamun as pharaoh. Or he may simply have been adopted by Amenophis III or Akhenaten, together with his shadowy elder brother, half-brother or uncle, Smenkhare, because Akhenaten and Nefertiti were incapable of producing a male heir, although they had produced a large brood of daughters. An even wider choice of mothers is available. The king may have been begotten by Amenophis III on the Great Royal Wife, Tiy, or on his own daughter-wife Sitamun, or on an unknown member of the royal harim. If he was the son of the "Divine Father" Ay, then his mother could have been the vizier's powerful principal wife, Tiy, or a secondary wife (incidentally, Ay and Tiy were very probably the parents of Nefertiti). It seems to the present writer that rather a good case can be made that Smenkhare and Tutankhamun were the sons of Amenophis III and Sitamun, one of Amenophis' many daughters by Tiy.

Akhenaten (Amenophis IV, son of Amenophis III) still has his champions, on chronological grounds, as the father of Tutankhamun, but the consensus is that the latter's father was Amenophis III. Among the scanty documents of this otherwise rich period is an inscription found at Gebel Barkal in the Sudan in which Tutankhamun calls Amenophis III his father—although some scholars insist that the title may be purely symbolic, as in other cases. As Carter noted in 1933, this view has its difficulties; he speaks of "the old king and queen," and indeed Amenophis III, as we know from his mummy and from the facts of his reign, had ruled since youth in a sybaritic and high-handed fashion, like Louis XIV of France, and was physically much worn down. He would only have needed, however, to be in his early or mid-fifties at the time of Tutankhamun's birth; but if the latter's mother was the Great Royal Wife, Tiy, on the other hand, she would have been about 48 at the time—though here again, she had given birth to a daughter only two years before, and many women, particularly Egyptian women, remain fertile until the age of 50.

It seems certain that Amenophis III reigned for 39 to 40 years; in his third volume Carter surmised that Akhenaten then reigned 17½ years, Tutankhamun 9½, Ay 4½, and Horemhab—the founder of the Nineteenth Dynasty—27½ years. The lengths he gives to the reigns of the last three pharaohs can be calculated with accuracy, and remain generally accepted today. The exception is the reign of Akhenaten, to which varying lengths are given, depending on whether the writer in question accepts or does not accept the existence of a co-regency between that king and his father Amenophis III. The question of the co-regency, one of the thorniest problems in the field of New Kingdom studies, plays havoc with the possibility of providing absolute dates for the final years of the Amarna period. Carter is chary about scattering

dates throughout his work; he wisely omits them almost entirely. For those who accept the co-regency of Akhenaten and Amenophis III, the dates of Tutankhamun's reign (itself securely dated to 9¾ years by wine sealings) run from as high as 1369 to 1360 B.C. or 1357 to 1350 B.C.; while, at the other end of the scale, those who reject the co-regency date his reign as low as 1351 to 1344 B.C., and even in one extreme case from 1340 to 1332 B.C. Thus, the beginning of the king's reign can be dated, according to the individual view, within a time span of almost 30 years. The vagueness of the overall picture is sufficiently demonstrated, and confident pronouncements ought not to be expected.

One may state, nevertheless, that the consensus among scholars is presently in favour of the co-regency, an institution for which there is definite evidence from other periods. What may have happened is that in about the twenty-eighth year of his reign Amenophis III associated his eldest son with him on the throne, when the latter came of age, and gave him the title of Amenophis IV, whereupon the older man largely retired to his private pleasures. The cult of the Aten or sun god, in contrast to the official cult of Amun, had already become firmly established at court for at least a quarter of a century before the advent of Amenophis III, but now Akhenaten, who had only recently married Nefertiti, herself an enthusiastic devotee of the new cult, began the building of public temples to the sun god. About the sixth year of the co-regency, Akhenaten formally changed his name from Amenophis, "Amun is satisfied," to Akhenaten, "Glory of the Aten." At the same time he began the building of the huge new Atenist capital he called Akhetaten, "Horizon of the Aten," at Tell el-Amarna, where work went ahead so furiously that it was mainly completed within three to four years. Then, after ten or eleven years of co-

regency, Amenophis III died and Akhenaten reigned alone.

Tutankhamun, then, would have been born somewhere about the thirty-fifth year of the reign of Amenophis III, which was also the seventh year of his co-regent Akhenaten. Born in the flood tide of Atenism, he was first called Tutankhaten, and it can fairly be presumed that he grew up in the brand new city of Akhetaten in close association with the so-called Heretic King, with Nefertiti and with Amenophis III's widow Tiy. We know almost nothing about the career of either of these two prominent and forceful women. Tiy, it is conjectured, was first a champion of Atenism, then grew fearful of its speedy growth and its excesses, and returned to the orthodox camp of Amun. Nefertiti, whose name means, appropriately, "The Beautiful One Has Come," is even more of an enigma. Once she was held to be of Asiatic origin, or a daughter of Amenophis III by a minor wife, but these theories are now discounted. It is probable, as has been mentioned, that she was the daughter of Akhenaten's senior adviser, Ay, who would therefore have been the king's father-in-law. For ten years and more she was definitely Akhenaten's chief partisan as well as his consort, as we can see from the touching representations of them that have survived; indeed, the computerized reconstruction of dismantled buildings of the Amarna period which has recently been undertaken suggests that she possessed two large temples erected and dedicated solely by herself, which would make her a very important woman indeed.

However, in the fourteenth or fifteenth year of Akhenaten's reign she disappears abruptly from the monuments. Some great crisis had occurred. It could have been a personal crisis, concerned with her wifely relationship with Akhenaten, or it could have been political or religious, and concerned with the increasing storms stirred

up by Atenism and by the king's almost exclusive concentration on the affairs of the solar cult. She seems to have retired to her own palace in Akhetaten, taking Tutankhaten with her, while Akhenaten and Smenkhare betook themselves to another. There are current attempts to show that the whole Amarna episode was not the radical departure from precedent that it has been taken to be, and that "heresy" and "revolution" are exaggerated terms, but it does seem irrefutable that at this time the kingdom was subjected to grievous strains and miseries. We know from the clay tablets called the Amarna Letters, with their anguished appeals from the king's foreign governors to their sovereign, that the Empire in Asia, acquired with much effort by the king's forebears, was falling apart; the Hittites and their allies had overrun Phoenicia and Syria, Megiddo and Jerusalem; Egypt herself was beginning to feel threatened. Ay seems to have sensed the necessity of returning to the old forms, placating the ancient deities, healing the rift with Amun. Willingly or unwillingly, Akhenaten seems to have accepted a pliant co-regent for the last three years of his reign: indeed, one recent writer goes so far as to suggest that Akhenaten had actually gone mad—and all the representations we have of him show that physically he was highly abnormal—and was incapable of reigning any longer alone. In fact, it is not improbable that Akhenaten had always been more or less mad, and had been allowed by his father to build Akhetaten and to live there in order to keep him amused and occupied; in his 17-year "reign" he really enjoyed only about 18 months of unfettered rule, during which he broke out and attacked the temples and other properties of Amun with fanatical frenzy. The co-regency with Smenkhare was thus a device on the part of the real rulers of the land to keep him in restraint.

However that may be, and whoever he was, Smen-

khare, who was married to the eldest daughter of Akhenaten and Nefertiti, was a mere puppet. He may have journeyed, or been taken, from Akhetaten to Thebes to begin the business of reconciliation, but in effect he died almost simultaneously with his father-in-law. Pathetically, and typically of the confusion that surrounds the whole era— "the shadows move but the dark is never quite uplifted" —a mummy came to light in Tomb 55 of the Valley of the Kings which at one time and another has been identified both as the older man and as the younger. Newberry wrote that the relationship between them was homosexual, but this seems somewhat tenuous, although it is curious that a stele exists showing the two men seated side by side in an equivocal pose, and also that when Akhenaten erased Nefertiti's name from her monuments one of them was bestowed on Smenkhare. At any event, the time had come for another puppet to be placed on the throne: the last surviving son of Amenophis III and Smenkhare's junior by perhaps 15 years.

Tutankhaten, whose reign followed that of the 47-year-old Akhenaten and the 25-year-old Smenkhare (the figures, like almost everything else, are approximate), was aged about nine at the time of his accession: his mummy was that of a boy of 18, and he is known to have reigned nine years. His wife was Ankhesenpaaten, third of the six daughters of Akhenaten and Nefertiti. Once the royal pair had left Akhetaten to take up their residence at Thebes, where they resumed the traditional mode of worship, their names were changed. Tutankhaten, "Living Image of the Aten," became Tutankhamun, "Living Image of Amun," and Ankhesenpaaten, "She Lives in the Aten," became Ankhesenamun, "She Lives in Amun." The child rulers thus represented a return to orthodoxy in a realm now held steady by the political experience of the "Divine Father" Ay and the military determination of General Horemhab. However, it is inter-

esting to note that, at the beginning, the desired movement away from the Aten and back to Amun was handled tactfully, no doubt by Ay. Thus, Tutankhaten was not required to change his name or leave Akhetaten until the fourth year of his reign, and in his tomb were found objects inscribed with the solar disk in whose worship he had been nurtured. During Ay's brief reign, after his protégé's death, the watchword was toleration, and it was only with the elevation of the implacable Horemhab that the manifestations of Atenism were set upon and the names of everyone associated with it savagely hacked out of their monuments and tombs. It looks as if the body of Ay himself was ejected from his tomb, and it has been suggested that Horemhab may have murdered him.

Tutankhamun's short reign, then, was passed in the shadow of Horemhab and Ay, who in their different ways were striving to put the kingdom to rights after the Atenist interlude. He was a makeshift pharaoh, which was no doubt why he was placed in a makeshift sepulchre. His remains were not treated with callousness or discourtesy; it was important at that juncture to observe the proper forms, and he was buried with all the correct formal observances. Furthermore, as we can tell from his many portraits, he was a sweet-natured boy, who had never done any one any harm; and Ay, if he was not his actual father, must have been very fond of him. Nevertheless the dead king was interred hastily in a minor tomb, doubtless prepared originally for a favoured nobleman, its walls either bare or sketchily decorated; his personal effects were almost literally thrown in on top of him; and the very shavings from the carpenter's adze beneath the bier were not even swept up. It is possible that the tomb was in fact that destined for Ay, who in view of his exalted position was granted permission to be buried in the royal valley, and that when the little pharaoh died and Ay became king, the latter appropriated his tomb as he is

known to have appropriated his monuments.

The king was buried decently but not, by Egyptian royal standards, elaborately—which can only make one wonder, once again, what the tomb of one of the greater monarchs of ancient Egypt might have yielded up to the ministrations of a Carter. However, the vandals have attended to that, as they are attending in our own time, for example, to the mutilation of Angkor Wat or the ransacking of the tombs of Etruria. ". . . And gone are Phidias' famous ivories / And all the golden grasshoppers and bees"

In conclusion, it may be asked what happened to the king's young widow after his death? Far from being a milk-and-water personality, Ankhesenamun seems to have possessed vigour and courage. It appears that she first ruled jointly with Ay, while making a determined search to find a new husband in order to deny the eventual kingship to the aggressive Horemhab, who probably planned to marry her to legitimize his own designs on the throne. In desperation, she wrote the remarkable letter to Suppiluliuma, the king of the Hittites, to which Carter refers on pages 47–49 (some scholars have argued that the letter was written by Nefertiti, but such is almost certainly not the case). In her letter, she begs the Hittite ruler to send her a husband, and Carter asks: "Did the Hittite prince ever start for Egypt . . . ? . . . We shall never know." As it happens, we do know, now, that Suppiluliuma actually despatched a prospective bridegroom to Egypt in response to her plea, but that on the way he was ambushed and killed by a detachment of Horemhab's cavalry. In this sad way do the obscure and luckless figures of Tutankhamun and his queen pass from the stage of history.

Such, briefly, are the few facts we possess concerning the boy who ruled Egypt some time between 1369 and 1332 B.C. They are few in number and not very satisfying.

Introduction to the Dover Edition

Considering the wealth of the material from the tomb, and the enveloping riches of the Eighteenth Dynasty, it is like being condemned to starve amid scenes of plenty. Yet, ironically, it was probably the relative unpretentiousness of the tomb and its occupant, together with the fact that in later centuries it became deceptively situated beneath the foothpath that led into the Valley, that preserved it for posterity. Thus the unfortunate little king, disregarded in life, slighted in death, has taken his mild revenge. As visitors to the Egyptian Museum in Cairo during recent years will have noted, the contents of his tomb now occupy a generous proportion of the space available on the second floor, while their description takes up a quarter of the catalogue. The travelling exhibition of Tutankhamun's effects is one of the major art events of the late 1970s. The pharaoh who in life was one of the least esteemed of Egypt's kings has become in death the most renowned.

True, it must be admitted that the style in which the objects from the tomb are executed is not to everyone's taste. There are those who profess to find the art of the Eighteenth Dynasty, and particularly the Amarna period, to be in certain respects too exaggerated, too overblown and bloated. They prefer the grand and chaste art of the Old Kingdom, or the simple and austere art of the Middle Kingdom. Seen in the mass, as in the Egyptian Museum, Amarna art can have a bewildering effect and give one a sense of satiety. Viewed individually or in select numbers, however, by far the greater portion of the objects are, by any standards, wonderful and captivating, of a unique quality. This is not a forthright or virile art, in the manner of the earlier epochs; it is human rather than supernatural, pretty rather than imposing, decorative rather than Olympian, intimate rather than remote, gentle rather than assertive. It strikes one as personalized for the boy king, and therefore shows, for the most

part, the playfulness, the gaiety and the ingratiating side of Egyptian art, lacking entirely the elevated, stony character that was its other aspect. There is nothing here to remind us of the consummate awe and mystery of Egyptian royalty; perhaps, by the close of the Eighteenth Dynasty, the mana and the mystique had largely departed. Yet these objects have a character and beauty of their own, representing as they do the unparalleled polish and perfection of Egyptian craftsmanship. It is a phase of Egyptian art that has its own appeal and kindles a special sense of pleasure. It conveys to us the joy in living, the love of mankind and nature that is the most attractive feature of ancient Egyptian society. It celebrates life and ennobles death. If it does not bring before us the full sweep and majesty of Egyptian civilization—and how could it?—it shows us, as nothing else has done, its extraordinary grace and abundance, its sheen, its truly civilized essence.

Fittingly, the king's body has been returned to its modest House of Eternity in the Valley; it rests there in its sandstone sarcophagus, adorned with one of his radiant masks. His chariots and weapons, jewellery and furniture, removed with such loving care by Howard Carter, now give all who are privileged to see them boundless delight. Carter, who died in 1939, was not the least of the pharaoh's servants. It is therefore melancholy to have to record that, from a worldly point of view, he never received his due. Although he laboured in Egypt so long and diligently, he received no recognition of any kind from the British government: no knighthood, no Commandership of the British Empire, not even the lowly Membership of the British Empire, an award given to mailmen and railway guards. No British university bestowed on him an honorary degree. He was fiercely independent, an awkward man to deal with, and had stepped on many toes, but it seems a pity that the snob-

bery and jealousy of his colleagues and his countrymen should have shown itself in such a wretched lack of magnanimity. Yale and Madrid alone afforded him a token of gratitude.

However, if Carter was denied the petty satisfaction of scrolls and ribands, which become dusty and forgotten after a man's death, his writings still are very much alive, as evidenced by this new republication. Moreover, he had enjoyed another satisfaction that was far greater and more glorious, and for which men will always praise and envy him: he had touched the garland on a pharaoh's brow; he had turned back time; he had been given the Freedom.

JON MANCHIP WHITE

PREFACE

THIS narrative of the discovery of the tomb of Tut·ankh·Amen is merely preliminary: a final record of purely scientific nature will take some time, nor can it be adequately made until the work of investigation of the tomb and its vast material has been completed. Nevertheless, in view of the public interest in our discovery, we felt that some account without loss of time, no matter how summary, was necessary, and that is the reason for the publication of this book.

We have here for the first time, a royal burial very little disturbed in spite of the hurried plundering it has suffered at the hands of the ancient tomb-robbers, and within the shrines of the tomb-chamber I believe the Pharaoh lies intact, in all his royal magnificence.

It has been suggested by certain Egyptologists that we should write up in the summer, and publish at once, all we have done in the winter. But there is, outside the stress of work and other duties, a strong reason against this. Our work will take several seasons of concentrated labour on our discovery—the tomb, of the contents of which we are making as faithful a record as possible. If, following the advice of our critics, we were to write up our progress in detail before our work could be collated in its entirety, mistakes would necessarily creep in which, when once made, would be hard to rectify. We therefore ven-

ture to hope that the method we have adopted is more in the interest of scientific accuracy, and less likely to give rise to erroneous impressions. Nor are warnings wanting against undue haste. For instance, we bear in mind the vault containing the cache of Akh·en·Aten found in this Valley. The account of this important and interesting discovery was hurriedly published and announced as the tomb of Queen Tyi, whereas, after more careful investigation, only one object in that magnificent find, the so-called canopy, which apparently had had an extraordinary influence on the minds of its discoverers and recorders, could be claimed as possibly belonging to that queen. Such mistakes as these we wish to avoid. Moreover, as we have as yet seen only one quarter of the contents of this tomb, in this preliminary account we venture to claim the indulgence of the reader. He will understand that it must be subject to possible future correction in accordance with the nature of facts revealed by the further progress of our work.

When, by the dim light of a candle, we made the first cursory examination of the Antechamber, we thought that one of the caskets (No. 101) contained rolls of papyri. But, later, under the rays of a powerful electric light, these proved to be rolls of linen, which had even then some resemblance to rolls of papyri. This was naturally disappointing, and gave rise to the suggestion that the historical harvest, compared with the artistic value of our discovery, will be unimportant because of the lack of literary evidence concerning King Tut·ankh·Amen and the political confusion of his time.

It has also been argued that these chambers do not represent the actual tomb of the king but that

Preface

Hor·em·heb, Tut·ankh·Amen's second successor, had probably usurped his real tomb and hurriedly placed his furniture in the chambers of this vault. Nor is this all. It has also been said that it was merely a cache, and further it has even more improbably been conjectured that the objects found therein were a collection of palace furniture, belonging to the dynasty, and hidden there as Tut·ankh·Amen was the last of that royal line, and that of these many were of Mesopotamian origin. I may perhaps be pardoned for here observing that these criticisms have been advanced by authors who have never seen the tomb, let alone its contents.

Now in reply to these objections I would here say that so far as we have gone we have found nothing that should not belong to the funerary equipment of the king. All the objects are in perfect keeping with the evidence and knowledge gleaned from the fragmentary material of the royal tombs of the New Empire discovered in this Valley, and they are in every way pure late Eighteenth Dynasty Egyptian.

That this discovery is the real tomb of Tut·ankh·Amen, there can, I think, be no doubt, but it must be remembered that, like the tomb of Ay, his immediate successor, it is of semi-royal and semi-private type. In fact it is rather the sepulchre of a possible heir to the throne than that of a king.

A comparison of the tomb plan with that of the tombs of the kings' mothers, the kings' wives, and the kings' children, in The Valley of the Queens, and with the tombs of his predecessors and successors in The Valley of the Kings will, I think, show this.

From its style of work and certain idiosyncrasies

observable, it is not improbable that it was made
by the same hand as the vault that contained the
transported burial of Akh·en·Aten which is in its near
vicinity. The plan of that vault closely resembles
the tomb of Tut·ankh·Amen, and both are alike
variants of the plan and principles of the tombs of
the Theban monarchs of the Empire. The apparent
curtailment of design in the Akh·en·Aten vault—it
having alone the one completed chamber—was prob-
ably due to its being made for a cache to receive
nothing but the revered mummy with a few
essentials belonging to its burial. It may be for that
reason that we find only the first chamber—the
Antechamber—prepared and plastered to receive
those remains. It should also be noticed that in the
right hand wall of this one chamber the ancient
Egyptian mason commenced a second room, which
now, in its incomplete state, suggests a niche ; but on
comparing it with the grave of Tut·ankh·Amen the
idea and the intention become obvious—it was to be
a sepulchral hall. In other words, in the design
there is a certain affinity with the tomb of Akh·
en·Aten at El Amarna, and the vault devised for a
cache in this Valley for that so-called heretic king,
and also with the tombs of Tut·ankh·Amen and Ay,
which is peculiar to that El Amarna branch of the
Dynasty. With them we also find the finest art of
the Imperial Age in Egypt, and also the germ of its
decadence which made itself manifest in the succeed-
ing Nineteenth Dynasty.

It was King Ay, Tut·ankh·Amen's successor, who
buried our monarch, for there, on the inner walls of
Tut·ankh·Amen's tomb-chamber, Ay, as king has
caused himself to be represented among the religious

scenes, officiating before Tut·ankh·Amen—a scene unprecedented in the royal tombs of this necropolis.

It were, perhaps, well at this point to say something concerning the mentality of the ancient Egyptians as manifested in their art, which is closely associated with their religion. If we study the ancient Egyptian religious ideas we may be absorbed by the curious medley of their mythology, yet in the end we shall feel that we have progressed beyond them. But if once we have acquired the power of admiring and understanding their art, we do not, for the most part, entertain this assurance of æsthetic progress and superiority. Perhaps we may do so in minor details, but no sensible person will ever imagine that he has got beyond the essentials their art embodies. We cannot with all our progress get beyond those essentials. Egyptian art expresses its aim in a stately and simple convention, and is thus dignified by its own sedateness, and was never wanting in reverence.

No doubt lack of perspective in their art implies limitation, therefore not a little must be surrendered to this limitation, but within its convention the best Egyptian art embodies refinement, embodies love of simplicity, patience in execution, and never descends to an unideal copy of nature. Simplicity is the sign of greatness in art, and the Egyptians never strove to be original or to be sensational. Within the trammels of his convention the ancient Egyptian looked at nature through his own eyes and thus character was imparted alone by his subjective personality, whether from a religious or æsthetic point of view. It is for this reason that Egyptian portraiture to the untrained eye often appears to have

a certain sameness and even monotony. This, however, is really due to the convention of the epoch, whereby individual traits were softened in accordance with the ideals of the Egyptian convention. These facts are manifested by the material in the tomb of Tut·ankh·Amen. We are astounded by the immense productivity of the art of its period which it contains, but in studying it, a somewhat unexpected aspect of the character and domestic tastes of the king is suggested. Tut·ankh·Amen's tastes seem to have been rather those of a nobleman than those associated with the religious and official art dominant in this royal Theban cemetery. In the art of his tomb it is the domestic affection and solar tendency that are the dominant ideas, rather than the austere religious convention that characterizes all the other royal tombs in this Valley.

Among the immense quantities of material in Tut·ankh·Amen's tomb, as also exhibited in the beautiful reliefs of his reign in the great colonnade of the Temple of Luxor, we find extreme delicacy of style together with character of the utmost refinement. In the case of a painted scene, vase, or statue, the primary idea of art is obvious, but in utilitarian objects such as a walking-stick, staff or wine-strainer, art, as we know too well to-day, is not a necessity. Here in this tomb the artistic value seems to have been always the first consideration.

This is scarcely the place to discuss the question of ancient Egyptian art, as the book deals mainly with the actual finding of the tomb. But The Valley cannot be overlooked, and it will be helpful to include some general statements upon its impressive history,

as well as to record certain unexpected events to which the discovery gave rise.

After so many years of barren labour a sudden development of great magnitude finds one unprepared. One is, for instance, confronted by the question of adequate and competent assistance. In this case the help needed obviously included the all important recording, photographing, planning, and the preservation of the objects—the latter demanding chemical knowledge. But the first and most pressing need was that of photography and drawing. Nothing could be contemplated until a full pictorial record of the contents of the Antechamber had been made. This must not only include photographs of the general disposition of the objects therein, and the order of their sequence, but must afterwards be followed by diagrammatic drawings showing relative positions as seen from above—a task involving not only photographic skill of a high order but also that of an experienced surveyor. Then came the consideration of their preservation, their removal, and their description—the work of a chemist, of a man experienced in the handling of antiquities, and finally of an archæologist.

This problem was quickly solved through the generosity of our colleagues of the American Expedition of the Metropolitan Museum of Art of New York. In answer to my appeal my most esteemed friend and colleague, Mr. A. M. Lythgoe, the Curator of the Egyptian Department of that museum, whose kind offer was subsequently most generously confirmed by his trustees and director, cabled and placed at my disposal, to the detriment of their own work, such members of their staff as might be required.

For such luck as this I had not dared to hope. It included the services of Mr. A. C. Mace, one of their associate curators, of Mr. Harry Burton, their expert photographic recorder, to whom the photographs in this volume are due, and of Messrs. Hall and Hauser, draftsmen to their expedition—a group of very able field-men and all of wide archæological knowledge. And let me here place on record the sacrifice that Mr. Mace, the director of their excavations on the pyramid field at Lisht, made in our interests, which meant the abandonment of his many years of research work at Lisht, and I should add that the preparation of this book has fallen largely on his shoulders. At the same time I must express our most sincere and grateful thanks to the trustees of the Metropolitan Museum of Art of New York, to their director, Mr. Edward Robinson, to Mr. Lythgoe, and also to Mr. H. E. Winlock, whose expedition for them at Thebes was thus considerably denuded.

While in Cairo another stroke of good luck occurred. Mr. Lucas, Director of the Chemical Department of the Egyptian Government, for the moment free of his official duties, offered us the valuable aid of his chemical knowledge.

Previous to this, when I realized the probable magnitude of the discovery, Mr. A. R. Callender at Erment, who had often assisted me on former occasions, at once came to my aid. Dr. Alan Gardiner also very kindly placed his unrivalled philological knowledge at our disposal. Moreover, Professor James H. Breasted, of the University of Chicago, the eminent historian of ancient Egypt, then in Egypt, gave me his valued advice and enlightened me upon the historical data and evidence of the seal-impressions

Karna, Luxor
5th August 1923

Mr. Howard Carter Esq —

Honourable Sir,

Beg to write this letter hoping that you are enjoying good health, and ask the Almighty to keep you & bring you back to us in Safety.

Beg to inform your Excellency that Store No. 15 is alright, Treasure is Alright, the Northern Store is alright. Wadain & House are all alright, & in all Your Work order is carried on according to your honourable instructions.

Rais Hussein, Gad Hassan, Hassan Awad Abdelal Ahmed and all the Gaffirs of the house beg to send their best regards.

My best regards to Your respectable Self, and all members of the Lord's family, & to all your friends in England

Longing to your early Coming.
Your Most Obedient Servant
Rais Ahmed Gurgar

on the four sealed doorways found in various conditions in the tomb.

Throughout the whole of this undertaking we received the utmost courtesy and kindness from all the officials connected with the Department of Antiquities of the Egyptian Government, and I herewith desire to express the acknowledgment due to Monsieur Lacau, Directeur Général au Service des Antiquités. And here I may mention how much I am indebted to the members of *The Times* staff for all their ready co-operation in all matters, even those outside the sphere of their own interests.

My appreciative thanks are also due to Lady Burghclere, Lord Carnarvon's devoted sister, for the biographical introduction which she has so kindly contributed, for no one could have been better fitted to carry out this task.

I must also thank my dear friend Mr. Percy White, the novelist, Professor of English Literature in the Egyptian University, for his ungrudging literary help.

Lastly I should like to express my recognition of the services of my Egyptian staff of workmen who have loyally and conscientiously carried out every duty which I entrusted to them. The letter, on p. xv, which, in its quaint English, shows their zeal during my absence, should perhaps go on record.

<div align="right">HOWARD CARTER.</div>

August, 1923.

CONTENTS

Except for the frontispiece, all the photographs were taken by Harry Burton of the Metropolitan Museum of Art, New York.

LIST OF PLATES

List of Plates

xlii

List of Plates

xliii

List of Plates

List of Plates

INTRODUCTION

BIOGRAPHICAL SKETCH OF THE LATE LORD CARNARVON

By Lady Burghclere

IF it is true that the whole world loves a lover, it is also true that either openly or secretly the world loves Romance. Hence, doubtless, the passionate and farflung interest aroused by the discovery of Tut·ankh·Amen's tomb, an interest extended to the discoverer, and certainly not lessened by the swift tragedy that waited on his brief hour of triumph. A story that opens like Aladdin's Cave, and ends like a Greek myth of Nemesis cannot fail to capture the imagination of all men and women who, in this workaday existence, can still be moved by tales of high endeavour and unrelenting doom. Let it be gratefully acknowledged by those to whom Carnarvon's going must remain an ever-enduring sorrow, that the sympathy displayed equalled the excitement evoked by the revelations in The Valley of the Kings. It is in thankful response to that warm-hearted sympathy that this slight sketch of a many-sided personality, around whom such emotions have centred, finds place here as introduction to the history of that discovery to which the discoverer so eagerly devoted his energies and ultimately sacrificed his life.

Introduction

To those who knew Lord Carnarvon, there is a singular fitness in the fact that he should have been the hero of one of the most dramatic episodes of the present day, since under the quiet exterior of this reticent Englishman, beat, in truth, a romantic heart. The circumstances of his life had undoubtedly fostered the natural bent of his character, Born on June 26th, 1866, George Edward Stanhope Molyneux Herbert, Lord Porchester, enjoyed the inestimable privilege of being reared in an atmosphere coloured by romance and permeated by a fine simplicity. Nor was he less happy in his outward surroundings. Even when matched against the many "stately homes of England," Highclere must rank as a domain of rare beauty. Much of its charm is due to its contrasted scenery. From the close-cropped lawns, shaded by giant cedars of Lebanon, where in a past century Pope sat and discoursed with his friend, Robert Caroline Herbert, the godson and namesake of George II's queen, the transition is brief to thickets of hawthorn, woods of beech and oak, and lakes, the happy haunts of wildfowl ; while all around stand the high downs either densely timbered or as bare and wild as when the Britons built their camp of refuge on Beacon Hill, the great chalk bastion that dominates the country-side. To children nurtured on Arthurian legends it needed little mental effort to translate the woodlands, where they galloped their ponies, into the Forest of Broceliande, or the old monkish fishponds, where they angled for pike and gathered water-lilies, into that magic mere which swallowed up the good blade Excalibur ; whilst a mound rising from a distant gravel-pit merely required the drawbridge, erected by the obliging house

carpenter across its surrounding trickle of water, to become Tintagel.

If, as any Catholic priest would assure us, the indelible impressions on the human mind are those stamped in the earliest years, Porchester graduated in a school of Romance and Adventure. Moreover, hereditary influences combined with environment to give an individual outlook on life. The son of two high-minded parents who were ever striving to give practical effect to their ideals for the benefit of others, there was nothing to unlearn in the early education. Indeed, it can confidently be asserted that, throughout his childhood, the curly-headed little boy neither heard nor witnessed anything that " common was or mean." The village, the household, were members of the family. It was the feudal, the patriarchal system at its best, the dreams of " Young England " realized. For the law that governed the community at Highclere was the law of kindness, though kindness that permitted no compromise with moral laxity. An amusing commentary on the standards recognized as governing—or at any rate expected to govern —home life, was furnished on one occasion by the children's nurse. One of her nurslings, thoroughly scared by the blood-curdling descriptions of Hell, and Hell-fire, contained in a horrible little religious primer, " The Peep o' Day " (now mercifully discarded by later generations) administered to her by an injudicious governess, naturally turned to the beloved " Nana " for consolation. She did not seek in vain. " Don't worry, dearie, over such tales," said the good old woman, " no one from Highclere Castle will ever go to Hell ! "

By common consent, Porchester's father, the

fourth Earl of Carnarvon, was regarded as a states-
man who had never allowed ambition to deflect him
by a hair's breadth from the path mapped out by a
meticulous conscience. But although he had re-
signed from the Derby-Disraeli Government rather
than support the Franchise Bill of 1867, he was the
reverse of a reactionary. Both in imperial and social
schemes he was far in advance of most of his con-
temporaries on both sides in politics. Indeed, it is
interesting to speculate how much of blood and
treasure would have been spared to this country if
the measures and judgment of this truly Conserva-
tive statesman had commanded the support of the
Cabinets and party with which he was connected.
Little boys are not interested in politics—except in
lighting bonfires to celebrate successful elections—
but whatever are the eventual developments, en-
vironment and heredity are the bedrock whence
character is hewn. The fifth Earl of Carnarvon—
the archæologist—in his physical and mental " make-
up," to use the modern phrase, did not recall his
father. But it was from the latter that he inherited
the quality of independent thought, coupled with an
extreme pleasure in putting his mind alongside that
of other men. Moreover, the power of scholarly
concentration which he brought to bear on the many
and varied subjects in which he was interested, was
certainly part of the paternal heritage, for the fourth
Earl was one of the finest classical scholars of his
generation. Indeed, there are those still living who
can bear witness to his faultless Latin oration as
Viceroy at Trinity College, Dublin, and remember his
admission, when pressed, that he could as easily
have made the speech in Greek.

In 1875 a shadow fell across the boy's life. His mother died after giving birth to a third daughter. The shadow was destined to be enduring, since Evelyn Stanhope, Lady Carnarvon, was one of those rare women who are in the world and yet not of it, and the want of her clever sympathy was a lifelong loss to Porchester. His whimsical wit and her keen sense of humour were made for mutual understanding. She would have helped him to overcome the ingrained reserve, which it needed the action of years to wear away, at the outset interpreting an unusual character to the world, and the world to her son.

Even when the surviving parent is as devoted a father as was Lord Carnarvon, it is perhaps unavoidable that the mother's death should bring an element of austerity into children's lives, though it also tends, as it certainly did in this instance, to tighten the links between brother and sisters. After their mother's death, Porchester, or "Porchy" as he was then habitually called, and the little girls were, however, unspeakably blessed in the devoted affection lavished upon them by their father's sisters Lady Gwendolen Herbert and Eveline, Lady Portsmouth. The former was a delicate invalid around whose sofa young and old clustered, secure of sympathy in sorrow or in joy. The fact that an unhappy chance had cheated her of her share of youth's fun and gaiety made her the more intent on securing these for the motherless children, in whose lives she realized her own life. She was the natural interpreter when vengeance threatened to follow on chemical experiments resulting in semi-asphyxiating and wholly malodorous vapours, or when excursions

amongst water-taps sent cataracts of water down the Vandycks. The schoolroom discipline of the 'seventies was not conceived on Montessori lines. The extreme mildness of Lady Gwendolen's rule did not always commend itself to tutors and governesses. They recalled that a spear, which at his earnest entreaty she had bestowed on Porchy, was fleshed in a valuable engraving; while another of her gifts, a large saw, was regarded as so dangerous that it became "tabu" and hung suspended by a broad blue ribbon, a curious ornament on the schoolroom wall. Nor can it be denied that to present a small boy with half-a-crown to console him for breaking a window is a homœopathic method of education, which would excite protests from pastors and teachers of any age. But despite her unfailing indulgence, her influence was never enervating. It is what we are, not our sayings, and still less our scoldings, that count with those keen-eyed critics, the younger generation. Naughtiness in Gwendolen's neighbourhood was unthinkable. In her own person she so endeared the quality of gentleness—not a virtue always popular with the young of the male sex—that Porchy's sisters and small half brothers never suffered from roughness at his hands. A tease he was, a terrific tease then and to the end of life, in sober middle-age getting the same rapture from a "rise" out of his friends or family as a fifth-form school boy. But the strand of gentleness that ran through his nature was not its least attaching quality, fostered in those early days by the one effectual method of education, the example of those we love.

Long years afterwards when her nephew laid Lady Gwendolen to rest at Highclere, he reverted

with grateful tenderness to the memories, the lessons of that selfless love. " What a blank," he wrote, would the absence of " that little figure in grey " mean to him at the family gatherings, the christenings, the weddings, where her presence carried him back to all the lovely memories of childhood.

Never robust, it is doubtful whether Lord Carnarvon would have accomplished even his brief span of life but for the part played in his boyhood by Lady Portsmouth and her home, Eggesford, which, became his second home. The England of the 'seventies was still an age of hermetically closed windows, overheated rooms, comforters and—worst horror of all—respirators. Fortunately for the boy, Lady Portsmouth, a pioneer in many phases of work and thought, was a strenuous advocate of open air. The delicate, white-faced child, after a couple of months spent in hunting and out-of-door games with the tribe of cousins in North Devon, was transformed into a hardy young sportsman. At Eggesford horses and hounds were as much the foreground of life as politics and books at Highclere. " Mr. Sponge's Sporting Tour " replaced " Marmion," though it was " The Talisman " and " Ivanhoe " that Lady Portsmouth read aloud to the family in the cherished evening hour, the climax of the busy, happy day at Eggesford. Different as the two houses might appear, they were, however, alike in essentials. They owned the same ethics, they acknowledged the same standards. Highclere could not be called conventional. But Eggesford, in a country which before the advent of the motor preserved much of the flavour of the past, was distinctly unconventional. The meets brought into the field a motley assembly of men,

boys, horses and ponies, such as probably outside Ireland could have been collected in no other corner of the United Kingdom. Of these not the least individual figure was Lord Portsmouth, probably the most popular M.F.H. in England. Seldom, indeed, can goodwill to men of goodwill have been more clearly writ large on a human countenance than on this great gentleman's, whose very raciness of expression only the more endeared him to the Hunt.

In later life Lord Carnarvon's friends often noted with amusement his fondness for those they describe as " quaint personalities." It may be that this taste owed its origin to those holiday hours spent waiting for the fox in spinneys, and by larch woods dappled with the early greenery of the incomparable West Country spring-tide. Perhaps it was there also that he received lessons in a less facile art than the observation of the quaint and curious. The perfect ease of friendship, a friendship that excludes alike patronage and familiarity, was the keynote of the old M.F.H.'s intercourse with man, woman, and child on those mornings. It was much the same keynote that governed Lord Carnarvon's relations with persons whose circumstances and mentality might seem to set a wide distance between them. Those who travelled with him on his annual journey—or progress rather—from Paddington to Highclere at Christmas can never forget the warmth of greetings his presence called forth in the railway employees of all grades, from inspectors to engine-drivers. The festival gave them and gave him an opportunity of expressing their feeling, their genuine feeling for one another. It is no exaggeration to

say that it was a moving scene, singularly appropriate to the celebration of the great family feast of the year.

A private school and Eton are the successive steps which automatically prepare a boy in Porchester's position for a future career. His private school was not happily chosen. It subsisted on its former reputation, and neither diet nor instruction was up to the mark, but he was at least fortunate in emerging alive from an epidemic of measles, which the boys treated by pouring jugs of cold water on each other when uncomfortably feverish.

To the end Eton retained in his eyes that glamour which marks the true Etonian, and his tutor, Mr. Marindin, shared in that affection. Yet it was something of a misfortune that school did nothing for the formation of methodical habits in a boy endowed with an exceptionally fine memory and unusual quickness. It would, for instance, have been a blessing if an expensive education had taught him to answer his letters. Thus, on one occasion, literary circles rang with the wrathful denunciations of a distinguished critic, who had vainly applied to Lord Carnarvon, as heir to the eighteenth-century Lord Chesterfield, for information regarding that statesman's relations with Montesquieu. It was known that the author of " L'Esprit des Lois " had visited either Chesterfield House or Bretby, where it was presumed that some trace of the visit might be found. On inquiry it transpired that Lord Carnarvon had spent hours, if not days, searching the library at Bretby, a library collected entirely by Lord Chesterfield, for any vestiges of Montesquieu. But the search having proved vain, it had not

occurred to Carnarvon to send a postcard to that effect—if only to point out how much trouble he had taken on an unknown stranger's behalf.

Before he left home for school, tutors and governesses had pronounced Porchy to be idle ; and probably, as in the case of most active young creatures, it was no easy task to hold his sustained attention. Yet, judged by the less exacting standards of the present day, a child of ten would now scarcely be considered backward who was bilingual—French being the language used with mother and teachers—was possessed of a fair knowledge of German, the Latin Grammar, and the elements of Greek, and sang charmingly to the old tin kettle of a schoolroom piano. Labels are fatal things. Once labelled idle it is the pupil and not the instructor who earns the blame. Perhaps also the perfection of the father's scholarship was a stumbling-block to the son. It is one of life's little ironies, on which schoolmasters should ponder, that a man destined to reveal a whole chapter of the Ancient World to the twentieth century, frankly detested the classics as taught at Eton.

The fourth Earl was too sensible to insist on his son pursuing indefinitely studies doomed to failure. Porchester left Eton early to study with a tutor at home and abroad what would now be called the "modern side." The amount of strenuous scientific work achieved in the little laboratory by the side of the lake at Highclere or during walking tours through the Black Forest was probably small ; but at any rate these two *wanderjahren* left him in possession of a store of miscellaneous information

Introduction

seldom accumulated by the average schoolboy—
the very material to stimulate his natural versa-
tility. Some months were spent at Embleton
under the tuition of the future Bishop of London,
Dr. Creighton, to whose memory he remained much
attached. Work with crammers in England and at
Hanover with a view to entering the army formed
the next phase. The project of a military career,
however, proved evanescent; and in 1885 Lord
Porchester was entered at Trinity College, Cam-
bridge. It was characteristic that being struck with
the beauty of the panelling in his college rooms,
he offered the authorities to have the many coats of
paint disfiguring the woodwork scraped off and the
rooms restored at his own expense—an offer un-
fortunately refused. Collecting was not then the
universal mania it has now become, but the under-
graduate was father to the man who was eventually
regarded as a court of appeal by the big dealers
in London. But long before Cambridge curiosity
shops had been his happy hunting grounds. As a
little lad, besides the stereotyped properties of the
average schoolboy, the inevitable stamp album, and
a snake—the latter housed for a whole term at
Eton in his desk—when he had a few shillings to
spare, blue and white cups, or specimens of cottage
china, would be added to his store of treasures. He
was still at Cambridge when he began collecting
French prints and drawings, notably the Rops draw-
ings, now highly valued by connoisseurs, then bought
for a few francs.

Nevertheless, at this period, sport rather than
antiquities was the main interest of the young man's
life, and it is to be feared that he was more often

seen at Newmarket than at lectures. His father had recently built a villa on the Italian Riviera, at Porto Fino, a lonely promontory, then absolutely remote from tourists, as a deep chasm in the high road leading to the little seaport formed an effectual barrier to communications, save by sea, with the outer world, As a means of locomotion Porchester acquired a sailing boat, and therewith acquired a passion for the water. The Mediterranean is not the halcyon lake it is sometimes painted by northern imagination. Indeed, Lerici, with its tragic memories of Shelley, is a warning, almost within view of Porto Fino, of the risks that attend on the mariner who neglects to shorten sail when a sudden gust sweeps down from the over-hanging mountains. These squalls more than once nearly brought about the end of the young " milord," the Italian boatmen having a tiresome habit, at such crises, of falling on their knees to invoke the Madonna, while Porchester and his stolid English servant were left unassisted to bring the boat to harbour.

To the born adventurer the zest of adventure lies in its flavour of danger, and it was the hazards run on these excursions that inoculated him with the love of seafaring. When he left Cambridge in 1887 he at once embarked in a sailing yacht for a cruise round the world, and henceforward it may be said that the lure of adventure never ceased to haunt him. From Vigo he sailed to the Cape Verde Islands, the West Indies, paused at Pernambuco, and then let drive for 42 days on end through the great solitude of the tropical seas till he brought up at Rio. It was on this voyage that he acquired the passion for reading, which was to be the mainstay of his existence,

a gain which was cheaply purchased at the cost of those long months spent under the Southern Cross. He was wont to say that, fond as he was of sport and motoring, he would gladly never stir out of his chair if only when he finished one absorbing book, another equally absorbing could drop into his hands. Thus, the curtain being rung down on his academic studies, the once idle undergraduate flung himself with avidity into the pursuit of knowledge, and especially of history, certain periods of which he studied with the meticulous research of a professor preparing a course of lectures.

Life on board the *Aphrodite* was not, however, solely dedicated to placid readings of successive series of improving tomes. There are bound to be pleasant and unpleasant episodes on a long voyage and the young man had his fill of both. In a high gale, while the captain lay unconscious and delirious, Porchester took command, and luck and a good first mate being with him, brought the yacht safe to land. Again, when one of the crew injured himself, and the ship's doctor was forced to operate, it was Porchester who, his finger on the man's pulse, administered the chloroform with the neatness and calm of a professional anæsthetist. At Buenos Aires, then in the floodtide of prosperity, with two Italian Opera companies performing nightly to Argentine millionaires, the young Englishman met with a cordial welcome from all classes of the community, native and foreign alike. In the style of the traditional " milord " he feasted the President on the *Aphrodite* —the first yacht to cast anchor in Argentine waters —while he also made friends with men of business, the Admiral commanding the British Squadron and

the Italian Opera singers. He rather plumed himself on the latter company having once called on him to replace their missing accompanist at a rehearsal; he admitted—for he loved telling a story against himself—that the request was never repeated, as he insisted on taking the artists according to his, rather than according to their, notion of time.

Of all these acquaintances and friendships Admiral Kennedy's undoubtedly was the most valuable, since it was thanks to his vigorous remonstrances that Porchester finally abandoned his projected journey through the Straits of Magellan, which, at the wrong time of year and in a sailing boat, the admiral declared to be suicidal. The complete tour of the world planned by Porchester therefore failed, but the journey was rich in experiences of all kinds to a young man fresh from college.

From Buenos Aires, Porchester returned in somewhat leisurely manner homewards. Many of the places he visited were *terra incognita* to the Englishman of that date, and even now are unfamiliar to the average tourist. In the Great War he was one of the few people able to give a first-hand description of the scene of the battle at the Falkland Islands, where he had predicted that the decisive fight for the control of the South Atlantic must take place.

From these early travels he brought back, however, something more than acquaintance with the waste places of the earth, beautiful scenery or strange types of humanity. In these wanderings he also saw something of the elemental conditions of life, where a man's hand must needs keep his head, an experience too often denied to the rich man of our latter-day civilization. A bibliophile, a collector of

Introduction

china and drawings and, indeed, of all things rare and beautiful, with a fine taste intensified by observation and study, his happiest hours were probably those when the unsought adventure called for rapid decision and prompt action. But it should be understood that the adventure must be unsought, for no one was ever less cast in the mould of a Don Quixote. His courage was of that peculiar calm variety which means a pleasurable quickening of the pulse in the hour of danger.

On one occasion in his youth he hired a boat to take him somewhere off the coast to his ship lying far out to sea. He was alone, steering the little bark rowed by a couple of stalwart fishermen. Suddenly, when far removed from land, and equally distant from his goal, the two ruffians gave him the choice between payment of a large sum or being pitched into the water. He listened quietly, and motioned to them to pass his dressing-bag. They obeyed, already in imagination fingering the English "Lord's" ransom. The situation was, however, reversed when he extracted, not a well-stuffed pocket-book, but a revolver, and pointing it at the pair sternly bade them row on, or he would shoot. The chuckle with which he recalled what was to him an eminently delectable episode, still remains with his hearer.

Truth compels his biographer to admit that he did not always emerge so triumphantly from his adventures. His next long journey was to South Africa. From Durban he wrote to the present writer, announcing his intention to go elephant hunting; and hunting he went, but the parts of hunter and hunted were reversed. Accompanied by a single

black, he lay in wait in the jungle for an elephant, and in due course the beast made his appearance. Porchester, generally an admirable shot, fired and missed him, and after a time, seeing no more of his quarry, slid down the tree where he was perched, intending to amble quietly homewards. To do this, he had to cross a piece of bare veldt which cut the forest in two. He was well in the middle of this shelterless tract, when he perceived that he was being stalked by the elephant, saw he had no time to re-load, and took to his heels with a speed he had never imagined he could compass. His rifle, his cartridge pouch, his glasses, his coat were all flung away as he ran for dear life, with the vindictive beast pounding on behind him. To him, as to the Spaniard, haste, on foot at least, had always been of the devil. Yet now, with life as the goal, it was he who won the race. He reached the friendly jungle, again climbed a tree and was saved. To be chased by an elephant and escape, he was afterwards told, was a more unusual feat than to bring one down to his gun. Eventually, he became one of the half-dozen best shots in England, but never again did he go elephant hunting.

The journey to South Africa was followed by another to Australia and Japan, whence Porchester returned in the early summer of 1890, happily just in time to be with his father, during Lord Carnarvon's last illness and death.

The new lord was only 23 when he entered on his heritage, and save that his passion for sport kept him at Highclere and Bretby during the shooting season, and his love of the Opera for a few weeks in London during the summer, he remained constant

to his love of travel. He would suddenly dash off to Paris or Constantinople, Sweden, Italy or Berlin, for long or short periods, returning home equally unexpectedly, having collected pictures and books and any number of acquaintances and friends, some of whose names, unfamiliar then, have since loomed as large in the world's history as they did in the young traveller's tales. Not that at this phase he was unduly communicative. He rather affected the allusive style, as " when I saw the chief of the Mafia in Naples "—a style eminently adapted to whet curiosities which he would then smilingly put by, to the despair of a hearer who naturally wished to know how he came across that mysterious potentate. His sense of fun made him more explicit with regard to his efforts to achieve acquaintance with another lurid character. This was no other than the late Sultan " Abdul the Damned," with whom during one of his visits to Constantinople, Carnarvon was seized with a desire to obtain an interview. Carnarvon's wardrobe was never his strong point. He had no uniform, but he furbished up a yacht jacket with extra brass buttons and hoped his attire would pass muster with the Chamberlain's department. His name having been submitted through the Embassy to the proper quarters, he was informed that an equerry and a carriage would convey him to the Yildiz Kiosk. On the appointed day the official made his appearance wearing, however, an embarrassed air, for he had to explain that H.M., though profoundly desolated, found himself unable to receive his lordship. " Perhaps another day ? "—" No, the Sultan feared no other day was available, but as a slight token of his esteem, he begged Lord

Introduction

Carnarvon's acceptance of the accompanying high order." Carnarvon declined the order, which he would certainly never have worn, and was left equally vexed and puzzled. It took some time to arrive at any explanation, but at last this was achieved.

His father, the fourth Earl of Carnarvon, had travelled extensively in Turkey, with the result that he retained a profound horror of the misgovernment of that unhappy country and an equally profound sympathy for the persecuted Christian races. He became the Chairman of the Society for the Protection of the Armenians and was regarded as one of their chief sympathizers. This was known to Abdul, though neither he nor his ministers had realized that this Lord Carnarvon was dead, and that a young man, bearing his name indeed, but otherwise not having inherited his political views or influence, was the English lord who had requested an audience of the Sultan. Abdul lived in perpetual dread of assassination, and in especial of assassination by one of the race he had so cruelly persecuted. He therefore jumped to the conclusion that Lord Carnarvon had asked for an interview with the purpose of killing him, and firmly declined to allow the supposed desperado to enter his presence. Lovers of history, like Carnarvon, are anxious to come face to face with those who, for good or ill, are the makers of history. Consequently he was genuinely disappointed at the failure to see one of the ablest though most sinister of these latter-day figures. But the notion of his father, of all men, being regarded as a potential murderer was too ludicrous not to outweigh the vexation, and he

frequently had a quiet laugh over this side of the story.

In later life, when he was largely thrown into their company, " The Lord," or " Lordy " as he was called by the Egyptians, contrived to establish more points of contact with Orientals of all classes from pasha to fellah than is usually possible to the Western man. But indeed he had an undeniable charm, which, when he chose to exert it, attracted the confidence of men and women all the world over. An instance in point which also illustrates the mingled shrewdness and whimsicality of his character concerned a visit to California. On his way thither he paused in New York, where he had promised a friend he would try to obtain information respecting a certain commercial undertaking. The fashion in which he sought for information was, to say the least, highly original. For it was of his hair-cutter that he inquired as to the person in control of the venture. The hair-cutter having proved, strange to say, able to enlighten him on the subject, Lord Carnarvon wrote a note to the financier in question requesting an interview. In due course he was received by a typical captain of industry, with eyes like gimlets and a mouth like a steel trap, who must have admired the candour of the stray Englishman asking him straight out for advice. The magnate listened courteously to his request for information and then unequivocally urged him on no account to touch the stocks. Carnarvon looked hard at him, thanked him, and went straight off to the telegraph office, where he cabled instructions to buy. He then departed to California, where he fished rapturously—he delighted in all varieties of

Introduction

sport—for tarpon. Six weeks later he returned to New York to find that the shares had soared upwards, and that his city friend was in ecstasies at the profit made owing to Carnarvon's decision. He then asked for another interview with the financier, and was again civilly received. This time, Carnarvon explained that he felt he could not leave America without returning thanks for advice which had proved so profitable that it had defrayed the expenses of a very costly trip. The magnate stared and exclaimed, " But Lord Carnarvon, I advised you *against* buying." " Oh, yes, I know you said that, but of course I saw that you wished me to understand the reverse." There was a moment's pause and then the great man burst into a roar of laughter, held out his hand and said, " Pray consider this house your home whenever you return to America." " And was your captain of industry the most interesting person you met on that journey ? " his hearer inquired. " Oh dear no ! " was the characteristic reply, " the most interesting man by far was the brakesman on the railway cars to California. I spent hours talking with him."

In 1894 Lord Carnarvon chartered the steam yacht *Catarina,* and in company with his friend Prince Victor Duleep Singh again visited South America. On his return in the summer of 1895 on his 29th birthday he married Miss Almina Wombwell. The marriage was celebrated at St. Margaret's, Westminster ; the wedding breakfast took place at Lansdowne House. All was sumptuous. The very pretty bride might well have sat as a model to Greuze, and the bridegroom's singular air of distinction was no less marked than her good looks. Moreover,

Introduction

he had been persuaded to order and to wear a frock coat for the great occasion. But when they set off for Highclere with its triumphal arches and its cheering tenants, the bride herself wearing rose-coloured gauze bespangled with emeralds and diamonds, Lord Carnarvon thankfully reverted to his straw hat and his favourite blue serge jacket, which the devoted old housekeeper, his mother's maid, had (much to her own scandal) darned that selfsame morning! The funny little detail was eminently characteristic, for though his fastidious taste welcomed all that made for the refinements of existence, with regard to himself he preserved intact his own curious simplicity.

During the next eight or ten years the couple lived the usual life, as it was lived in those cheerful pre-war days, of young folk whose lot has been cast in pleasant places. In 1898, much to their rejoicing, a son, Henry, Lord Porchester, was born to them, followed in 1901 by a daughter, Evelyn, destined to become her father's dearest friend and close companion in the last eventful and fatal journey to Egypt.

About 1890 Lord Carnarvon took up racing in which he soon became deeply interested, for he was incapable of giving half-hearted attention to any business or pursuit. Ultimately his main interest lay in his stud farm where he was considered fortunate. He won some of the big races; many of the Ascot stakes, the Steward's Cup at Goodwood, the Doncaster Cup and the City and Suburban. He was a member of the Jockey Club.

Undoubtedly, especially as he grew older, the human element accounted for a large proportion of

the entertainment he derived from the Turf. Apart from his friendships with those of his own world, he was genuinely interested in the many " quaint personalities " known to him, one and all, by nick-names he never forgot, and into whose domestic lives, joys and anxieties he was initiated. When the spare figure, unmistakably that of a gentleman, appeared in the paddock or on the racecourse,wearing a unique sort of low-crowned felt hat, of a shape never seen on any head but his, his throat in all weathers muffled in a yellow scarf, and shod, whatever the smartness of the meeting, with brown shoes—" that fellow's d—d brown shoes " as a great personage, noted for his observance of the ritual of dress, once described them—he could count on a special welcome as peculiar to himself as his dress and his presence.

This is perhaps the place to say something of his friendships, which were indeed an integral part of himself. No man ever laid more to heart Polonius's axioms on that momentous side of life; and un-doubtedly it was with " links of steel " that he grappled to himself his " friends and their affections tried." As one of the most distinguished of these writes, " He was a very firm friend. It perhaps took a long time before one was admitted to his friendship, but once admittance was granted it was for always and for ever. Nothing would change or weaken his friendship. Those thus privileged knew well that even if separated for years, the bonds of his friendship existed as strong as ever, and when they met again, they would be met as if they had never been parted from him." It is, indeed, true that nothing could weaken his friendship. One of the few occasions on

which the present writer saw him break down was when he was forced to confess that a very dear friend, recently dead, had abused his confidence. But even then he would not reveal what the offence had been. He jealously guarded the man's reputation, nor, cut to the heart as he was, would he allow the man's dependants to suffer for his fault. It was only years afterward that by a mere chance his hearer was put into possession of the facts, and was enabled to estimate the magnitude of the injury and the generosity of the injured.

A man who is generous in thought is bound also to be generous in deed. The number of lame dogs he helped over stiles will never be known, for he religiously obeyed the Evangelical precept not to allow his right hand to know what his left hand did. Only occasionally when he felt he could trust his hearer would his sense of humour get the better of his discretion.

Thus, one of his old tenants, whose farm was rented at £727 11s. 4d. a year, for three years in succession brought exactly £27 11s. 4d. to the annual audit, and quite honestly considered that he was entitled to receive a discharge in full. When this happened for the third time, and as evidently the land was going to rack and ruin, Lord Carnarvon felt he must give the man notice. It was not an over-rented holding, he anxiously explained, since no sooner was his decision known, than he received an offer of £1,100. " But," he added, " I was so sorry for the poor old fellow, who had spent his life on the place, that I arranged to give him a sort of pension of £250. I thought it would be a com-

fort." But for the farmer's singular views on the balancing of accounts, which appealed to Carnarvon's sense of humour, the little tale would have remained untold.

The same loyal fidelity which bound his affections in perpetuity to his family, his sisters and brothers and friends, made him an admirable master and a true friend to his servants. He falsified, rather amusingly, the proverb that a man cannot be a hero to his valet. Short of a serious fault, once a man entered his employment, he remained in it for life, but on the condition that he gave good service. That Lord Carnarvon expected, and that he got. In the same way, being courteous and considerate himself, he expected civility in return. He was seldom disappointed, for, as he said in his last letter to the present writer, " it is wonderful what a little politeness can do." But meeting with rudeness, he could give a rebuke which, for being rather obliquely delivered, was none the less effective. In the war, having occasion to go to one of the Control Departments, he was received by a damsel with " bobbed " hair and bobbed manners who, in a voice of utter scorn, demanded to know on what business he could have come. Since no human being could enter the Department save for the one purpose of obtaining the commodity in which the Control dealt, the question, apart from the fashion in which it was delivered, was an impertinence. In the sweetest of voices, Lord Carnarvon replied, " Of course, I have come to talk to you about the hippopotamus in the Zoo " —after which speech his business was put through in double-quick time.

A fine shot, an owner of race-horses, a singularly

well inspired art collector—his privately printed catalogue of rare books is a model of its kind—Lord Carnarvon was also a pioneer of motoring. He owned cars in France before they were allowed in England. In fact, his was the third motor registered in this country, after the repeal of the act making it obligatory for all machine-propelled carriages to be preceded on the high road by a man carrying a red flag. Motoring was bound to appeal to one of his disposition, and he threw himself with passion into the new sport. He was a splendid driver, well served by his gift—a gift which also served him in shooting and golf—of judging distances accurately, whilst possessing that unruffled calm in difficulties which often, if not invariably, is the best insurance against disaster.

Though Carnarvon enjoyed a reputation for recklessness he was in reality far too collected and had too much common sense to woo danger. When the present writer reproached him for taking unnecessary risks, he replied : " Do you take me for a fool ? In motoring the danger lies round corners, and I never take a corner fast." This was probably true, but the " best-laid schemes o' mice and men gang aft a-gley," and it was on a perfectly straight road that he met with the accident that materially affected his whole life.

It was on a journey through Germany that disaster overtook Carnarvon. He and his devoted chauffeur, Edward Trotman, who accompanied him on all his expeditions for eight-and-twenty years, had been flying for many miles along an empty road, ruled with Roman precision through an interminable Teutonic forest, towards Schwalbach, where Lady

Carnarvon was awaiting their arrival. Before them, as behind, the highway still stretched out, when, suddenly, as they crested a rise, they were confronted by an unexpected dip in the ground, so steep as to be invisible up to within 20 yards, and at the bottom, right across the road, were drawn up two bullock carts. Carnarvon did the only thing possible. Trusting to win past, he put the car at the grass margin, but a heap of stones caught the wheel, two tyres burst, the car turned a complete somersault and fell on the driver, while Trotman was flung clear some feet away. Happily for them both, the latter's thick coat broke his fall, and with splendid presence of mind he lost not a second in coming to his master's rescue. The car had fallen aslant across a ditch. Had it fallen on the road, Carnarvon must have been crushed to death, instead of being embedded head foremost in mud. With the energy of despair, Trotman contrived to drag the light car aside and to extricate Carnarvon, who was unconscious, his heart even appearing to have stopped. The bullock drivers knowing themselves in fault had bolted, but Trotman saw some workmen in an adjoining field, saw they had a can of water, and without pausing to apologize seized the can and dashed the water in Lord Carnarvon's face. The shock set the heart beating anew, and meanwhile the workmen, who had followed hot-foot in pursuit of their can, arrived on the scene. They had no common language, but the awful spectacle and the chauffeur's signs were sufficient explanation and they brought a doctor to the spot. He found a shattered individual, evidently suffering from severe concussion, his face swollen to shapelessness, his legs severely burnt, his wrist broken, temporarily blind, the

palate of his mouth and his jaw injured, caked in mud from head to foot. In fact, he was only just alive; but he recovered consciousness to put the one question which overpowered all else, " Have I killed anyone ? " was reassured, and lapsed again into unconsciousness. In this condition he was carried to the nearest pot-house, where Lady Carnarvon, who almost instantly rejoined him, summoned doctors and surgeons to his bedside. It was characteristic that almost the first words he murmured when he had recovered speech were, " I don't think I have lost my nerve ! " He was right, he had not lost his nerve, but he had lost his health. Nothing that skill or care could effect then or later was spared, but throughout the remainder of his life he suffered from perpetually recurrent operations and dangerous illnesses. He bore these with a noble courage, and emerged mellowed rather than embittered from these trials and the renunciations of work and ambitions curtailed. Sometimes he lapsed into long silences, seldom into complaints. It was a fine triumph of will, assisted by the sense of humour which was the warp and woof of his being.

With regard to recreations, his versatility came to his help. When agonizing headaches made shooting too painful, he took to golf, at which he was " scratch." When golf proved beyond his strength, he set himself to study the technique of photography, and aided by his artistic faculty he shortly became a master of the art. Indeed, in the words of an expert, "Carnarvon's work was known in all parts of the globe where pictorial photography has an honoured place, and it is not too much to say that

Introduction

his productions were unique in their artistry and in the knowledge that he displayed in their production." (*Quarterly Journal of the Camera Club*, Vol. I, 202, May, 1923, p. 13, by F. J. Mortimer, F.R.P.S.). In 1916 he was elected President of the Camera Club. He appreciated the distinction ; but the recognition of his work in this field that brought him the greatest pleasure was a summons he received during the war to the Front to advise Royal Headquarters Flying Corps on the subject of aerial photography. The three days he spent at St. André went a little way, though only a little way, to console him for not being a combatant, and he rejoiced accordingly ; though on his return to England he paid for the effort with a sharp attack of illness. He had always been attracted by mechanical inventions. It was under Beacon Hill, on his property, that Captain de Haviland constructed the first aeroplane, which in its perfected form of D.H.9 became the chief fighting aeroplane in the war.

Nevertheless, strive as he would, the renunciations involved were not inconsiderable. He was deeply interested in the elections of 1905 and 1910 and the House of Lords controversy of 1911 ; and he would probably have taken an active part in politics but for his belief that the serious injury to his mouth and jaw must militate against public speaking. He may have exaggerated this drawback, for, when he delivered his lecture at the Central Hall, Westminster, on January 11th, 1923, he was easily heard by a large audience. But he disliked doing things badly, and his fear of being indistinct, added to his many illnesses, extinguished his hope of entering public life. Many of his friends both now and then regretted

Introduction

this forced abstention from the public life of the country. Sir William Garstin, whose verdict must carry weight, writes, " Lord Carnarvon took a deep interest in all questions connected with English politics, but it was the foreign policy of this country that more particularly interested him. His extensive travels, as well as his studies, gave him a grasp of the subjects connected with ' World policy ' that is unusual in Englishmen who live much of their lives at home. Perhaps the politics of the Near East attracted him more than those of any other country. His frequent visits to Turkey and the Balkan States, and his recognition of the ties that closely bind England with these nations, gave him a direct personal interest in the questions. He certainly could and did talk well and intelligently upon everything connected with England's relations with Turkey and the East."

The net result of the accident was the necessity to winter out of England, since, with his difficulty of breathing, a bad attack of bronchitis would probably have proved fatal. In 1903 he consequently went to Egypt and was at once captivated by the fascination of " digging." An unfinished fragment on the subject, on which he was engaged at his death, gives an account of these early days:

" It had always been my wish and intention even as far back as 1889 to start excavating, but for one reason or another I had never been able to begin. However, in 1906 with the aid of Sir William Garstin, who was then adviser to the Public Works; I started to excavate in Thebes.

" I may say that at this period I knew nothing

whatever about excavating, so I suppose with the idea of keeping me out of mischief, as well as keeping me employed, I was allotted a site at the top of Sheikh Abdel Gurna. I had scarcely been operating for 24 hours when we suddenly struck what seemed to be an untouched burial pit. This gave rise to much excitement in the Antiquities Department, which soon simmered down when the pit was found to be unfinished. There, for six weeks, enveloped in clouds of dust, I stuck to it day in and day out. Beyond finding a large mummified cat in its case, which now graces the Cairo Museum, nothing whatsoever rewarded my strenuous and very dusty endeavours. This utter failure, however, instead of disheartening me had the effect of making me keener than ever."

The more he toiled, however, the more it became clear to him that he needed expert aid; accordingly he consulted Sir Gaston Maspero, who advised him to have recourse to Mr. Howard Carter.

Sir Gaston Maspero's advice proved even more fruitful of good than Lord Carnarvon anticipated. In Mr. Howard Carter Carnarvon obtained the collaboration not only of a learned expert, an archæologist gifted with imagination, and as Lord Carnarvon said " a very fine artist," but that of a true friend. For the next sixteen years the two men worked together with varying fortune, yet ever united not more by their common aim than by their mutual regard and affection.

An account of Lord Carnarvon and Mr. Carter's work is to be found in the sumptuous volume entitled " Five Years' Explorations at Thebes " which they

published in 1912. Lord Carnarvon's description of the first excavations effected with Mr. Howard Carter should, however, find place here. " After perhaps 10 days' work at Deir el Bahari in 1907," he writes, " we came upon what proved to be an untouched tomb. I shall never forget the first sight of it. There was something extraordinarily modern about it. Several coffins were in the tomb, but the first that arrested our attention was a white brilliantly painted coffin with a pall loosely thrown over it, and a bouquet of flowers lying just at its foot. There these coffins had remained untouched and forgotten for 2,500 years. The reason for the sepulchre being inviolate was soon apparent. There was no funerary furniture, and evidently the owners of the coffins were poor people, and they or their relations had put all the funeral money they were able to spend into the ornamental coffins that contained their bodies.

" One of these coffins I presented to the Newbury Museum. The results of this season were very poor, still one day we thought that we had at last found something which had every appearance of an untouched tomb some 400 yards from the Temple of Deir el Bahari. In the morning, I rode out, and no sooner did I see Carter's face than I knew something unpleasant and unforeseen had occurred. Alas ! What looked promising the day before turned out to be merely a walled-up sort of stable where the ancient Egyptian foreman had tethered his donkey and kept his accounts. But this is a common occurrence, for in excavation it is generally the unexpected that happens and the unexpected is nearly always unpleasant." So

wrote the future revealer of Tut·ankh·Amen's tomb.

In 1907 Lord Carnarvon began to form his now celebrated Egyptian collection. " My chief aim," he writes, " was then, and is now, not merely to buy because a thing is rare, but rather to consider the beauty of an object than its pure historic value. Of course when the two, beauty and historic interest, are blended in a single object the interest and delight of possession are more than doubled." The testimony of that eminent authority, Sir Ernest Budge, strikingly confirms Lord Carnarvon's own account of his collection. " He only cared," says Sir Ernest, " for the best, and nothing but the best would satisfy him, and having obtained the best he persisted in believing that there must be somewhere something better than the best. His quest for the beautiful in Egyptian design, form and colour became the cult of his life in recent years. His taste was faultless and his instinct for the true and genuine was unrivalled. When compared with a beautiful ' antica ' money had no value for him, and he was wont to say with Sir Henry Rawlinson, 'it is easier to get money than anticas.' "*

Of all the renunciations forced upon him by bad health the one which cost him most was his inability to take a personal part in the Great War. Although he was past military age, his quick intelligence and his intimate knowledge of the French language and French mentality would have made him a valuable liaison officer. Indeed, at one moment he cherished the hope that he might accompany his friend General

* *Tut·ankh·Amen, Amenism, Atemism and Egyptian Monotheism*, Pref., xxi.

Introduction

Sir John Maxwell to the Front, but as at the moment the jolting of a taxi caused him almost unbearable pain, he had to content himself with such work as he could find to do at home. Nevertheless, when his brother Aubrey Herbert, to whom he was specially devoted, was wounded and lost during the retreat from Mons, he was preparing to go, pain or no pain, to hunt for him in his motor, when the news of Aubrey's escape arrived. At a later stage of the war to attempt such an adventure would have been unthinkable, but at that crisis, immediately after the victory of the Marne, before the war had hardened into a war of trenches, it is just possible that Carnarvon's mingled resource and calmness might have been successful.

It was characteristic that quite a week before war was declared, being convinced that it was imminent, and believing that food shortage would be the immediate danger, he quietly made preparations for feeding the population on his property. The beauty of his scheme lay in the fact that it did not entail a run on the shops. The potatoes remained in the field, the corn in the ricks, though ready when the pinch came to be doled out, carefully rationed, to the little community of 253 souls for whom he held himself responsible. As we know, he had misdated that particular peril, and quick to realize his mistakes, he promptly turned his energies in other directions.

From the very outbreak of the war, Lord and Lady Carnarvon converted Highclere into an officers' hospital, which was subsequently transferred to 38 Bryanston Square, and whether in town or country noted for the tender and efficient care of

its inmates. After Lady Carnarvon moved her hospital to London, Carnarvon occupied himself, amongst other things, in promoting the conversion of pasture at Highclere into arable land. He was well seconded by his old and attached employees, and was more successful than those who knew the thin chalk soil dared to hope. While alone, on one of his periodical visits to Highclere, he was seized with appendicitis. Lady Carnarvon accompanied by surgeons and doctors rushed down and carried him off to the hospital in London, where he was promptly operated upon. And thus in all probability it was owing to the hospital this husband and wife had founded that his life was eventually saved, for nowhere else, at that particular time, could he have obtained the same unremitting care.

It was, however, a close call. The great surgeon, Sir Berkeley Moynihan, who was summoned from Leeds to his bedside, admitted that he himself had only given him another three-quarters of an hour to live. Lord Carnarvon afterwards declared that, though he realized his danger, he was convinced that his sufferings were too acute to allow him to die. True to his inextinguishable sense of humour, even at this crisis, he contrived to make a joke and was surprised that it did not seem to amuse his medical attendants. "It was not much of a joke, but still there was a point to it and only George [his very devoted servant] smiled," he complained. In the circumstances, the doctors might be excused, for it was something of a miracle when their patient pulled through. He himself ascribed his recovery to his wife's resource and exertions and to the skill and devotion with which she surrounded him—

devotion readily given, for his nurses adored a patient who, even *in extremis*, remained considerate and courteous.

Two years later, he had to undergo another vital operation, and again he recovered, and seemed to have got a firmer grip of life. By that time, moreover, the war had come to an end, and his only son, who had fought through the Mesopotamian campaign, was once more safe at home at his side. This was an untold relief to Carnarvon. He was too true an Englishman to grudge his boy to the country's service, but in many little ways he showed how greatly he felt the strain. Habitually the most reserved of men, when one of the pencil letters reached him, for which so many hungry hearts yearned in those dark days, he would hurry round to read the precious epistle to a sympathetic audience. And from the moment of the young soldier's embarkation " my boy's " little fox terrier never left his side.

Carnarvon's love for his children played a great part in his life. He thoroughly enjoyed their companionship, and perhaps even more the evident pleasure they took in his society. His love for them enlarged his outlook on life as a whole, or rather perhaps swept away the remnant of the constitutional reserve which sometimes set a veil between his true self and the outer world. He who, as a friend said, " laughed through life," and, in especial, laughed at himself and his tribulations, confessed himself surprised at the extent that fear for their welfare could penetrate his defensive armour. When anxious about his daughter, his gallant little gibes deserted him. " I cannot tell you how this has upset me,"

he wrote, " I really can't sleep or eat. I had no idea that anything could worry me so." And it is doubtful whether the great discovery itself would not have lost half its savour if this daughter, his inseparable companion, had not been there to share in the rapture of that amazing revelation.

Even during the war Lord Carnarvon had made efforts to get to Egypt. In fact, but for a bad attack of pleurisy which at the last moment detained him in England, he would have arrived at Cairo the very day the Turks made their unsuccessful onslaught on the Canal. Naturally, as soon as the Armistice was signed, he took steps to rejoin Mr. Carter, who in the intervals of his war work at G.H.Q. in Cairo had been able to start preliminary investigations in The Valley of the Kings. Journeys were, however, no easy matter in 1919. With great difficulty berths were procured on a boat, which was protected during the crossing by paravanes to avoid the disaster that had recently overtaken a French ship, sunk by a floating mine. But mines were a less danger than the sanitary condition of the boat. She had served as a troopship during the war, had not yet been disinfected, and was packed with Arabs to be landed at Bizerta. Happily the journey was short, but in that short space there was much sickness and a few deaths. The journey so inauspiciously begun did not improve as time went on. It was a period of unrest in Egypt, and it was fortunate that Carnarvon's desire to explore the Fayum with a view to excavations brought the party back earlier than usual from Luxor to Cairo. Everything had been

arranged for the Fayum expedition, and the hour for the departure fixed, when, the evening before the start, Carnarvon received such disquieting reports of the situation in the provinces that he decided to defer the journey. It was a lucky decision, since the next day witnessed the beginning of trouble in the Fayum, and in a day or two, as he himself wrote, "the country was in a state of anarchy. During a lull in the general disorder," he continues, " I managed to pack off my family to Port Said, and I well remember how relieved I was to get a telegram to say they had embarked safely."

As for himself he remained on for a time in Cairo, partly in the hope of being able to achieve some more digging, but also because he was genuinely interested in the situation. As Sir William Garstin remarks, " It was Carnarvon's interest in Egyptology that first drew him to Egypt. He very soon, however, became much interested in Egyptian politics. He had a great liking for the Egyptians and for those who were trying to restore her as a nation, and he showed a sympathetic interest in them to which they readily responded. Few Englishmen have been more liked in Egypt, and the sorrow that was evinced at his death was universal and sincere." Sir William Garstin's estimate of Lord Carnarvon's position in Egypt is fully confirmed by Sir John Maxwell, also a great authority on Egyptian politics. " He was one of the few Englishmen," he says, " who realized and appreciated what Egypt did for us during the war, and how difficult it would have been for us had she taken an unfriendly attitude ; also that a loyal, con-

tented friend on our Eastern communications was infinitely preferable to a sullen, discontented enemy. He was convinced that the former could be accomplished. He was a good and patient listener and gained the confidence of many of the best class in Egypt. Both in London and at Highclere he entertained the Egyptian delegations. All were appreciative of his hospitality and consideration and all felt that, in his death, they had lost a real friend of their country."

As the days passed, it became evident, however, that any work for that season was out of the question. He was needed in England and he decided to leave. This was not easy and he was about to charter a sailing boat, when he obtained a passage home. Lord Carnarvon was fated to pay several more visits to Egypt. After his operation in 1919 while scarcely convalescent, he insisted on leaving for Luxor at the usual season and there recovered his health and strength.

A description of Tut·ankh·Amen's tomb and its discovery does not fall within the province of this sketch, which concerns the man rather than the archæologist. Carnarvon was never addicted to self-analysis, and though he could give detailed descriptions of the beautiful objects discovered in the tomb, words failed him to express the effect on himself personally of the actual discovery. He could only assure his hearers that it was " a very exciting moment " ! Nor, unlike most events, as the weeks passed, did the excitement wane for the public or for Lord Carnarvon ; and naturally, perhaps, to no one more than to him did these successive revelations bring delight. " He was as

happy as he was modest," said a distinguished scholar.

In this sad world it would seem that triumphs have to be paid for in weariness of soul and body. It was a glorious episode, but when the tomb was closed for the season, Lord Carnarvon was very tired. A mosquito bit him, the wound got poisoned, and though wife and daughter, doctors and nurses, fought valiantly for his life it was a losing fight. Through those long three weeks of pain and misery he remained his old gallant self. Readers of the bulletins may remember that the gloomiest generally concluded with an assurance that the patient's spirits were good. But he himself had no illusions. " I have heard the call," he said to a friend, " I am preparing." On the 6th of April, 1923, he passed away.

In his will he expressed the wish to be buried on Beacon Hill. It was, therefore, on the summit of the great down overlooking the home that he had so passionately loved, that he was laid to rest. Only his nearest and dearest, and a few workmen and servants, many of whom had grown grey in his service, stood around the grave, but these too he had accounted part of his family, and their lament, " Of course, he was my master, but he was my friend too," was the epitaph he would himself have chosen. Organ, music, choristers, there were none at this burying. The beautiful old office, commending " the body of our dear brother to the ground in sure and certain hope," had something of the stark grandeur of a funeral at sea. But the whole air was alive with the springtide song of the larks. They sang deliriously, in a passion of ecstasy which can never

be forgotten by those who heard that song. And so we left him, feeling that the ending was in harmony with the life.

" Here, here's his place, where meteors shoot, clouds form,
 Lightnings are loosened,
 Stars come and go ! Let joy break the storm—
 Peace let the dew send !
 Lofty design must close in like effects :
 Loftily lying,
 Leave him—still loftier than the World suspects,
 Living and dying."

 WINIFRED BURGHCLERE.

THE LAKE,
 HIGHCLERE,

 September 17, 1923.

THE TOMB OF TUT·ANKH·AMEN

CHAPTER I

THE KING AND THE QUEEN

A FEW preliminary words about Tut·ankh·
Amen, the king whose name the whole
world knows, and who in that sense prob-
ably needs an introduction less than anyone in
history. He was the son-in-law, as everyone knows,
of that most written-about, and probably most over-
rated, of all the Egyptian Pharaohs, the heretic king
Akh·en·Aten. Of his parentage we know nothing.
He may have been of the blood royal and had some
indirect claim to the throne on his own account. He
may on the other hand have been a mere commoner.
The point is immaterial, for, by his marriage to a
king's daughter, he at once, by Egyptian law of suc-
cession, became a potential heir to the throne. A
hazardous and uncomfortable position it must have
been to fill at this particular stage of his country's
history. Abroad, the Empire founded in the fifteenth
century B.C. by Thothmes III, and held, with diffi-
culty it is true, but still held, by succeeding
monarchs, had crumpled up like a pricked balloon.
At home dissatisfaction was rife. The priests of the
ancient faith, who had seen their gods flouted and
their very livelihood compromised, were straining
at the leash, only waiting the most convenient

moment to slip it altogether: the soldier class, condemned to a mortified inaction, were seething with discontent, and apt for any form of excitement: the foreign *harim* element, women who had been introduced into the Court and into the families of soldiers in such large numbers since the wars of conquest, were now, at a time of weakness, a sure and certain focus of intrigue: the manufacturers and merchants, as foreign trade declined and home credit was diverted to a local and extremely circumscribed area, were rapidly becoming sullen and discontented: the common populace, intolerant of change, grieving, many of them, at the loss of their old familiar gods, and ready enough to attribute any loss, deprivation, or misfortune, to the jealous intervention of these offended deities, were changing slowly from bewilderment to active resentment at the new heaven and new earth that had been decreed for them. And through it all Akh·en·Aten, Gallio of Gallios, dreamt his life away at Tell el Amarna.

The question of a successor was a vital one for the whole country, and we may be sure that intrigue was rampant. Of male heirs there was none, and interest centres on a group of little girls, the eldest of whom could not have been more than fifteen at the time of her father's death. Young as she was, this eldest princess, Mert·Aten by name, had already been married some little while, for in the last year or two of Akh·en·Aten's reign we find her husband associated with him as co-regent, a vain attempt to avert the crisis which even the arch-dreamer Akh·en·Aten must have felt to be inevitable. Her taste of queenship was but a short one, for Smenkh·ka·Re, her husband, died within a

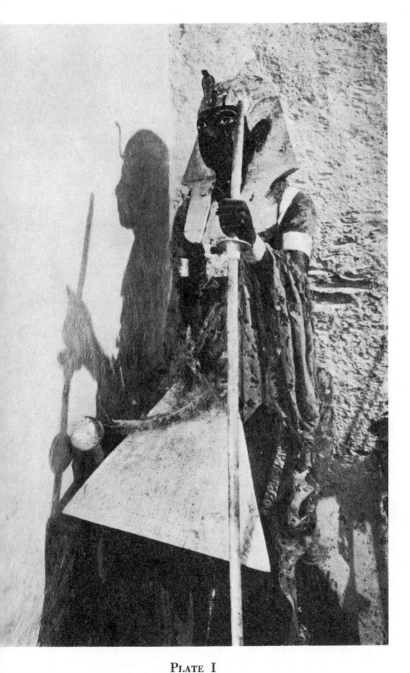

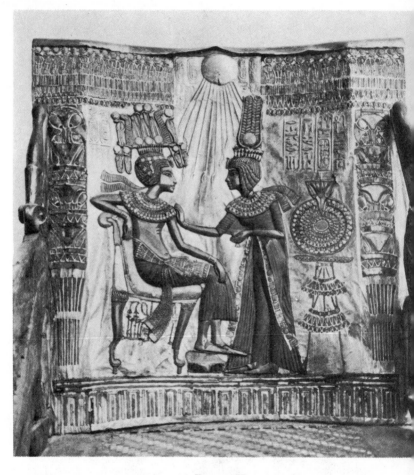

PLATE II

BACK PANEL OF THE THRONE, DEPICTING THE KING AND
THE QUEEN.

short while of Akh·en·Aten. He may even, as evidence in this tomb seems to show, have predeceased him, and it is quite possible that he met his death at the hands of a rival faction. In any case he disappears, and his wife with him, and the throne was open to the next claimant.

The second daughter, Makt·Aten, died unmarried in Akh·en·Aten's lifetime. The third, Ankh·es·en·pa·Aten, was married to Tut·ankh·Aten as he then was, the Tut·ankh·Amen with whom we are now so familiar. Just when this marriage took place is not certain. It may have been in Akh·en·Aten's lifetime, or it may have been contracted hastily immediately after his death, to legalize his claim to the throne. In any event they were but children. Ankh·es·en·pa·Aten was born in the eighth year of her father's reign, and therefore cannot have been more than ten; and we have reason to believe, from internal evidence in the tomb, that Tut·ankh·Amen himself was little more than a boy. Clearly in the first years of this reign of children there must have been a power behind the throne, and we can be tolerably certain who this power was. In all countries, but more particularly in those of the Orient, it is a wise rule, in cases of doubtful or weak succession, to pay particular attention to the movements of the most powerful Court official. In the Tell el Amarna Court this was a certain Ay, Chief Priest, Court Chamberlain, and practically Court everything else. He himself was a close personal friend of Akh·en·Aten's, and his wife Tyi was nurse to the royal wife Nefertiti, so we may be quite sure there was nothing that went on in the palace that they did not know. Now, looking ahead a little, we

find that it was this same Ay who secured the throne himself after Tut·ankh·Amen's death. We also know, from the occurrence of his cartouche in the sepulchral chamber of the newly found tomb, that he made himself responsible for the burial ceremonies of Tut·ankh·Amen, even if he himself did not actually construct the tomb. It is quite unprecedented in The Valley to find the name of a succeeding king upon the walls of his predecessor's sepulchral monument. The fact that it was so in this case seems to imply a special relationship between the two, and we shall probably be safe in assuming that it was Ay who was largely responsible for establishing the boy king upon the throne. Quite possibly he had designs upon it himself already, but, not feeling secure enough for the moment, preferred to bide his time and utilize the opportunities he would undoubtedly have, as minister to a young and inexperienced sovereign, to consolidate his position. It is interesting to speculate, and when we remember that Ay in his turn was supplanted by another of the leading officials of Akh·en·Aten's reign, the General Hor·em·heb, and that neither of them had any real claim to the throne, we can be reasonably sure that in this little by-way of history, from 1375 to 1350 B.C., there was a well set stage for dramatic happenings.

However, as self-respecting historians, let us put aside the tempting " might have beens " and " probablys " and come back to the cold hard facts of history. What do we really know about this Tut·ankh·Amen with whom we have become so surprisingly familiar ? Remarkably little, when you come right down to it. In the present state of our

knowledge we might say with truth that the one outstanding feature of his life was the fact that he died and was buried. Of the man himself—if indeed he ever arrived at the dignity of manhood—and of his personal character we know nothing. Of the events of his short reign we can glean a little, a very little, from the monuments. We know, for instance, that at some time during his reign he abandoned the heretic capital of his father-in-law, and removed the Court back to Thebes. That he began as an Aten worshipper, and reverted to the old religion, is evident from his name Tut·ankh·Aten, changed to Tut·ankh·Amen, and from the fact that he made some slight additions and restorations to the temples of the old gods at Thebes. There is also a stela in the Cairo Museum, which originally stood in one of the Karnak temples, in which he refers to these temple restorations in somewhat grandiloquent language. " I found," he says, " the temples fallen into ruin, with their holy places overthrown, and their courts overgrown with weeds. I reconstructed their sanctuaries, I re-endowed the temples, and made them gifts of all precious things. I cast statues of the gods in gold and electrum, decorated with lapis lazuli and all fine stones."[1] We do not know at what particular period in his reign this change of religion took place, nor whether it was due to personal feeling or was dictated to him for political reasons. We know from the tomb of one of his officials that certain tribes in Syria and in the Sudan were subject to him and brought him tribute, and on

[1] This stela, parts of which are roughly translated above, was subsequently usurped by Hor·em·heb, as were almost all Tut·ankh·Amen's monuments.

many of the objects in his own tomb we see him trampling with great gusto on prisoners of war, and shooting them by hundreds from his chariot, but we must by no means take for granted that he ever in actual fact took the field himself. Egyptian monarchs were singularly tolerant of such polite fictions.

That pretty well exhausts the facts of his life as we know them from the monuments. From his tomb, so far, there is singularly little to add. We are getting to know to the last detail what he had, but of what he was and what he did we are still sadly to seek. There is nothing yet to give us the exact length of his reign. Six years we knew before as a minimum : much more than that it cannot have been. We can only hope that the inner chambers will be more communicative. His body, if, as we hope and expect, it still lies beneath the shrines within the sepulchre, will at least tell us his age at death, and may possibly give us some clue to the circumstances.

Just a word as to his wife, Ankh·es·en·pa·Aten as she was known originally, and Ankh·es·en·Amen after the reversion to Thebes. As the one through whom the king inherited, she was a person of considerable importance, and he makes due acknowledgment of the fact by the frequency with which her name and person appear upon the tomb furniture. A graceful figure she was, too, unless her portraits do her more than justice, and her friendly relations with her husband are insisted on in true Tell el Amarna style. There are two particularly charming representations of her. In one, on the back of the throne (Plate II), she anoints her husband with perfume : in the other, she accompanies him on a shooting

expedition, and is represented crouching at his feet, handing him an arrow with one hand, and with the other pointing out to him a particularly fat duck which she fears may escape his notice. Charming pictures these, and pathetic, too, when we remember that at seventeen or eighteen years of age the wife was left a widow. Well, perhaps. On the other hand, if we know our Orient, perhaps not, for to this story there is a sequel, provided for us by a number of tablets, found some years ago in the ruins of Boghozkeui, and only recently deciphered. An interesting little tale of intrigue it outlines, and in a few words we get a clearer picture of Queen Ankh·es·en·Amen than Tut·ankh·Amen was able to achieve for himself in his entire equipment of funeral furniture.

She was, it seems, a lady of some force of character. The idea of retiring into the background in favour of a new queen did not appeal to her, and immediately upon the death of her husband she began to scheme. She had, we may presume, at least two months' grace, the time that must elapse between Tut·ankh·Amen's death and burial, for until the last king was buried it was hardly likely that the new one would take over the reins. Now, in the past two or three reigns there had been constant intermarriages between the royal houses of Egypt and Asia. One of Ankh·es·en·Amen's sisters had been sent in marriage to a foreign court, and many Egyptologists think that her own mother was an Asiatic princess. It was not surprising, then, that in this crisis she should look abroad for help, and we find her writing a letter to the King of the Hittites in the following terms : " My husband

is dead and I am told that you have grown-up sons. Send me one of them, and I will make him my husband, and he shall be king over Egypt."

It was a shrewd move on her part, for there was no real heir to the throne in Egypt, and the swift dispatch of a Hittite prince, with a reasonable force to back him up, would probably have brought off a very successful coup. Promptitude, however, was the one essential, and here the queen was reckoning without the Hittite king. Hurry in any matter was well outside his calculations. It would never do to be rushed into a scheme of this sort without due deliberation, and how did he know that the letter was not a trap ? So he summoned his counsellors and the matter was talked over at length. Eventually it was decided to send a messenger to Egypt to investigate the truth of the story. " Where," he writes in his reply—and you can see him patting himself on the back for his shrewdness—" is the son of the late king, and what has become of him ? "

Now, it took some fourteen days for a messenger to go from one country to the other, so the poor queen's feelings can be imagined, when, after a month's waiting, she received, in answer to her request, not a prince and a husband, but a dilatory futile letter. In despair she writes again : " Why should I deceive you ? I have no son, and my husband is dead. Send me a son of yours and I will make him king." The Hittite king now decides to accede to her request and to send a son, but it is evidently too late. The time had gone by. The document breaks off here, and it is left to our imagination to fill in the rest of the story.

The King and the Queen

Did the Hittite prince ever start for Egypt, and how far did he get? Did Ay, the new king, get wind of Ankh·es·en·Amen's schemings and take effectual steps to bring them to naught? We shall never know. In any case the queen disappears from the scene and we hear of her no more. It is a fascinating little tale. Had the plot succeeded there would never have been a Rameses the Great.

CHAPTER II

THE VALLEY AND THE TOMB

THE Valley of the Tombs of the Kings—the very name is full of romance, and of all Egypt's wonders there is none, I suppose, that makes a more instant appeal to the imagination. Here, in this lonely valley-head, remote from every sound of life, with the "Horn," the highest peak in the Theban hills, standing sentinel like a natural pyramid above them, lay thirty or more kings, among them the greatest Egypt ever knew. Thirty were buried here. Now, probably, but two remain —Amen·hetep II—whose mummy may be seen by the curious lying in his sarcophagus—and Tut·ankh· Amen, who still remains intact beneath his golden shrine. There, when the claims of science have been satisfied, we hope to leave him lying.

I do not propose to attempt a word picture of The Valley itself—that has been done too often in the past few months. I would like, however, to devote a certain amount of time to its history, for that is essential to a proper understanding of our present tomb.

Tucked away in a corner at the extreme end of The Valley, half concealed by a projecting bastion of rock, lies the entrance to a very unostentatious tomb. It is easily overlooked and rarely visited, but it has a very special interest as being the first ever constructed in The Valley. More than that: it

PLATE III

ROAD TO THE TOMBS OF THE KINGS.

is notable as an experiment in a new theory of tomb design. To the Egyptian it was a matter of vital importance that his body should rest inviolate in the place constructed for it, and this the earlier kings had thought to ensure by erecting over it a very mountain of stone. It was also essential to a mummy's well-being that it should be fully equipped against every need, and, in the case of a luxurious and display-loving Oriental monarch, this would naturally involve a lavish use of gold and other treasure. The result was obvious enough. The very magnificence of the monument was its undoing, and within a few generations at most the mummy would be disturbed and its treasure stolen. Various expedients were tried ; the entrance passage—naturally the weak spot in a pyramid—was plugged with granite monoliths weighing many tons ; false passages were constructed ; secret doors were contrived ; everything that ingenuity could suggest or wealth could purchase was employed. Vain labour all of it, for by patience and perseverance the tomb robber in every case surmounted the difficulties that were set to baffle him. Moreover, the success of these expedients, and therefore the safety of the monument itself, was largely dependent on the good will of the mason who carried out the work, and the architect who designed it. Careless workmanship would leave a danger point in the best planned defences, and, in private tombs at any rate, we know that an ingress for plunderers was sometimes contrived by the officials who planned the work.

Efforts to secure the guarding of the royal monument were equally unavailing. A king might leave enormous endowments—as a matter of fact each

king did—for the upkeep of large companies of pyramid officials and guardians, but after a time these very officials were ready enough to connive at the plundering of the monument they were paid to guard, while the endowments were sure, at the end of the dynasty at latest, to be diverted by some subsequent king to other purposes. At the beginning of the Eighteenth Dynasty there was hardly a king's tomb in the whole of Egypt that had not been rifled—a somewhat grisly thought to the monarch who was choosing the site for his own last resting place. Thothmes I evidently found it so, and devoted a good deal of thought to the problem, and as a result we get the lonely little tomb at the head of The Valley. Secrecy was to be the solution to the problem.

A preliminary step in this direction had been taken by his predecessor, Amen·hetep I, who made his tomb some distance away from his funerary temple, on the summit of the Drah Abu'l Negga foot-hills, hidden beneath a stone, but this was carrying it a good deal further. It was a drastic break with tradition, and we may be sure that he hesitated long before he made the decision. In the first place his pride would suffer, for love of ostentation was ingrained in every Egyptian monarch and in his tomb more than anywhere else he was accustomed to display it. Then, too, the new arrangement would seem likely to cause a certain amount of inconvenience to his mummy. The early funerary monuments had always, in immediate proximity to the actual place of burial, a temple in which the due ceremonies were performed at the various yearly festivals, and daily offerings were made. Now there was to be no monu-

ment over the tomb itself, and the funerary temple in which the offerings were made was to be situated a mile or so away, on the other side of the hill. It was certainly not a convenient arrangement, but it was necessary if the secrecy of the tomb was to be kept, and secrecy King Thothmes had decided on, as the one chance of escaping the fate of his predecessors.

The construction of this hidden tomb was entrusted by Thothmes to Ineni, his chief architect, and in the biography which was inscribed on the wall of his funerary chapel Ineni has put on record the secrecy with which the work was carried out. " I superintended the excavation of the cliff tomb of His Majesty," he tells us, " alone, no one seeing, no one hearing." Unfortunately he omits to tell us anything about the workmen he employed. It is sufficiently obvious that a hundred or more labourers with a knowledge of the king's dearest secret would never be allowed at large, and we can be quite sure that Ineni found some effectual means of stopping their mouths. Conceivably the work was carried out by prisoners of war, who were slaughtered at its completion.

How long the secret of this particular tomb held we do not know. Probably not long, for what secret was ever kept in Egypt ? At the time of its discovery in 1899 little remained in it but the massive stone sarcophagus, and the king himself was moved, as we know, first of all to the tomb of his daughter Hat·shep·sût, and subsequently, with the other royal mummies, to Deir el Bahari. In any case, whether the hiding of the tomb was temporarily successful or not, a new fashion had been set, and the remaining kings of this Dynasty, together with those of

the Nineteenth and Twentieth, were all buried in The Valley.

The idea of secrecy did not long prevail. From the nature of things it could not, and the later kings seem to have accepted the fact, and gone back to the old plan of making their tombs conspicuous. Now that it had become the established custom to place all the royal tombs within a very restricted area they may have thought that tomb-robbery was securely provided against, seeing that it was very much to the reigning king's interest to see that the royal burial site was protected. If they did, they mightily deceived themselves. We know from internal evidence that Tut·ankh·Amen's tomb was entered by robbers within ten, or at most fifteen, years of his death. We also know, from *graffiti* in the tomb of Thothmes IV, that that monarch too had suffered at the hands of plunderers within a very few years of his burial, for we find King Hor·em·heb in the eighth year of his reign issuing instructions to a certain high official named Maŷa to "renew the burial of King Thothmes IV, justified, in the Precious Habitation in Western Thebes." They must have been bold spirits who made the venture: they were evidently in a great hurry, and we have reason to believe that they were caught in the act. If so, we may be sure they died deaths that were lingering and ingenious.

Strange sights The Valley must have seen, and desperate the ventures that took place in it. One can imagine the plotting for days beforehand, the secret rendezvous on the cliff by night, the bribing or drugging of the cemetery guards, and then the desperate burrowing in the dark, the scramble

through a small hole into the burial-chamber, the hectic search by a glimmering light for treasure that was portable, and the return home at dawn laden with booty. We can imagine these things, and at the same time we can realize how inevitable it all was. By providing his mummy with the elaborate and costly outfit which he thought essential to its dignity, the king was himself compassing its destruction. The temptation was too great. Wealth beyond the dreams of avarice lay there at the disposal of whoever should find the means to reach it, and sooner or later the tomb-robber was bound to win through.

For a few generations, under the powerful kings of the Eighteenth and Nineteenth Dynasties, The Valley tombs must have been reasonably secure. Plundering on a big scale would be impossible without the connivance of the officials concerned. In the Twentieth Dynasty it was quite another story. There were weaklings on the throne, a fact of which the official classes, as ever, were quick to take advantage. Cemetery guardians became lax and venial, and a regular orgy of grave-robbing seems to have set in. This is a fact of which we have actual first-hand evidence, for there have come down to us, dating from the reign of Rameses IX, a series of papyri dealing with this very subject, with reports of investigations into charges of tomb-robbery, and accounts of the trial of the criminals concerned. They are extraordinarily interesting documents. We get from them, in addition to very valuable information about the tombs, something which Egyptian documents as a rule singularly lack, a story with a real human element in it, and we are enabled to see

right into the minds of a group of officials who lived in Thebes three thousand years ago.

The leading characters in the story are three, Khamwese, the vizier, or governor of the district, Peser, the mayor of that part of the city which lay on the east bank, and Pewero, the mayor of the western side, *ex-officio* guardian of the necropolis. The two latter were evidently, one might say naturally, on bad terms : each was jealous of the other. Consequently, Peser was not ill pleased to receive one day reports of tomb-plundering on an extensive scale that was going on on the western bank. Here was a chance to get his rival into trouble, so he hastened to report the matter to the vizier, giving, somewhat foolishly, exact figures as to the tombs which had been entered—ten royal tombs, four tombs of the priestesses of Amen, and a long list of private tombs.

On the following day Khamwese sent a party of officials across the river to confer with Pewero, and to investigate the charges. The results of their investigations were as follows. Of the ten royal tombs, one was found to have been actually broken into, and attempts had been made on two of the others. Of the priestesses' tombs, two were pillaged and two were intact. The private tombs had all been plundered. These facts were hailed by Pewero as a complete vindication of his administration, an opinion which the vizier apparently endorsed. The plundering of the private tombs was cynically admitted, but what of that ? To people of our class what do the tombs of private individuals matter ? Of the four priestesses' tombs two were plundered and two were not. Balance the one against the other, and what

cause has anyone to grumble? Of the ten royal tombs mentioned by Peser only one had actually been entered; only one out of ten, so clearly his whole story was a tissue of lies! Thus Pewero, on the principle, apparently, that if you are accused of ten murders and are only found guilty of one, you leave the court without a stain on your character.

As a celebration of his triumph Pewero collected next day "the inspectors, the necropolis administrators, the workmen, the police, and all the labourers of the necropolis" and sent them as a body to the east side, with instructions to make a triumphant parade throughout the town generally, but particularly in the neighbourhood of Peser's house. You may be sure they carried out this latter part of their instructions quite faithfully. Peser bore it as long as he could, but at last his feelings got too much for him, and in an altercation with one of the western officials he announced his intention, in front of witnesses, of reporting the whole matter to the king himself. This was a fatal error, of which his rival was quick to take advantage. In a letter to the vizier he accused the unfortunate Peser—first, of questioning the good faith of a commission appointed by his direct superior, and secondly, of going over the head of that superior, and stating his case directly to the king, a proceeding at which the virtuous Pewero threw up his hands in horror, as contrary to all custom and subversive of all discipline. This was the end of Peser. The offended vizier summoned a court, a court in which the unhappy man, as a judge, was bound himself to sit, and in it he was tried for perjury and found guilty.

That in brief is the story: it is told at full

length in Vol. IV, par. 499 ff., of Breasted's "Ancient Records of Egypt." It is tolerably clear from it that both the mayor and the vizier were themselves implicated in the robberies in question. The investigation they made was evidently a blind, for within a year or two of these proceedings we find other cases of tomb-robbing cropping up in the Court records, and at least one of the tombs in question occurs in Peser's original list.

The leading spirits in this company of cemetery thieves seem to have been a gang of eight men, five of whose names have come down to us—the stone-cutter Hapi, the artisan Iramen, the peasant Amen·em·heb, the water-carrier Kemwese, and the negro slave Ehenefer. They were eventually apprehended on the charge of having desecrated the royal tomb referred to in the investigation, and we have a full account of their trial. It began, according to custom, by beating the prisoners "with a double rod, smiting their feet and their hands," to assist their memories. Under this stimulus they made full confession. The opening sentences in the confession are mutilated in the text, but they evidently describe how the thieves tunnelled through the rock to the burial chamber, and found the king and queen in their sarcophagi : "We penetrated them all, we found her resting likewise." The text goes on——

"We opened their coffins, and their coverings in which they were. We found the august mummy of this king. . . . There was a numerous list of amulets and ornaments of gold at its throat ; its head had a mask of gold upon it ; the august mummy of this king was overlaid with gold throughout. Its coverings were wrought with

PLATE IV

VIEW OF THE ROYAL CEMETERY WITH ITS GUARDIAN PEAK ABOVE.

gold and silver, within and without; inlaid with every costly stone. We stripped off the gold, which we found on the august mummy of this god, and its amulets and ornaments which were at its throat, and the covering wherein it rested. We found the king's wife likewise; we stripped off all that we found on her likewise. We set fire to their coverings. We stole their furniture, which we found with them, being vases of gold, silver, and bronze. We divided, and made the gold which we found on these two gods, on their mummies, and the amulets, ornaments and coverings, into eight parts." [1]

On this confession they were found guilty, and removed to the house of detention, until such time as the king himself might determine their punishment.

In spite of this trial and a number of others of a similar character, matters in The Valley went rapidly from bad to worse. The tombs of Amen·hetep III, Seti I, and Rameses II, are mentioned in the Court records as having been broken into, and in the following Dynasty all attempts at guarding the tombs seem to have been abandoned, and we find the royal mummies being moved about from sepulchre to sepulchre in a desperate effort to preserve them. Rameses III, for instance, was disturbed and re-buried three times at least in this Dynasty, and other kings known to have been transferred include Ahmes, Amen·hetep I, Thothmes II, and even Rameses the Great himself. In this last case the docket states :—

"Year 17, third month of the second season, day 6, day of bringing Osiris, King Usermare-Setepnere (Rameses II), to bury him again, in the tomb of Osiris, King Men·ma·Re-Seti (I) : by the High Priest of Amen, Paynezem."

[1] Breasted, *Ancient Records of Egypt*, Vol. IV, par. 538.

A reign or two later we find Seti I and Rameses II being moved from this tomb and re-buried in the tomb of Queen Inhapi ; and in the same reign we get a reference to the tomb we have been using as our laboratory this year :—

"Day of bringing King Men·pehti·Re (Rameses I) out from the tomb of King Men·ma·Re-Seti (II), in order to bring him into the tomb of Inhapi, which is in the Great Place, wherein King Amen·hetep rests."

No fewer than thirteen of the royal mummies found their way at one time or another to the tomb of Amen·hetep II, and here they were allowed to remain. The other kings were eventually collected from their various hiding places, taken out of The Valley altogether, and placed in a well-hidden tomb cut in the Deir el Bahari cliff. This was the final move, for by some accident the exact locality of the tomb was lost, and the mummies remained in peace for nearly three thousand years.

Throughout all these troublous times in the Twentieth and Twenty-first Dynasties there is no mention of Tut·ankh·Amen and his tomb. He had not escaped altogether—his tomb, as we have already noted, having been entered within a very few years of his death—but he was lucky enough to escape the ruthless plundering of the later period. For some reason his tomb had been overlooked. It was situated in a very low-lying part of The Valley, and a heavy rain storm might well have washed away all trace of its entrance. Or again, it may owe its safety to the fact that a number of huts, for the use of workmen who were employed in excavating the tomb of a later king, were built immediately above it.

The Valley and the Tomb

With the passing of the mummies the history of The Valley, as known to us from ancient Egyptian sources, comes to an end. Five hundred years had passed since Thothmes I had constructed his modest little tomb there, and, surely in the whole world's history, there is no small plot of ground that had five hundred years of more romantic story to record. From now on we are to imagine a deserted valley, spirit-haunted doubtless to the Egyptian, its cavernous galleries plundered and empty, the entrances of many of them open, to become the home of fox, desert owl, or colonies of bats. Yet, plundered, deserted and desolate as were its tombs, the romance of it was not yet wholly gone. It still remained the sacred Valley of the Kings, and crowds of the sentimental and the curious must still have gone to visit it. Some of its tombs, indeed, were actually re-used in the time of Osorkon I (about 900 B.C.) for the burial of priestesses.

References to its rock-hewn passages are numerous in classical authors, and that many of them were still accessible to visitors in their day is evident from the reprehensible manner in which, like John Smith, 1878, they carved their names upon the walls. A certain Philetairos, son of Ammonios, who inscribed his name in several places on the walls of the tomb in which we had our lunch, intrigued me not a little during the winter, though perhaps it would have been better not to mention the fact, lest I seem to countenance the beastly habits of the John Smiths.

One final picture, before the mist of the Middle Ages settles down upon The Valley, and hides it

from our view. There is something about the atmo-
sphere of Egypt—most people experience it I think
—that attunes one's mind to solitude, and that is
probably one of the reasons why, after the con-
version of the country to Christianity, so many of its
inhabitants turned with enthusiasm to the hermit's
life. The country itself, with its equable climate,
its narrow strip of cultivable land, and its desert
hills on either side, honeycombed with natural and
artificial caverns, was well adapted to such a pur-
pose. Shelter and seclusion were readily obtainable,
and that within easy reach of the outer world, and
the ordinary means of subsistence. In the early
centuries of the Christian era there must have been
thousands who forsook the world and adopted the
contemplative life, and in the rock-cut sepulchres
upon the desert hills we find their traces every-
where. Such an ideal spot as The Valley of the
Kings could hardly pass unnoticed, and in the
II—IV centuries A.D. we find a colony of anchor-
ites in full possession, the open tombs in use as cells,
and one transformed into a church.

This, then, is our final glimpse of The Valley in
ancient times, and a strange incongruous picture it
presents. Magnificence and royal pride have been
replaced by humble poverty. The " precious habita-
tion " of the king has narrowed to a hermit's cell.

CHAPTER III

THE VALLEY IN MODERN TIMES

FOR our first real description of The Valley in modern times we must turn to the pages of Richard Pococke, an English traveller who in 1743 published "A Description of the East" in several volumes. His account is extremely interesting, and, considering the hurried nature of his visit, extraordinarily accurate. Here is his description of the approach to The Valley :—

"The Sheik furnished me with horses, and we set out to go to Biban-el-Meluke, and went about a mile to the north, in a sort of street, on each side of which the rocky ground about ten feet high has rooms cut into it, some of them being supported with pillars; and, as there is not the least sign in the plain of private buildings, I thought that these in the very earliest times might serve as houses, and be the first invention after tents, and contrived as better shelter from wind, and cold of the nights. It is a sort of gravelly stone, and the doors are cut regularly to the street.[1] We then turned to the north west, enter'd in between the high rocky hills, and went in a very narrow valley. We after turn'd towards the south, and then to the north west, going in all between the mountains about a mile or a mile and a half. . . . We came to a part that is wider, being a round opening like an amphitheatre and ascended by a narrow step passage about ten feet high, which seems to have been broken down thro' the rock,

[1] They certainly have the appearance of houses, but actually they are façade tombs of the Middle Kingdom.

63

the antient passage being probably from the Memnonium under the hills, and it may be from the grottos I enter'd on the other side. By this passsage we came to Biban-el-Meluke, or Bab-el-Meluke, that is, the gate or court of the kings, being the sepulchres of the Kings of Thebes."[1]

The tradition of a secret passage through the hills to the Deir el Bahari side of the cliff is still to be found among the natives, and to the present day there are archæologists who subscribe to it. There is, however, little or no basis for the theory, and certainly not a vestige of proof.

Pococke then goes on to an account of such of the tombs as were accessible at the time of his visit. He mentions fourteen in all, and most of them are recognizable from his description. Of five of them, those of Rameses IV, Rameses VI, Rameses XII, Seti II, and the tomb commenced by Ta·usert and finished by Set·nekht, he gives the entire plan. In the case of four—Mer·en·Ptah, Rameses III, Amen·meses and Rameses XI—he only planned the outer galleries and chambers, the inner chambers evidently being inaccessible ; and the remaining five he speaks of as " stopped up." [2] It is evident from Pococke's narrative that he was not able to devote as much time to his visit as he would have liked. The Valley was not a safe spot to linger in, for the pious anchorite we left in possession had given place to a horde of bandits, who dwelt among the Kurna hills, and terrorized the whole country-side. " The Sheik also was in haste to go," he remarks, " being afraid, as I imagine, lest the people should

[1] Pococke, *A Description of the East*, Vol. I., p. 97.
[2] From the evidence of *graffiti* these same tombs were open in classical times. The Greek authors refer to them as σύριγγες (syringes), from their reed-like form.

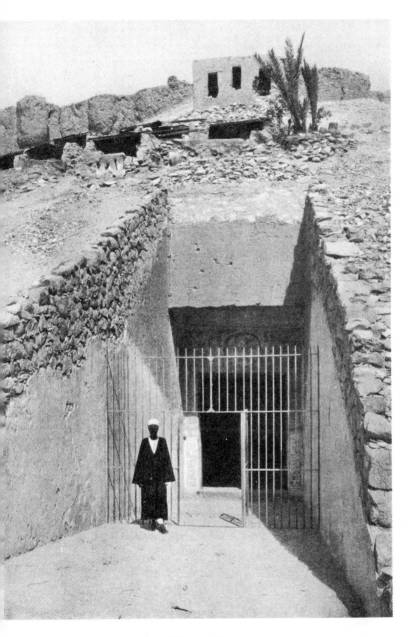

PLATE V

ENTRANCE TO THE TOMB OF RAMESES VI.

have opportunity to gather together if we staid out long."

These Theban bandits were notorious, and we find frequent mention of them in the tales of eighteenth century travellers. Norden, who visited Thebes in 1737, but who never got nearer The Valley than the Ramasseum—he seems to have thought himself lucky to have got so far—describes them thus :—

" These people occupy, at present, the grottos, which are seen in great numbers in the neighbouring mountains. They obey no one ; they are lodged so high, that they discover at a distance if anyone comes to attack them. Then, if they think themselves strong enough, they descend into the plain, to dispute the ground ; if not, they keep themselves under shelter in their grottos, or they retire deeper into the mountains, whither you would have no great desire to follow them." [1]

Bruce, who visited The Valley in 1769, also suffered at the hands of these bandits, and puts on record a somewhat drastic, but fruitless, attempt, made by one of the native governors, to curb their activities :—

" A number of robbers, who much resemble our gypsies, live in the holes of the mountains above Thebes. They are all outlaws, punished with death if elsewhere found. Osman Bey, an ancient governor of Girge, unable to suffer any longer the disorders committed by these people, ordered a quantity of dried faggots to be brought together, and, with his soldiers, took possession of the face of the mountain, where the greatest number of these wretches were : he then ordered all their caves to be filled with this dry brushwood, to which he set fire, so that most of

[1] Norden, *Travels in Egypt and Nubia*, translated by Dr. Peter Templeman. London, 1757.

them were destroyed ; but they have since recruited their numbers without changing their manners." [1]

In the course of this visit Bruce made copies of the figures of harpers in the tomb of Rameses III, a tomb which still goes by his name, but his labours were brought to an abrupt conclusion. Finding that it was his intention to spend the night in the tomb, and continue his researches in the morning, his guides were seized with terror, " With great clamour and marks of discontent, they dashed their torches against the largest harp, and made the best of their way out of the cave, leaving me and my people in the dark ; and all the way as they went, they made dreadful denunciations of tragical events that were immediately to follow, upon their departure from the cave." That their terror was genuine and not ill-founded, Bruce was soon to discover, for as he rode down The Valley in the gathering darkness, he was attacked by a party of the bandits, who lay in wait for him, and hurled stones at him from the side of the cliff. With the aid of his gun and his servant's blunderbuss he managed to beat them off, but, on arriving at his boat, he thought it prudent to cast off at once, and made no attempt to repeat his visit.

Nor did even the magic of Napoleon's name suffice to curb the arrogance of these Theban bandits, for the members of his scientific commission who visited Thebes in the last days of the century were molested, and even fired upon. They succeeded, however, in making a complete survey of all the tombs then open, and also carried out a small amount of excavation.

Let us pass on now to 1815, and make the ac-

[1] Bruce, *Travels to Discover the Source of the Nile*, Vol. I, p. 125.

quaintance of one of the most remarkable men in the whole history of Egyptology. In the early years of the century, a young Italian giant, Belzoni by name, was earning a precarious income in England by performing feats of strength at fairs and circuses. Born in Padua, of a respectable family of Roman extraction, he had been intended for the priesthood, but a roving disposition, combined with the internal troubles in Italy at that period, had driven him to seek his fortune abroad. We happened recently upon a reference to him in his pre-Egyptian days, in one of " Rainy Day " Smith's books of reminiscences, where the author describes how he was carried round the stage, with a group of other people, by the "strong man" Belzoni. In the intervals of circus work Belzoni seems to have studied engineering, and in 1815 he thought he saw a chance of making his fortune by introducing into Egypt a hydraulic wheel, which would, he claimed, do four times the work of the ordinary native appliance. With this in view, he made his way to Egypt, contrived an introduction to Mohammed Ali the " Bashaw," and in the garden of the palace actually set up his wheel. According to Belzoni it was a great success, but the Egyptians refused to have anything to do with it, and he found himself stranded in Egypt.

Then, through the traveller Burchardt, he got an introduction to Salt, the British Consul-General in Egypt, and contracted with him to bring the "colossal Memnion bust" (Rameses II, now in the British Museum) from Luxor to Alexandria. This was in 1815, and the next five years he spent in Egypt, excavating and collecting antiquities, first for Salt, and afterwards on his own account, and quarrel-

ling with rival excavators, notably Drovetti, who represented the French Consul. Those were the great days of excavating. Anything to which a fancy was taken, from a scarab to an obelisk, was just appropriated, and if there was a difference of opinion with a brother excavator one laid for him with a gun.

Belzoni's account of his experiences in Egypt, published in 1820, is one of the most fascinating books in the whole of Egyptian literature, and I should like to quote from it at length—how, for instance, he dropped an obelisk in the Nile and fished it out again, and the full story of his various squabbles. We must confine ourselves, however, to his actual work in The Valley. Here he discovered and cleared a number of tombs, including those of Ay, Mentu· her·khepesh·ef, Rameses I, and Seti I. In the last named he found the magnificent alabaster sarcophagus which is now in the Soane Museum in London.

This was the first occasion on which excavations on a large scale had ever been made in The Valley, and we must give Belzoni full credit for the manner in which they were carried out. There are episodes which give the modern excavator rather a shock, as, for example, when he describes his method of dealing with sealed doorways—by means of a battering ram—but on the whole the work was extraordinarily good. It is perhaps worth recording the fact that Belzoni, like everyone else who has ever dug in The Valley, was of the opinion that he had absolutely exhausted its possibilities. " It is my firm opinion," he states, " that in the Valley of Beban el Malook, there are no more (tombs) than are now known, in consequence of my late discoveries ; for, previously to my quitting that place, I exerted all my humble abilities in endeavouring to

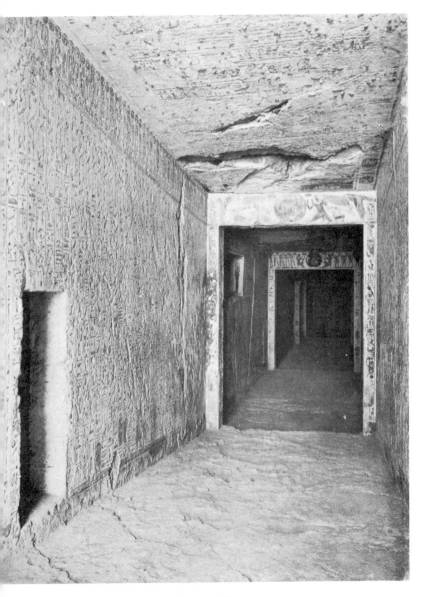

PLATE VI

INTERIOR OF THE TOMB OF RAMESES IX.

find another tomb, but could not succeed ; and what is a still greater proof, independent of my own researches, after I quitted the place, Mr. Salt, the British Consul, resided there four months and laboured in like manner in vain to find another."

In 1820 Belzoni returned to England, and gave an exhibition of his treasures, including the alabaster sarcophagus and a model of the tomb of Seti, in a building which had been erected in Piccadilly in 1812, a building which many of us can still remember—the Egyptian Hall. He never returned to Egypt, but died a few years later on an expedition to Timbuctoo.

For twenty years after Belzoni's day The Valley was well exploited, and published records come thick and fast. We shall not have space here to do more than mention a few of the names—Salt, Champollion, Burton, Hay, Head, Rosellini, Wilkinson, who numbered the tombs, Rawlinson, Rhind. In 1844 the great German expedition under Lepsius made a complete survey of The Valley, and cleared the tomb of Rameses II, and part of the tomb of Mer·en·Ptah. Hereafter comes a gap ; the German expedition was supposed to have exhausted the possibilities, and nothing more of any consequence was done in The Valley until the very end of the century.

In this period, however, just outside The Valley, there occurred one of the most important events in the whole of its history. In the preceding chapter we told how the various royal mummies were collected from their hiding-places, and deposited all together in a rock cleft at Deir el Bahari. There for nearly three thousand years they had rested, and there, in the summer of 1875, they were found by the members of a Kurna family,

the Abd-el-Rasuls. It was in the thirteenth century B.C. that the inhabitants of this village first adopted the trade of tomb-robbing, and it is a trade that they have adhered to steadfastly ever since. Their activities are curbed at the present day, but they still search on the sly in out-of-the-way corners, and occasionally make a rich strike. On this occasion the find was too big to handle. It was obviously impossible to clear the tomb of its contents, so the whole family was sworn to secrecy, and its heads determined to leave the find where it was, and to draw on it from time to time as they needed money. Incredible as it may seem the secret was kept for six years, and the family, with a banking account of forty or more dead Pharaohs to draw upon, grew rich.

It soon became manifest, from objects which came into the market, that there had been a rich find of royal material somewhere, but it was not until 1881 that it was possible to trace the sale of the objects to the Abd-el-Rasul family. Even then it was difficult to prove anything. The head of the family was arrested and subjected by the Mudir of Keneh, the notorious Daoud Pasha, whose methods of administering justice were unorthodox but effectual, to an examination. Naturally he denied the charge, and equally naturally the village of Kurna rose as one man and protested that in a strictly honest community the Abd-el-Rasul family were of all men the most honest. He was released provisionally for lack of evidence, but his interview with Daoud seems to have shaken him. Interviews with Daoud usually did have that effect.

One of our older workmen told us once of an

experience of his in his younger days. He had
been by trade a thief, and in the exercise of his
calling had been apprehended and brought before the
Mudir. It was a hot day, and his nerves were shaken
right at the start by finding the Mudir taking his
ease in a large earthenware jar of water. From this
unconventional seat of justice Daoud had looked
at him—just looked at him—" and as his eyes went
through me I felt my bones turning to water within
me. Then very quietly he said to me, ' This is the
first time you have appeared before me. You are
dismissed, but—be very, very careful that you do
not appear a second time,' and I was so terrified
that I changed my trade and never did."

Some effect of this sort must have been produced
on the Abd-el-Rasul family, for a month later one
of its members went to the Mudir and made full
confession. News was telegraphed at once to Cairo,
Emile Brugsch Bey of the Museum was sent up to
investigate and take charge, and on the 5th of July,
1881, the long-kept secret was revealed to him. It
must have been an amazing experience. There,
huddled together in a shallow, ill-cut grave, lay the
most powerful monarchs of the ancient East, kings
whose names were familiar to the whole world, but
whom no one in their wildest moments had ever
dreamt of seeing. There they had remained, where
the priests in secrecy had hurriedly brought them
that dark night three thousand years ago; and
on their coffins and mummies, neatly docketed, were
the records of their journeyings from one hiding-place
to another. Some had been re-wrapped, and two or
three in the course of their many wanderings had con-
trived to change their coffins. In forty-eight hours

—we don't do things quite so hastily nowadays—the tomb was cleared ; the kings were embarked upon the Museum barge ; and within fifteen days of Brugsch Bey's arrival in Luxor, they were landed in Cairo and were deposited in the Museum.

It is a familiar story, but worth repeating, that as the barge made its way down the river the men of the neighbouring villages fired guns as for a funeral, while the women followed along the bank, tearing their hair, and uttering that shrill quavering cry of mourning for the dead, a cry that has doubtless come right down from the days of the Pharaohs themselves.

To return to The Valley. In 1898, acting on information supplied by local officials, M. Loret, then Director General of the Service of Antiquities, opened up several new royal tombs, including those of Thothmes I, Thothmes III, and Amen·hetep II. This last was a very important discovery. We have already stated that in the Twenty-first Dynasty thirteen royal mummies had found sanctuary in this Amen·hetep's tomb, and here in 1898 the thirteen were found. It was but their mummies that remained. The wealth, which in their power they had lavished on their funerals, had long since vanished, but at least they had been spared the last indignity. The tomb had been entered, it is true ; it had been robbed, and the greater part of the funeral equipment had been plundered and broken, but it had escaped the wholesale destruction that the other royal tombs had undergone, and the mummies remained intact. The body of Amen·hetep himself still lay within its own sarcophagus, where it had rested for more than three thousand years. Very

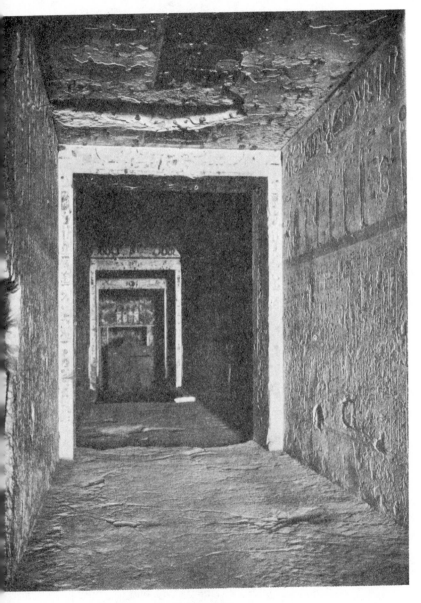

PLATE VII

INTERIOR OF THE TOMB OF RAMESES IV, SHOWING THE SARCOPHAGUS.

rightly the Government, at the representation of Sir William Garstin, decided against its removal. The tomb was barred and bolted, a guard was placed upon it, and there the king was left in peace.

Unfortunately there is a sequel to this story. Within a year or two of the discovery the tomb was broken into by a party of modern tomb-robbers, doubtless with the connivance of the guard, and the mummy was removed from its sarcophagus and searched for treasure. The thieves were subsequently tracked down by the Chief Inspector of Antiquities, and arrested, although he was unable to secure their conviction at the hands of the Native Court. The whole proceedings, as set forth in the official report, remind one very forcibly of the records of ancient tomb-robbery described in the preceding chapter, and we are forced to the conclusion that in many ways the Egyptian of the present day differs little from his ancestor in the reign of Rameses IX.

One moral we can draw from this episode, and we commend it to the critics who call us Vandals for taking objects from the tombs. By removing antiquities to museums we are really assuring their safety : left *in situ* they would inevitably, sooner or later, become the prey of thieves, and that, for all practical purposes, would be the end of them.

In 1902 permission to dig in The Valley under Government supervision was granted to an American, Mr. Theodore Davis, and he subsequently excavated there for twelve consecutive seasons. His principal finds are known to most of us. They include the tombs of Thothmes IV, Hat·shep·sût,

The Tomb of Tut·ankh·Amen

Si·Ptah, Yua and Thua—great-grandfather and grandmother these of Tut·ankh·Amen's queen—Hor·em·heb, and a vault, not a real tomb, devised for the transfer of the burial of Akh·en·Aten from its original tomb at Tell el Amarna. This cache comprised the mummy and coffin of the heretic king, a very small part of his funerary equipment, and portions of the sepulchral shrine of his mother Tyi. In 1914 Mr. Davis's concession reverted to us, and the story of the tomb of Tut·ankh·Amen really begins.

CHAPTER IV

Our Prefatory Work at Thebes

EVER since my first visit to Egypt in 1890 it had been my ambition to dig in The Valley, and when, at the invitation of Sir William Garstin and Sir Gaston Maspero, I began to excavate for Lord Carnarvon in 1907, it was our joint hope that eventually we might be able to get a concession there. I had, as a matter of fact, when Inspector of the Antiquities Department, found, and superintended the clearing of, two tombs in The Valley for Mr. Theodore Davis, and this had made me the more anxious to work there under a regular concession. For the moment it was impossible, and for seven years we dug with varying fortune in other parts of the Theban necropolis. The results of the first five of these years have been published in " Five Years' Explorations at Thebes," a joint volume brought out by Lord Carnarvon and myself in 1912.

In 1914 our discovery of the tomb of Amen· hetep I, on the summit of the Drah abu'l Negga foothills, once more turned our attention Valleywards, and we awaited our chance with some impatience. Mr. Theodore Davis, who still held the concession, had already published the fact that he considered The Valley exhausted, and that there were no more tombs to be found, a statement corroborated by the fact that in his last two seasons

he did very little work in The Valley proper, but spent most of his time excavating in the approach thereto, in the neighbouring north valley, where he hoped to find the tombs of the priest kings and of the Eighteenth Dynasty queens, and in the mounds surrounding the Temple of Medinet Habu. Nevertheless he was loath to give up the site, and it was not until June, 1914, that we actually received the long-coveted concession. Sir Gaston Maspero, Director of the Antiquities Department, who signed our concession, agreed with Mr. Davis that the site was exhausted, and told us frankly that he did not consider that it would repay further investigation. We remembered, however, that nearly a hundred years earlier Belzoni had made a similar claim, and refused to be convinced. We had made a thorough investigation of the site, and were quite sure that there were areas, covered by the dumps of previous excavators, which had never been properly examined.

Clearly enough we saw that very heavy work lay before us, and that many thousands of tons of surface debris would have to be removed before we could hope to find anything ; but there was always the chance that a tomb might reward us in the end, and, even if there was nothing else to go upon, it was a chance that we were quite willing to take. As a matter of fact we had something more, and, at the risk of being accused of *post actum* prescience, I will state that we had definite hopes of finding the tomb of one particular king, and that king Tut·ankh·Amen.

To explain the reasons for this belief of ours we must turn to the published pages of Mr. Davis's

excavations. Towards the end of his work in The Valley he had found, hidden under a rock, a faience cup which bore the name of Tut·ankh·Amen. In the same region he came upon a small pit-tomb, in which were found an unnamed alabaster statuette, possibly of Ay, and a broken wooden box, in which were fragments of gold foil, bearing the figures and names of Tut·ankh·Amen and his queen. On the basis of these fragments of gold he claimed that he had actually found the burial place of Tut·ankh· Amen. The theory was quite untenable, for the pit-tomb in question was small and insignificant, of a type that might very well belong to a member of the royal household in the Ramesside period, but ludicrously inadequate for a king's burial in the Eighteenth Dynasty. Obviously, the royal material found in it had been placed there at some later period, and had nothing to do with the tomb itself.

Some little distance eastward from this tomb, he had also found in one of his earlier years of work (1907–8), buried in an irregular hole cut in the side of the rock, a cache of large pottery jars, with sealed mouths, and hieratic inscriptions upon their shoulders. A cursory examination was made of their contents, and as these seemed to consist merely of broken pottery, bundles of linen, and other oddments, Mr. Davis refused to be interested in them, and they were laid aside and stacked away in the store-room of his Valley house. There, some while afterwards, Mr. Winlock noticed them, and immediately realized their importance. With Mr. Davis's consent the entire collection of jars was packed and sent to the Metropolitan Museum of Art, New York, and there Mr. Winlock made a

thorough examination of their contents. Extraordinarily interesting they proved to be. There were clay seals, some bearing the name of Tut·ankh·Amen and others the impression of the royal necropolis seal, fragments of magnificent painted pottery vases, linen head-shawls—one inscribed with the latest known date of Tut·ankh·Amen's reign—floral collars, of the kind represented as worn by mourners in burial scenes, and a mass of other miscellaneous objects ; the whole representing, apparently, the material which had been used during the funeral ceremonies of Tut·ankh·Amen, and afterwards gathered together and stacked away within the jars.

We had thus three distinct pieces of evidence— the faience cup found beneath the rock, the gold foil from the small pit-tomb, and this important cache of funerary material—which seemed definitely to connect Tut·ankh·Amen with this particular part of The Valley. To these must be added a fourth. It was in the near vicinity of these other finds that Mr. Davis had discovered the famous Akh·en·Aten cache. This contained the funerary remains of heretic royalties, brought hurriedly from Tell el Amarna and hidden here for safety, and that it was Tut·ankh·Amen himself who was responsible for their removal and reburial we can be reasonably sure from the fact that a number of his clay seals were found.

With all this evidence before us we were thoroughly convinced in our own minds that the tomb of Tut·ankh·Amen was still to find, and that it ought to be situated not far from the centre of The Valley. In any case, whether we found Tut·ankh·Amen or not, we felt that a systematic and exhaustive search of

the inner valley presented reasonable chances of success, and we were in the act of completing our plans for an elaborate campaign in the season of 1914–15 when war broke out, and for the time being all our plans had to be left in abeyance.

War-work claimed most of my time for the next few years, but there were occasional intervals in which I was able to carry out small pieces of excavation. In February, 1915, for example, I made a complete clearance of the interior of the tomb of Amen·hetep III, partially excavated in 1799 by M. Devilliers, one of the members of Napoleon's " Commission d'Égypte," and re-excavated later by Mr. Theodore Davis. In the course of this work we made the interesting discovery, from the evidence of intact foundation-deposits outside the entrance, and from other material found within the tomb, that it had been originally designed by Thothmes IV, and that Queen Tyi had actually been buried there.

The following year, while on a short holiday at Luxor, I found myself involved quite unexpectedly in another piece of work. The absence of officials owing to the war, to say nothing of the general demoralization caused by the war itself, had naturally created a great revival of activity on the part of the local native tomb-robbers, and prospecting parties were out in all directions. News came into the village one afternoon that a find had been made in a lonely and unfrequented region on the western side of the mountain above The Valley of the Kings. Immediately a rival party of diggers armed themselves and made their way to the spot, and in the lively engagement that ensued the original party were beaten and driven off, vowing vengeance.

To avert further trouble the notables of the village came to me and asked me to take action. It was already late in the afternoon, so I hastily collected the few of my workmen who had escaped the Army Labour Levies, and with the necessary materials set out for the scene of action, an expedition involving a climb of more than 1,800 feet over the Kurna hills by moonlight. It was midnight when we arrived on the scene, and the guide pointed out to me the end of a rope which dangled sheer down the face of a cliff. Listening, we could hear the robbers actually at work, so I first severed their rope, thereby cutting off their means of escape, and then, making secure a good stout rope of my own, I lowered myself down the cliff. Shinning down a rope at midnight, into a nestful of industrious tomb-robbers, is a pastime which at least does not lack excitement. There were eight at work, and when I reached the bottom there was an awkward moment or two. I gave them the alternative of clearing out by means of my rope, or else of staying where they were without a rope at all, and eventually they saw reason and departed. The rest of the night I spent on the spot, and, as soon as it was light enough, climbed down into the tomb again to make a thorough investigation.

The tomb was in a most remarkable situation (Plate VIII). Its entrance was contrived in the bottom of a natural water-worn cleft, 130 feet from the top of the cliff, and 220 feet above the valley bed, and so cunningly concealed that neither from the top nor the bottom could the slightest trace of it be seen. From the entrance a lateral passage ran straight into the face of the cliff, a distance of some 55 feet,

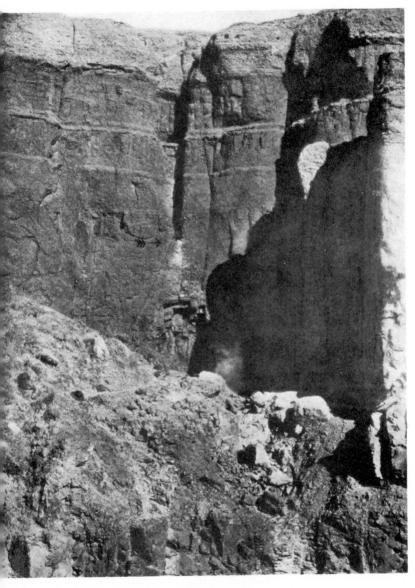

PLATE VIII

VIEW SHOWING POSITION OF HAT·SHEP·SÛT'S CLEFT-TOMB.
(*See* Arrow.)

after which it turned at right angles, and a short passage, cut on a sharp slope, led down into a chamber about 18 feet square. The whole place was full of rubbish from top to bottom, and through this rubbish the robbers had burrowed a tunnel over 90 feet long, just big enough for a man to crawl through.

It was an interesting discovery, and might turn out to be very important, so I determined to make a complete clearance. Twenty days it took, working night and day with relays of workmen, and an extraordinarily difficult job it proved. The method of gaining access to the tomb by means of a rope from the top was unsatisfactory, for it was not a very safe proceeding at best, and it necessitated, moreover, a stiff climb from the valley. Obviously means of access from the valley-bottom would be preferable, and this we contrived by erecting sheers at the entrance to the tomb, so that by a running tackle we could pull ourselves up or let ourselves down. It was not a very comfortable operation even then, and I personally always made the descent in a net.

Excitement among the workmen ruled high as the work progressed, for surely a place so well concealed must contain a wonderful treasure, and great was their disappointment when it proved that the tomb had neither been finished nor occupied. The only thing of value it contained was a large sarcophagus of crystalline sandstone, like the tomb, unfinished, with inscriptions which showed it to have been intended for Queen Hat·shep·sût. Presumably this masterful lady had had the tomb constructed for herself as wife of King Thothmes II. Later, when she seized the throne and ruled actually

as a king, it was clearly necessary for her to have her tomb in The Valley like all the other kings— as a matter of fact I found it there myself in 1903 —and the present tomb was abandoned. She would have been better advised to hold to her original plan. In this secret spot her mummy would have had a reasonable chance of avoiding disturbance : in The Valley it had none. A king she would be, and a king's fate she shared.

In the autumn of 1917 our real campaign in The Valley opened. The difficulty was to know where to begin, for mountains of rubbish thrown out by previous excavators encumbered the ground in all directions, and no sort of record had ever been kept as to which areas had been properly excavated and which had not. Clearly the only satisfactory thing to do was to dig systematically right down to bed-rock, and I suggested to Lord Carnarvon that we take as a starting-point the triangle of ground defined by the tombs of Rameses II, Mer·en·Ptah, and Rameses VI, the area in which we hoped the tomb of Tut·ankh·Amen might be situated.

It was rather a desperate undertaking, the site being piled high with enormous heaps of thrown-out rubbish, but I had reason to believe that the ground beneath had never been touched, and a strong conviction that we should find a tomb there. In the course of the season's work we cleared a considerable part of the upper layers of this area, and advanced our excavations right up to the foot of the tomb of Rameses VI. Here we came on a series of workmen's huts (*see* Plate X), built over masses of flint boulders, the latter usually indicating in The Valley the near proximity of a tomb. Our natural

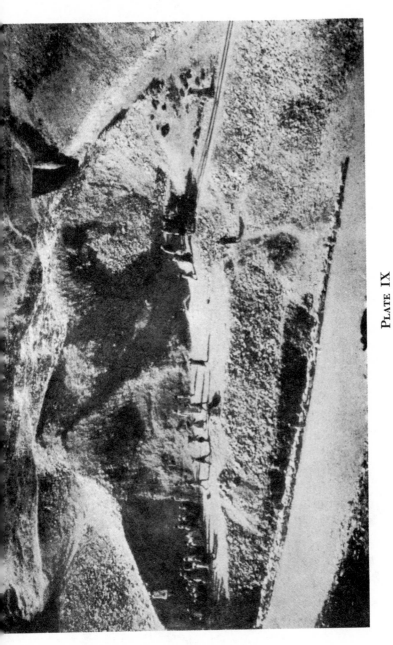

PLATE IX

REMOVING SURFACE DEBRIS IN SEARCH OF THE TOMB OF TUT·ANKH·AMEN.

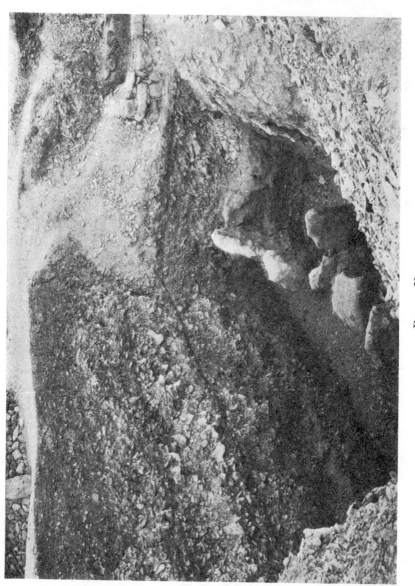

Plate X

impulse was to enlarge our clearing in this direction, but by doing this we should have cut off all access to the tomb of Rameses above, to visitors one of the most popular tombs in the whole Valley. We determined to await a more convenient opportunity. So far the only results from our work were some *ostraca*,[1] interesting but not exciting.

We resumed our work in this region in the season of 1919-20. Our first need was to break fresh ground for a dump, and in the course of this preliminary work we lighted on some small deposits of Rameses IV, near the entrance to his tomb. The idea this year was to clear the whole of the remaining part of the triangle already mentioned, so we started in with a fairly large gang of workmen. By the time Lord and Lady Carnarvon arrived in March the whole of the top debris had been removed, and we were ready to clear down into what we believed to be virgin ground below. We soon had proof that we were right, for we presently came upon a small cache containing thirteen alabaster jars, bearing the names of Rameses II and Mer·en·Ptah, probably from the tomb of the latter. As this was the nearest approach to a real find that we had yet made in The Valley, we were naturally somewhat excited, and Lady Carnarvon, I remember, insisted on digging out these jars—beautiful specimens they were—with her own hands.

With the exception of the ground covered by the workmen's huts, we had now exhausted the whole of our triangular area, and had found no tomb. I was still hopeful, but we decided to leave this par-

[1] Potsherds and flakes of limestone, used for sketching and writing purposes.

ticular section until, by making a very early start in the autumn, we could accomplish it without causing inconvenience to visitors.

For our next attempt we selected the small lateral valley in which the tomb of Thothmes III was situated. This occupied us throughout the whole of the two following seasons, and, though nothing intrinsically valuable was found, we discovered an interesting archæological fact. The actual tomb in which Thothmes III was buried had been found by Loret in 1898, hidden in a cleft in an inaccessible spot some way up the face of the cliff. Excavating in the valley below, we came upon the beginning of a tomb, by its foundation-deposits originally intended for the same king. Presumably, while the work on this low-level tomb was in progress, it occurred to Thothmes or to his architect that the cleft in the rock above was a better site. It certainly presented better chances of concealment, if that were the reason for the change; though probably the more plausible explanation would be that one of the torrential downpours of rain which visit Luxor occasionally may have flooded out the lower tomb, and suggested to Thothmes that his mummy would have a more comfortable resting-place on a higher level.

Near by, at the entrance to another abandoned tomb, we came upon foundation-deposits of his wife Meryt·Re·Hat·shep·sût, sister of the great queen of that name. Whether we are to infer that she was buried there is a moot point, for it would be contrary to all custom to find a queen in The Valley. In any case the tomb was afterwards appropriated by the Theban official, Sen·nefer.

We had now dug in The Valley for several seasons

with extremely scanty results, and it became a much debated question whether we should continue the work, or try for a more profitable site elsewhere. After these barren years were we justified in going on with it? My own feeling was that so long as a single area of untouched ground remained the risk was worth taking. It is true that you may find less in more time in The Valley than in any other site in Egypt, but, on the other hand, if a lucky strike be made, you will be repaid for years and years of dull and unprofitable work.

There was still, moreover, the combination of flint boulders and workmen's huts at the foot of the tomb of Rameses VI to be investigated, and I had always had a kind of superstitious feeling that in that particular corner of The Valley one of the missing kings, possibly Tut·ankh·Amen, might be found. Certainly the stratification of the debris there should indicate a tomb. Eventually we decided to devote a final season to The Valley, and, by making an early start, to cut off access to the tomb of Rameses VI, if that should prove necessary, at a time when it would cause least inconvenience to visitors. That brings us to the present season and the results that are known to everyone.

CHAPTER V

The Finding of the Tomb

THE history of The Valley, as I have endea-
voured to show in former chapters, has never
lacked the dramatic element, and in this,
the latest episode, it has held to its traditions. For
consider the circumstances. This was to be our final
season in The Valley. Six full seasons we had ex-
cavated there, and season after season had drawn a
blank ; we had worked for months at a stretch and
found nothing, and only an excavator knows how
desperately depressing that can be ; we had almost
made up our minds that we were beaten, and were
preparing to leave The Valley and try our luck
elsewhere ; and then—hardly had we set hoe to
ground in our last despairing effort than we made a
discovery that far exceeded our wildest dreams.
Surely, never before in the whole history of excava-
tion has a full digging season been compressed within
the space of five days.

Let me try and tell the story of it all. It will
not be easy, for the dramatic suddenness of the
initial discovery left me in a dazed condition, and the
months that have followed have been so crowded with
incident that I have hardly had time to think.
Setting it down on paper will perhaps give me a
chance to realize what has happened and all that
it means.

I arrived in Luxor on October 28th, and by

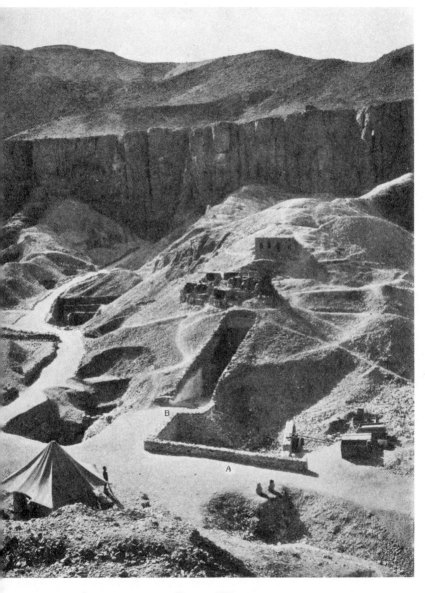

PLATE XI

VIEW OF THE ROYAL CEMETERY: SHOWING THE RELATIVE POSITIONS
OF THE TOMBS OF TUT·ANKH·AMEN (A) AND RAMESES VI (B).

The Finding of the Tomb

November 1st I had enrolled my workmen and was ready to begin. Our former excavations had stopped short at the north-east corner of the tomb of Rameses VI, and from this point I started trenching southwards. It will be remembered that in this area there were a number of roughly constructed workmen's huts, used probably by the labourers in the tomb of Rameses. These huts, built about three feet above bed-rock, covered the whole area in front of the Ramesside tomb, and continued in a southerly direction to join up with a similar group of huts on the opposite side of The Valley, discovered by Davis in connexion with his work on the Akh·en·Aten cache. By the evening of November 3rd we had laid bare a sufficient number of these huts for experimental purposes, so, after we had planned and noted them, they were removed, and we were ready to clear away the three feet of soil that lay beneath them.

Hardly had I arrived on the work next morning (November 4th) than the unusual silence, due to the stoppage of the work, made me realize that something out of the ordinary had happened, and I was greeted by the announcement that a step cut in the rock had been discovered underneath the very first hut to be attacked. This seemed too good to be true, but a short amount of extra clearing revealed the fact that we were actually in the entrance of a steep cut in the rock, some thirteen feet below the entrance to the tomb of Rameses VI, and a similar depth from the present bed level of The Valley (Plate XI). The manner of cutting was that of the sunken stairway entrance so common in The Valley, and I almost dared to hope that we had found our tomb at last.

Work continued feverishly throughout the whole of that day and the morning of the next, but it was not until the afternoon of November 5th that we succeeded in clearing away the masses of rubbish that overlay the cut, and were able to demarcate the upper edges of the stairway on all its four sides (Plate XII).

It was clear by now beyond any question that we actually had before us the entrance to a tomb, but doubts, born of previous disappointments, persisted in creeping in. There was always the horrible possibility, suggested by our experience in the Thothmes III Valley, that the tomb was an unfinished one, never completed and never used : if it had been finished there was the depressing probability that it had been completely plundered in ancient times. On the other hand, there was just the chance of an untouched or only partially plundered tomb, and it was with ill-suppressed excitement that I watched the descending steps of the staircase, as one by one they came to light. The cutting was excavated in the side of a small hillock, and, as the work progressed, its western edge receded under the slope of the rock until it was, first partially, and then completely, roofed in, and became a passage, 10 feet high by 6 feet wide. Work progressed more rapidly now ; step succeeded step, and at the level of the twelfth, towards sunset, there was disclosed the upper part of a doorway, blocked, plastered, and sealed.

A sealed doorway—it was actually true, then ! Our years of patient labour were to be rewarded after all, and I think my first feeling was one of congratulation that my faith in The Valley had not been unjustified. With excitement growing to fever

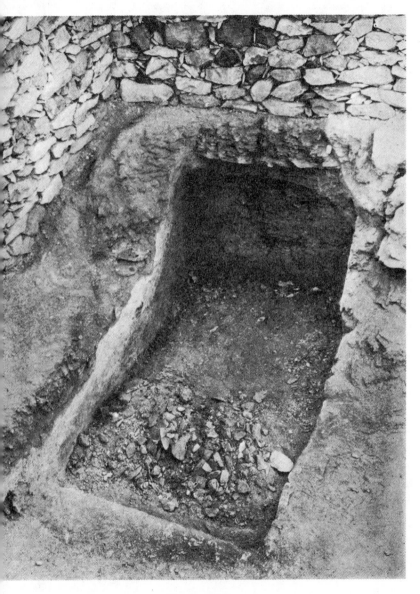

PLATE XII

ENTRANCE TO THE TOMB AS FIRST SEEN.

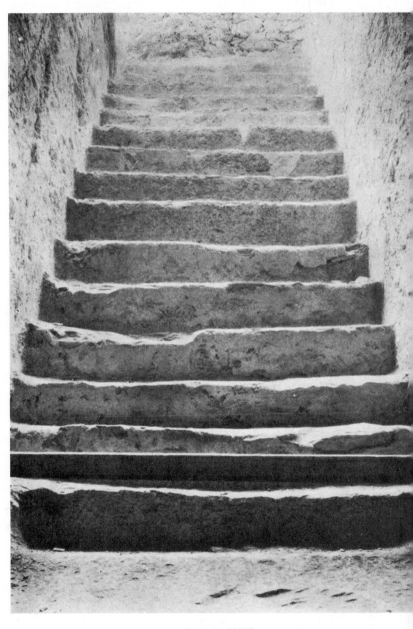

PLATE XIII

THE SIXTEEN STEPS.

heat I searched the seal impressions on the door for evidence of the identity of the owner, but could find no name : the only decipherable ones were those of the well-known royal necropolis seal, the jackal and nine captives. Two facts, however, were clear : first, the employment of this royal seal was certain evidence that the tomb had been constructed for a person of very high standing; and second, that the sealed door was entirely screened from above by workmen's huts of the Twentieth Dynasty was sufficiently clear proof that at least from that date it had never been entered. With that for the moment I had to be content.

While examining the seals I noticed, at the top of the doorway, where some of the plaster had fallen away, a heavy wooden lintel. Under this, to assure myself of the method by which the doorway had been blocked, I made a small peephole, just large enough to insert an electric torch, and discovered that the passage beyond the door was filled completely from floor to ceiling with stones and rubble—additional proof this of the care with which the tomb had been protected.

It was a thrilling moment for an excavator. Alone, save for my native workmen, I found myself, after years of comparatively unproductive labour, on the threshold of what might prove to be a magnificent discovery. Anything, literally anything, might lie beyond that passage, and it needed all my self-control to keep from breaking down the doorway, and investigating then and there.

One thing puzzled me, and that was the smallness of the opening in comparison with the ordinary Valley tombs. The design was certainly of the

Eighteenth Dynasty. Could it be the tomb of a noble buried here by royal consent? Was it a royal cache, a hiding-place to which a mummy and its equipment had been removed for safety? Or was it actually the tomb of the king for whom I had spent so many years in search?

Once more I examined the seal impressions for a clue, but on the part of the door so far laid bare only those of the royal necropolis seal already mentioned were clear enough to read. Had I but known that a few inches lower down there was a perfectly clear and distinct impression of the seal of Tut·ankh· Amen, the king I most desired to find, I would have cleared on, had a much better night's rest in consequence, and saved myself nearly three weeks of uncertainty. It was late, however, and darkness was already upon us. With some reluctance I re-closed the small hole that I had made, filled in our excavation for protection during the night, selected the most trustworthy of my workmen— themselves almost as excited as I was—to watch all night above the tomb, and so home by moonlight, riding down The Valley.

Naturally my wish was to go straight ahead with our clearing to find out the full extent of the discovery, but Lord Carnarvon was in England, and in fairness to him I had to delay matters until he could come. Accordingly, on the morning of November 6th I sent him the following cable:—" At last have made wonderful discovery in Valley; a magnificent tomb with seals intact; re-covered same for your arrival; congratulations."

My next task was to secure the doorway against interference until such time as it could finally be

re-opened. This we did by filling our excavation up again to surface level, and rolling on top of it the large flint boulders of which the workmen's huts had been composed. By the evening of the same day, exactly forty-eight hours after we had discovered the first step of the staircase, this was accomplished. The tomb had vanished. So far as the appearance of the ground was concerned there never had been any tomb, and I found it hard to persuade myself at times that the whole episode had not been a dream.

I was soon to be reassured on this point. News travels fast in Egypt, and within two days of the discovery congratulations, inquiries, and offers of help descended upon me in a steady stream from all directions. It became clear, even at this early stage, that I was in for a job that could not be tackled single-handed, so I wired to Callender, who had helped me on various previous occasions, asking him if possible to join me without delay, and to my relief he arrived on the very next day. On the 8th I had received two messages from Lord Carnarvon in answer to my cable, the first of which read, " Possibly come soon," and the second, received a little later, " Propose arrive Alexandria 20th."

We had thus nearly a fortnight's grace, and we devoted it to making preparations of various kinds, so that when the time of re-opening came, we should be able, with the least possible delay, to handle any situation that might arise. On the night of the 18th I went to Cairo for three days, to meet Lord Carnarvon and make a number of necessary purchases, returning to Luxor on the 21st. On the 23rd Lord Carnarvon arrived in Luxor with his

daughter, Lady Evelyn Herbert, his devoted companion in all his Egyptian work, and everything was in hand for the beginning of the second chapter of the discovery of the tomb. Callender had been busy all day clearing away the upper layer of rubbish, so that by morning we should be able to get into the staircase without any delay.

By the afternoon of the 24th the whole staircase was clear, sixteen steps in all (Plate XIII), and we were able to make a proper examination of the sealed doorway. On the lower part the seal impressions were much clearer, and we were able without any difficulty to make out on several of them the name of Tut·ankh·Amen (Plate XIV). This added enormously to the interest of the discovery. If we had found, as seemed almost certain, the tomb of that shadowy monarch, whose tenure of the throne coincided with one of the most interesting periods in the whole of Egyptian history, we should indeed have reason to congratulate ourselves.

With heightened interest, if that were possible, we renewed our investigation of the doorway. Here for the first time a disquieting element made its appearance. Now that the whole door was exposed to light it was possible to discern a fact that had hitherto escaped notice—that there had been two successive openings and re-closings of a part of its surface : furthermore, that the sealing originally discovered, the jackal and nine captives, had been applied to the re-closed portions, whereas the sealings of Tut·ankh·Amen covered the untouched part of the doorway, and were therefore those with which the tomb had been originally secured. The tomb then was not absolutely intact, as we had hoped.

Plunderers had entered it, and entered it more than once—from the evidence of the huts above, plunderers of a date not later than the reign of Rameses VI— but that they had not rifled it completely was evident from the fact that it had been re-sealed.[1]

Then came another puzzle. In the lower strata of rubbish that filled the staircase we found masses of broken potsherds and boxes, the latter bearing the names of Akh·en·Aten, Smenkh·ka·Re and Tut·ankh· Amen, and, what was much more upsetting, a scarab of Thothmes III and a fragment with the name of Amen·hetep III. Why this mixture of names ? The balance of evidence so far would seem to indicate a cache rather than a tomb, and at this stage in the proceedings we inclined more and more to the opinion that we were about to find a miscellaneous collection of objects of the Eighteenth Dynasty kings, brought from Tell el Amarna by Tut·ankh·Amen and deposited here for safety.

So matters stood on the evening of the 24th. On the following day the sealed doorway was to be removed, so Callender set carpenters to work making a heavy wooden grille to be set up in its place. Mr. Engelbach, Chief Inspector of the Antiquities Department, paid us a visit during the afternoon, and witnessed part of the final clearing of rubbish from the doorway.

On the morning of the 25th the seal impressions on the doorway were carefully noted and photographed, and then we removed the actual blocking of the door, consisting of rough stones carefully built

[1] From later evidence we found that this re-sealing could not have taken place later than the reign of Hor·em·heb, i.e. from ten to fifteen years after the burial.

from floor to lintel, and heavily plastered on their outer faces to take the seal impressions.

This disclosed the beginning of a descending passage (not a staircase), the same width as the entrance stairway, and nearly seven feet high. As I had already discovered from my hole in the doorway, it was filled completely with stone and rubble, probably the chip from its own excavation. This filling, like the doorway, showed distinct signs of more than one opening and re-closing of the tomb, the untouched part consisting of clean white chip, mingled with dust, whereas the disturbed part was composed mainly of dark flint. It was clear that an irregular tunnel had been cut through the original filling at the upper corner on the left side, a tunnel corresponding in position with that of the hole in the doorway.

As we cleared the passage we found, mixed with the rubble of the lower levels, broken potsherds, jar sealings, alabaster jars, whole and broken, vases of painted pottery, numerous fragments of smaller articles, and water skins, these last having obviously been used to bring up the water needed for the plastering of the doorways. These were clear evidence of plundering, and we eyed them askance. By night we had cleared a considerable distance down the passage, but as yet saw no sign of second doorway or of chamber.

The day following (November 26th) was the day of days, the most wonderful that I have ever lived through, and certainly one whose like I can never hope to see again. Throughout the morning the work of clearing continued, slowly perforce, on account of the delicate objects that were mixed with the filling.

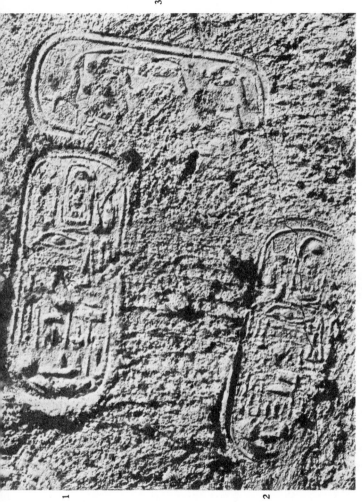

3

PLATE XIV

EXAMPLES OF SEAL IMPRESSIONS.

1 and 2. Tut · ankh · Amen's Seal. 3. Royal Necropolis Seal.

1

2

The Finding of the Tomb

Then, in the middle of the afternoon, thirty feet down from the outer door, we came upon a second sealed doorway, almost an exact replica of the first. The seal impressions in this case were less distinct, but still recognizable as those of Tut·ankh·Amen and of the royal necropolis. Here again the signs of opening and re-closing were clearly marked upon the plaster. We were firmly convinced by this time that it was a cache that we were about to open, and not a tomb. The arrangement of stairway, entrance passage and doors reminded us very forcibly of the cache of Akh·en·Aten and Tyi material found in the very near vicinity of the present excavation by Davis, and the fact that Tut·ankh·Amen's seals occurred there likewise seemed almost certain proof that we were right in our conjecture. We were soon to know. There lay the sealed doorway, and behind it was the answer to the question.

Slowly, desperately slowly it seemed to us as we watched, the remains of passage debris that encumbered the lower part of the doorway were removed, until at last we had the whole door clear before us. The decisive moment had arrived. With trembling hands I made a tiny breach in the upper left hand corner. Darkness and blank space, as far as an iron testing-rod could reach, showed that whatever lay beyond was empty, and not filled like the passage we had just cleared. Candle tests were applied as a precaution against possible foul gases, and then, widening the hole a little, I inserted the candle and peered in, Lord Carnarvon, Lady Evelyn and Callender standing anxiously beside me to hear the verdict. At first I could see nothing, the hot air escaping from the chamber causing the candle flame to flicker, but

presently, as my eyes grew accustomed to the light, details of the room within emerged slowly from the mist, strange animals, statues, and gold—everywhere the glint of gold. For the moment—an eternity it must have seemed to the others standing by—I was struck dumb with amazement, and when Lord Carnarvon, unable to stand the suspense any longer, inquired anxiously, " Can you see anything ? " it was all I could do to get out the words, " Yes, wonderful things." Then widening the hole a little further, so that we both could see, we inserted an electric torch.

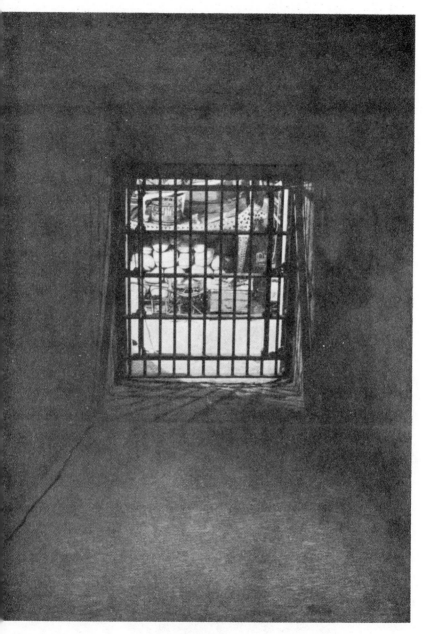

PLATE XV

'IEW OF THE ANTECHAMBER AS SEEN FROM THE PASSAGE THROUGH
THE STEEL GRILLE.

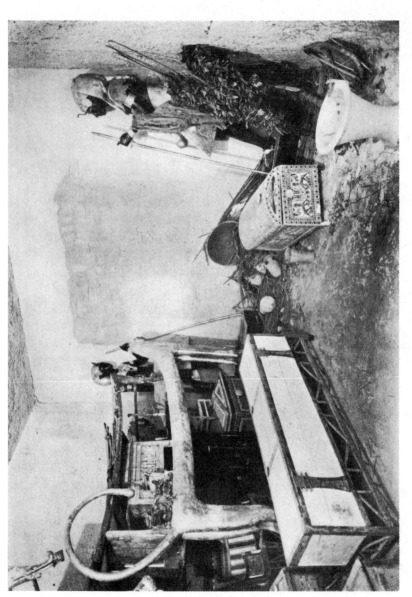

PLATE XVI

CHAPTER VI

A Preliminary Investigation

I SUPPOSE most excavators would confess to a feeling of awe—embarrassment almost—when they break into a chamber closed and sealed by pious hands so many centuries ago. For the moment, time as a factor in human life has lost its meaning. Three thousand, four thousand years maybe, have passed and gone since human feet last trod the floor on which you stand, and yet, as you note the signs of recent life around you—the half-filled bowl of mortar for the door, the blackened lamp, the finger-mark upon the freshly painted surface, the farewell garland dropped upon the threshold— you feel it might have been but yesterday. The very air you breathe, unchanged throughout the centuries, you share with those who laid the mummy to its rest. Time is annihilated by little intimate details such as these, and you feel an intruder.

That is perhaps the first and dominant sensation, but others follow thick and fast—the exhilaration of discovery, the fever of suspense, the almost over-mastering impulse, born of curiosity, to break down seals and lift the lids of boxes, the thought—pure joy to the investigator—that you are about to add a page to history, or solve some problem of research, the strained expectancy—why not confess it?—of the treasure-seeker. Did these thoughts actually pass through our minds at the time, or have I imagined

them since ? I cannot tell. It was the discovery that my memory was blank, and not the mere desire for dramatic chapter-ending, that occasioned this digression.

Surely never before in the whole history of excavation had such an amazing sight been seen as the light of our torch revealed to us. The reader can get some idea of it by reference to the photographs on Plates XVI–XX, but these were taken afterwards when the tomb had been opened and electric light installed. Let him imagine how they appeared to us as we looked down upon them from our spy-hole in the blocked doorway, casting the beam of light from our torch—the first light that had pierced the darkness of the chamber for three thousand years—from one group of objects to another, in a vain attempt to interpret the treasure that lay before us. The effect was bewildering, overwhelming. I suppose we had never formulated exactly in our minds just what we had expected or hoped to see, but certainly we had never dreamed of anything like this, a roomful—a whole museumful it seemed —of objects, some familiar, but some the like of which we had never seen, piled one upon another in seemingly endless profusion.

Gradually the scene grew clearer, and we could pick out individual objects. First, right opposite to us—we had been conscious of them all the while, but refused to believe in them—were three great gilt couches, their sides carved in the form of monstrous animals, curiously attenuated in body, as they had to be to serve their purpose, but with heads of startling realism. Uncanny beasts enough to look upon at any time : seen as we saw them,

their brilliant gilded surfaces picked out of the darkness by our electric torch, as though by limelight, their heads throwing grotesque distorted shadows on the wall behind them, they were almost terrifying. Next, on the right, two statues caught and held our attention; two life-sized figures of a king in black, facing each other like sentinels, gold kilted, gold sandalled, armed with mace and staff, the protective sacred cobra upon their foreheads.

These were the dominant objects that caught the eye at first. Between them, around them, piled on top of them, there were countless others—exquisitely painted and inlaid caskets; alabaster vases, some beautifully carved in openwork designs; strange black shrines, from the open door of one a great gilt snake peeping out; bouquets of flowers or leaves; beds; chairs beautifully carved; a golden inlaid throne; a heap of curious white oviform boxes; staves of all shapes and designs; beneath our eyes, on the very threshold of the chamber, a beautiful lotiform cup of translucent alabaster; on the left a confused pile of overturned chariots, glistening with gold and inlay; and peeping from behind them another portrait of a king.

Such were some of the objects that lay before us. Whether we noted them all at the time I cannot say for certain, as our minds were in much too excited and confused a state to register accurately. Presently it dawned upon our bewildered brains that in all this medley of objects before us there was no coffin or trace of mummy, and the much-debated question of tomb or cache began to intrigue us afresh. With this question in view we re-examined the scene before us, and noticed for the first time that between

the two black sentinel statues on the right there was another sealed doorway. The explanation gradually dawned upon us. We were but on the threshold of our discovery. What we saw was merely an antechamber. Behind the guarded door there were to be other chambers, possibly a succession of them, and in one of them, beyond any shadow of doubt, in all his magnificent panoply of death, we should find the Pharaoh lying.

We had seen enough, and our brains began to reel at the thought of the task in front of us. We re-closed the hole, locked the wooden grille that had been placed upon the first doorway, left our native staff on guard, mounted our donkeys and rode home down The Valley, strangely silent and subdued.

It was curious, as we talked things over in the evening, to find how conflicting our ideas were as to what we had seen. Each of us had noted something that the others had not, and it amazed us next day to discover how many and how obvious were the things that we had missed. Naturally, it was the sealed door between the statues that intrigued us most, and we debated far into the night the possibilities of what might lie behind it. A single chamber with the king's sarcophagus ? That was the least we might expect. But why one chamber only ? Why not a succession of passages and chambers, leading, in true Valley style, to an innermost shrine of all, the burial chamber ? It might be so, and yet in plan the tomb was quite unlike the others. Visions of chamber after chamber, each crowded with objects like the one we had seen, passed through our minds and left us gasping for breath. Then came the thought of the plunderers again. Had they suc-

ceeded in penetrating this third doorway—seen from a distance it looked absolutely untouched—and, if so, what were our chances of finding the king's mummy intact ? I think we slept but little, all of us, that night.

Next morning (November 27th) we were early on the field, for there was much to be done. It was essential, before proceeding further with our examination, that we should have some more adequate means of illumination, so Callender began laying wires to connect us up with the main lighting system of The Valley. While this was in preparation we made careful notes of the seal-impressions upon the inner doorway and then removed its entire blocking. By noon everything was ready and Lord Carnarvon, Lady Evelyn, Callender and I entered the tomb and made a careful inspection of the first chamber (afterwards called the Antechamber). The evening before I had written to Mr. Engelbach, the Chief Inspector of the Antiquities Department, advising him of the progress of clearing, and asking him to come over and make an official inspection. Unfortunately he was at the moment in Kena on official business, so the local Antiquities Inspector, Ibraham Effendi, came in his stead.

By the aid of our powerful electric lamps many things that had been obscure to us on the previous day became clear, and we were able to make a more accurate estimate of the extent of our discovery. Our first objective was naturally the sealed door between the statues, and here a disappointment awaited us. Seen from a distance it presented all the appearance of an absolutely intact blocking, but close examination revealed the fact that a small

breach had been made near the bottom, just wide enough to admit a boy or a slightly built man, and that the hole made had subsequently been filled up and re-sealed. We were not then to be the first. Here, too, the thieves had forestalled us, and it only remained to be seen how much damage they had had the opportunity or the time to effect.

Our natural impulse was to break down the door, and get to the bottom of the matter at once, but to do so would have entailed serious risk of damage to many of the objects in the Antechamber, a risk which we were by no means prepared to face. Nor could we move the objects in question out of the way, for it was imperative that a plan and complete photographic record should be made before anything was touched, and this was a task involving a considerable amount of time, even if we had had sufficient plant available—which we had not—to carry it through immediately. Reluctantly we decided to abandon the opening of this inner sealed door until we had cleared the Antechamber of all its contents. By doing this we should not only ensure the complete scientific record of the outer chamber which it was our duty to make, but should have a clear field for the removal of the door-blocking, a ticklish operation at best.

Having satisfied to some extent our curiosity about the sealed doorway, we could now turn our attention to the rest of the chamber, and make a more detailed examination of the objects which it contained. It was certainly an astounding experience. Here, packed tightly together in this little chamber, were scores of objects, any one of which would have filled us with excitement under ordinary

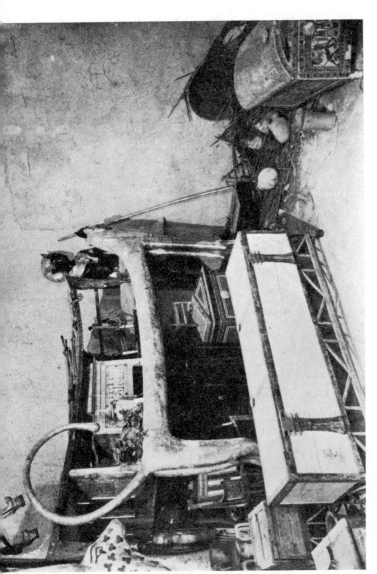

PLATE XVII

INTERIOR OF ANTECHAMBER: THE LION-HEADED COUCH.

PLATE XVIII

circumstances, and been considered ample repayment for a full season's work. Some were of types well enough known to us ; others were new and strange, and in some cases these were complete and perfect examples of objects whose appearance we had heretofore but guessed at from the evidence of tiny broken fragments found in other royal tombs.

Nor was it merely from a point of view of quantity that the find was so amazing. The period to which the tomb belongs is in many respects the most interesting in the whole history of Egyptian art, and we were prepared for beautiful things. What we were not prepared for was the astonishing vitality and animation which characterized certain of the objects. It was a revelation to us of unsuspected possibilities in Egyptian art, and we realized, even in this hasty preliminary survey, that a study of the material would involve a modification, if not a complete revolution, of all our old ideas. That, however, is a matter for the future. We shall get a clearer estimate of exact artistic values when we have cleared the whole tomb and have the complete contents before us.

One of the first things we noted in our survey was that all of the larger objects, and most of the smaller ones, were inscribed with the name of Tut·ankh·Amen. His, too, were the seals upon the innermost door, and therefore his, beyond any shadow of doubt, the mummy that ought to lie behind it. Next, while we were still excitedly calling each other from one object to another, came a new discovery. Peering beneath the southernmost of the three great couches, we noticed a small irregular hole in the wall. Here was yet another sealed doorway, and

a plunderers' hole, which, unlike the others, had never been repaired. Cautiously we crept under the couch, inserted our portable light, and there before us lay another chamber, rather smaller than the first, but even more crowded with objects.

The state of this inner room (afterwards called the Annexe) simply defies description. In the Antechamber there had been some sort of an attempt to tidy up after the plunderers' visit, but here everything was in confusion, just as they had left it. Nor did it take much imagination to picture them at their work. One—there would probably not have been room for more than one—had crept into the chamber, and had then hastily but systematically ransacked its entire contents, emptying boxes, throwing things aside, piling them one upon another, and occasionally passing objects through the hole to his companions for closer examination in the outer chamber. He had done his work just about as thoroughly as an earthquake. Not a single inch of floor space remains vacant, and it will be a matter of considerable difficulty, when the time for clearing comes, to know how to begin. So far we have not made any attempt to enter the chamber, but have contented ourselves with taking stock from outside. Beautiful things it contains, too, smaller than those in the Antechamber for the most part, but many of them of exquisite workmanship. Several things remain in my mind particularly—a painted box, apparently quite as lovely as the one in the Antechamber; a wonderful chair of ivory, gold, wood, and leather-work; alabaster and faience vases of beautiful form; and a gaming board, in carved and coloured ivory.

I think the discovery of this second chamber,

with its crowded contents, had a somewhat sobering effect upon us. Excitement had gripped us hitherto, and given us no pause for thought, but now for the first time we began to realize what a prodigious task we had in front of us, and what a responsibility it entailed. This was no ordinary find, to be disposed of in a normal season's work; nor was there any precedent to show us how to handle it. The thing was outside all experience, bewildering, and for the moment it seemed as though there were more to be done than any human agency could accomplish.

Moreover, the extent of our discovery had taken us by surprise, and we were wholly unprepared to deal with the multitude of objects that lay before us, many in a perishable condition, and needing careful preservative treatment before they could be touched. There were numberless things to be done before we could even begin the work of clearing. Vast stores of preservatives and packing material must be laid in ; expert advice must be taken as to the best method of dealing with certain objects ; provision must be made for a laboratory, some safe and sheltered spot in which the objects could be treated, catalogued and packed ; a careful plan to scale must be made, and a complete photographic record taken, while everything was still in position ; a dark-room must be contrived.

These were but a few of the problems that confronted us. Clearly, the first thing to be done was to render the tomb safe against robbery ; we could then with easy minds work out our plans—plans which we realized by this time would involve, not one season only, but certainly two, and possibly three or four. We had our wooden grille at the

entrance to the passage, but that was not enough, and I measured up the inner doorway for a gate of thick steel bars. Until we could get this made for us—and for this and for other reasons it was imperative for me to visit Cairo—we must go to the labour of filling in the tomb once more.

Meanwhile the news of the discovery had spread like wildfire, and all sorts of extraordinary and fanciful reports were going abroad concerning it; one story, that found considerable credence among the natives, being to the effect that three aeroplanes had landed in The Valley, and gone off to some destination unknown with loads of treasure. To overtake these rumours as far as possible, we decided on two things—first, to invite Lord Allenby and the various heads of the departments concerned to come and pay a visit to the tomb, and secondly, to send an authoritative account of the discovery to *The Times*. On the 29th, accordingly, we had an official opening of the tomb, at which were present Lady Allenby—Lord Allenby was unfortunately unable to leave Cairo—Abd el Aziz Bey Yehia, the Governor of the Province, Mohamed Bey Fahmy, Mamour of the District, and a number of other Egyptian notables and officials; and on the 30th Mr. Tottenham, Adviser to the Ministry of Public Works, and M. Pierre Lacau, Director-General of the Service of Antiquities, who had been unable to be present on the previous day, made their official inspection. Mr. Merton, *The Times* correspondent, was also present at the official opening, and sent the dispatch which created so much excitement at home.

On December 3rd, after closing up the entrance doorway with heavy timber, the tomb was filled to

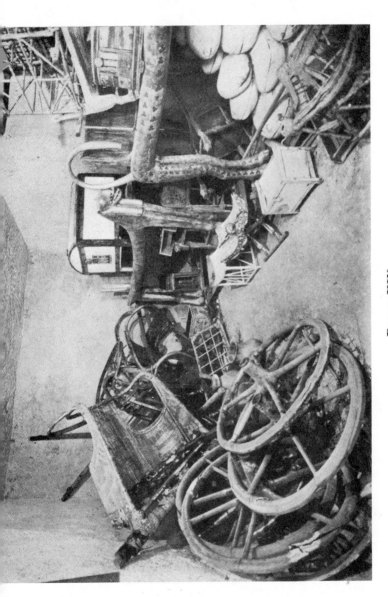

PLATE XIX

INTERIOR OF ANTECHAMBER: SOUTHERN END, SHOWING THE THOUERIS COUCH
AND CHARIOTS.

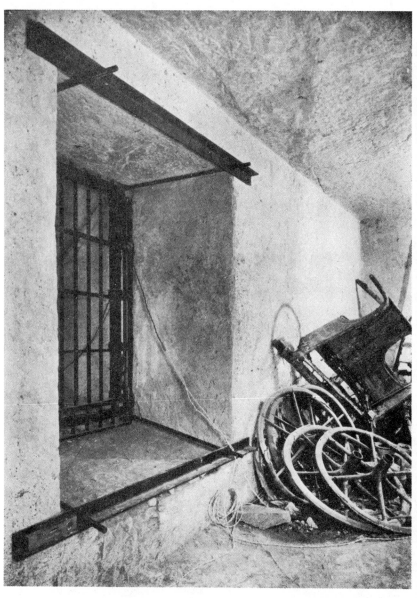

PLATE XX

INTERIOR OF ANTECHAMBER: THE ENTRANCE WITH STEEL GATE.

surface level. Lord Carnarvon and Lady Evelyn left on the 4th, on their way to England, to conclude various arrangements there, preparatory to returning later in the season ; and on the 6th, leaving Callender to watch over the tomb in my absence, I followed them to Cairo to make my purchases. My first care was the steel gate, and I ordered it the morning I arrived, under promise that it should be delivered within six days. The other purchases I took more leisurely, and a miscellaneous collection they were, including photographic material, chemicals, a motor-car, packing-boxes of every kind, with thirty-two bales of calico, more than a mile of wadding, and as much again of surgical bandages. Of these last two important items I was determined not to run short.

While in Cairo I had time to take stock of the position, and it became more and more clear to me that assistance—and that on a big scale—was necessary if the work in the tomb was to be carried out in a satisfactory manner. The question was, where to turn for this assistance. The first and pressing need was in photography, for nothing could be touched until a complete photographic record had been made, a task involving technical skill of the highest order. A day or two after I arrived in Cairo I received a cable of congratulation from Mr. Lythgoe, Curator of the Egyptian Department of the Metropolitan Museum of Art, New York, whose concession at Thebes ran in close proximity to our own, being only divided by the natural mountain wall, and in my reply I somewhat diffidently inquired whether it would be possible—for the immediate emergency, at any rate—to secure the assist-

ance of Mr. Harry Burton, their photographic expert. He promptly cabled back, and his cable ought to go on record as an example of disinterested scientific co-operation: "Only too delighted to assist in any possible way. Please call on Burton and any other members of our staff."

This offer was subsequently most generously confirmed by the Trustees and the Director of the Metropolitan Museum, and on my return to Luxor I arranged with my friend Mr. Winlock, the director of the New York excavations on that concession, and who was to be the actual sufferer under the arrangement, not only that Mr. Burton should be transferred, but that Mr. Hall and Mr. Hauser, draughtsmen to the expedition, should devote such of their time as might be necessary to make a large-scale drawing of the Antechamber and its contents. Another member of the New York staff, Mr. Mace, director of their excavations on the pyramid field at Lisht, was also available, and at Mr. Lythgoe's suggestion cabled offering help. Thus no fewer than four members of the New York staff were for whole or part time associated in the work of the season. Without this generous help it would have been impossible to tackle the enormous amount of work in front of us.

Another piece of luck befell me in Cairo. Mr. Lucas, Director of the Chemical Department of the Egyptian Government, was taking three months' leave prior to retiring from the Government on completion of service, and for this three months he generously offered to place his chemical knowledge at our disposal, an offer which, needless to say, I hastened to accept. That completed our regular

working staff. In addition, Dr. Alan Gardiner kindly undertook to deal with any inscriptional material that might be found, and Professor Breasted, in a couple of visits, gave us much assistance in the difficult task of deciphering the historical significance of the seal impressions from the doors.

By December 13th the steel gate was finished and I had completed my purchases. I returned to Luxor, and on the 15th everything arrived safely in The Valley, delivery of the packages having been greatly expedited by the courtesy of the Egyptian State Railway officials, who permitted them to travel by express instead of on the slow freight train. On the 16th we opened up the tomb once more, and on the 17th the steel gate was set up in the door of the chamber and we were ready to begin work. On the 18th work was actually begun, Burton making his first experiments in the Antechamber, and Hall and Hauser making a start on their plan. Two days later Lucas arrived, and at once began experimenting on preservatives for the various classes of objects.

On the 22nd, as the result of a good deal of clamour, permission to see the tomb was given to the Press, both European and native, and the opportunity was also afforded to a certain number of the native notables of Luxor, who had been disappointed at not receiving an invitation to the official opening. It had only been possible on that occasion to invite a very limited number, owing to a difficulty of ensuring the safety of the objects in the very narrow space that was available. On the 25th Mace arrived, and two days later, photographs and plans being sufficiently advanced, the first object was removed from the tomb.

CHAPTER VII

A Survey of the Antechamber

IN this chapter we propose to make a detailed survey of the objects in the Antechamber, and it will give the reader a better idea of things if we make it systematically, and do not range backwards and forwards from one end of it to the other, as in the first excitement of discovery we naturally did. It was but a small room, some 26 feet by 12 feet, and we had to tread warily, for, though the officials had cleared for us a small alley-way in the centre, a single false step or hasty movement would have inflicted irreparable damage on one of the delicate objects with which we were surrounded.

In front of us, in the doorway—we had to step over it to get into the chamber—lay the beautiful wishing-cup shown on Plate XLVI. It was of pure semi-translucent alabaster, with lotus-flower handles on either side, supporting the kneeling figures which symbolize Eternity. Turning right as we entered, we noticed, first, a large cylindrical jar of alabaster; next, two funerary bouquets of leaves, one leaning against the wall, the other fallen; and in front of them, standing out into the chamber, a painted wooden casket (*see* Plate XXI). This last will probably rank as one of the greatest artistic treasures of the tomb, and on our first visit we found it hard to tear ourselves away from it. Its outer face was completely covered with gesso; upon this prepared surface there

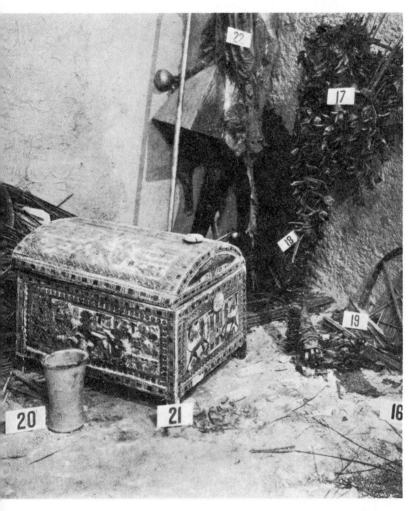

PLATE XXI

PAINTED CASKET (No. 21) *IN SITU.*

were a series of brilliantly coloured and exquisitely painted designs—hunting scenes upon the curved panels of the lid, battle scenes upon the sides, and upon the ends representations of the king in lion form, trampling his enemies under his feet. The illustrations on Plates L–LIV give but a faint idea of the delicacy of the painting, which far surpasses anything of the kind that Egypt has yet produced. No photograph could do it justice, for even in the original a magnifying glass is essential to a due appreciation of the smaller details, such as the stippling of the lions' coats, or the decoration of the horses' trappings.

There is another remarkable thing about the painted scenes upon this box. The motives are Egyptian and the treatment Egyptian, and yet they leave an impression on your mind of something strangely non-Egyptian, and you cannot for the life of you explain exactly where the difference lies. They remind you of other things, too—the finest Persian miniatures, for instance—and there is a curious floating impression of Benozzo Gozzoli, due, maybe, to the gay little tufts of flowers which fill the vacant spaces. The contents of the box were a queer jumble. At the top there were a pair of rush and papyrus sandals, and a royal robe, completely covered with a decoration of beadwork and gold sequins. Beneath them were other decorated robes, one of which had had attached to it upwards of three thousand gold rosettes, three pairs of Court sandals elaborately worked in gold, a gilt head-rest, and other miscellaneous objects. This was the first box we opened, and the ill-assorted nature of its contents—to say nothing of the manner in which

they were crushed and bundled together—was a considerable puzzle to us. The reason of it became plain enough later, as we shall show in the following chapter.

Next, omitting some small unimportant objects, we came to the end (north) wall of the chamber. Here was the tantalizing sealed doorway, and on either side of it, mounting guard over the entrance, stood the life-size wooden statues of the king already described. Strange and imposing figures these, even as we first saw them, surrounded and half concealed by other objects : as they stand now in the empty chamber, with nothing in front of them to distract the eye, and beyond them, through the opened door, the golden shrine half visible, they present an appearance that is almost painfully impressive. Originally they were shrouded in shawls of linen, and this, too, must have added to the effect. One other point about this end wall, and an interesting one. Unlike the other walls of the chamber, its whole surface was covered with plaster, and a close examination revealed the fact that from top to bottom it was but a blind, a mere partition wall.

Turning now to the long (west) wall of the chamber, we found the whole of the wall-space occupied by the three great animal-sided couches, curious pieces of furniture which we knew from illustrations in the tomb paintings, but of which we had never seen actual examples before. The first was lion-headed, the second cow-headed, and the third had the head of a composite animal, half hippopotamus and half crocodile. Each was made in four pieces for convenience in carrying, the frame of the actual bed fitting by means of hook and staple to the

animal sides, the feet of the animals themselves fitting into an open pedestal. As is usually the case in Egyptian beds, each had a foot panel but nothing at the head. Above, below, and around these couches, packed tightly together, and in some cases perched precariously one upon another, was a miscellany of smaller objects, of which we shall only have space here to mention the more important.

Thus, resting on the northernmost of the couches—the lion-headed one—there was a bed of ebony and woven cord, with a panel of household gods delightfully carved, and, resting upon this again, there were a collection of elaborately decorated staves, a quiverful of arrows, and a number of compound bows. One of these last was cased with gold and decorated with bands of inscription and animal motives in granulated work of almost inconceivable fineness—a masterpiece of jewellers' craft. Another, a double compound bow, terminated at either end in the carved figure of a captive, so arranged that their necks served as notches for the string, the pleasing idea being that every time the king used the bow he bow-strung a brace of captives. Between bed and couch there were four torch-holders of bronze and gold, absolutely new in type, one with its torch of twisted linen still in position in the oil-cup; a charmingly wrought alabaster libation vase; and, its lid resting askew, a casket, with decorative panels of brilliant turquoise-blue faience and gold. This casket, as we found later in the laboratory, contained a number of interesting and valuable objects, among others a leopard-skin priestly robe, with decoration of gold and silver stars and gilt leopard-head, inlaid with coloured glass; a very

large and beautifully worked scarab of gold and lapis lazuli blue glass ; a buckle of sheet gold, with a decoration of hunting scenes applied in infinitesimally small granules ; a sceptre in solid gold and lapis lazuli glass (Plate XXIII) ; beautifully coloured collarettes and necklaces of faience ; and a handful of massive gold rings, twisted up in a fold of linen— of which more anon.

Beneath the couch, resting on the floor, stood a large chest, made of a delightful combination of ebony, ivory, and red wood, which contained a number of small vases of alabaster and glass ; two black wooden shrines, each containing the gilt figure of a snake, emblem and standard of the tenth nome of Upper Egypt (Aphroditopolis) ; a delightful little chair, with decorative panels of ebony, ivory, and gold, too small for other than a child's use ; two folding duck-stools, inlaid with ivory ; and an alabaster box, with incised ornamentation filled in with pigments.

A long box of ebony and white painted wood, with trellis-worked stand and hinged lid, stood free upon the floor in front of the couch. Its contents were a curious mixture. At the top, crumpled together and stuffed in as packing, there were shirts and a number of the king's under-garments, whereas below, more or less orderly arranged upon the bottom of the box, there were sticks, bows, and a large number of arrows, the points of these last having all been broken off and stolen for their metal. As originally deposited, the box probably contained nothing but sticks, bows and arrows, and included not only those from the top of the bed already described, but a number of others which had been

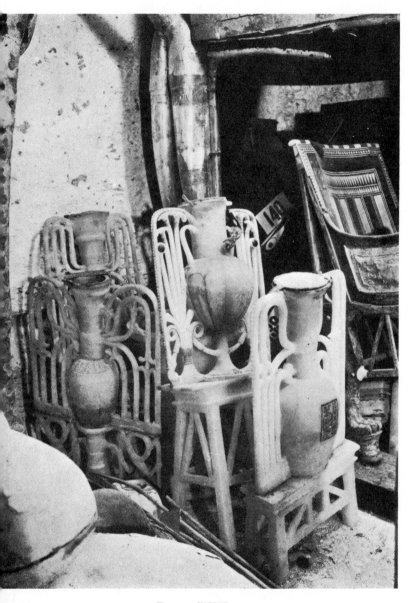

PLATE XXII

CLUSTER OF ALABASTER VASES.

scattered in various quarters of the chamber. Some of the sticks were of very remarkable workmanship. One terminated in a curve, on which were fashioned the figures of a pair of captives, with tied arms and interlocked feet, the one an African, the other an Asiatic, their faces carved in ebony and ivory respectively. The latter figure, an almost painfully realistic piece of work, is shown on Plate LXX. On another of the sticks a very effective decoration was contrived by arranging minute scales of iridescent beetle-wings in a pattern, while in others again there was an applied pattern of variegated barks. With the sticks there were a whip in ivory and four cubit measures. To the left of the couch, between it and the next one, there were a toilet table and a cluster of wonderful perfume jars in carved alabaster (*see* Plate XXII).

So much for the first couch. The second, the cow-headed one, facing us as we entered the chamber, was even more crowded. Resting precariously on top of it there was another bed of wood, painted white, and, balanced on top of this again, a rush-work chair, extraordinarily modern-looking in appearance and design, and an ebony and red-wood stool. Below the bed and resting actually on the framework of the couch, there were, among other things, an ornamental white stool, a curious rounded box of ivory and ebony veneer, and a pair of gilt *sistra* —instruments of music that are usually associated with Hathor, the goddess of joy and dancing [1] (Plate XXIII). Below, the centre space was occupied by a pile of oviform wooden cases, containing trussed ducks and a variety of other food offerings.

[1] These are two of the attributes of Hathor. There are many others.

Standing on the floor in front of the couch there were two wooden boxes, one having a collarette and a pad of rings resting loose upon its lid ; a large stool of rush-work, and a smaller one of wood and reed. The larger of the two boxes had an interesting and varied list of contents. A docket, written in hieratic on the lid, quotes seventeen objects of lapis lazuli blue, and within there were sixteen libation vases of blue faience, the seventeenth being found subsequently in another part of the chamber. In addition, thrown carelessly in, there were a number of other faience cups; a pair of electrum boomerangs, mounted at either end with blue faience ; a beautiful little casket of carved ivory; a calcite wine-strainer; a very elaborate tapestry-woven garment; and the greater part of a corslet. This last —which we shall have occasion to describe at some length in Chapter X—was composed of several thousand pieces of gold, glass, and faience, and there is no doubt that when it has been cleaned and its various parts assembled it will be the most imposing thing of its kind that Egypt has ever produced. Between this couch and the third one, tilted carelessly over on to its side, lay a magnificent cedarwood chair, elaborately and delicately carved, and embellished with gold (see Plate LX).

We come now to the third couch, flanked by its pair of queer composite animals, with open mouths, and teeth and tongue of ivory. Resting on top of it in solitary state there was a large round-topped chest, with ebony frame and panels painted white. This was originally the chest of under-linen. It still contained a number of garments—loin-cloths, etc.— most of them folded and rolled into neat little

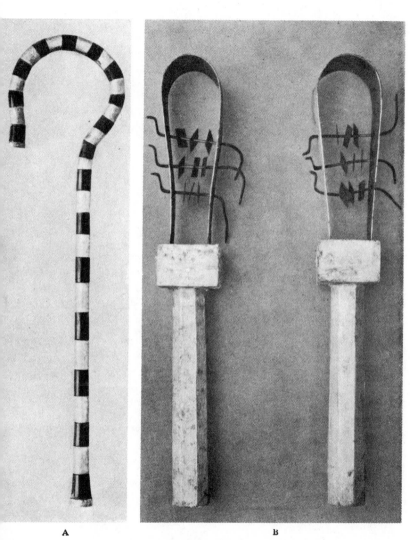

A B

PLATE XXIII

(A) THE KING'S SCEPTRE OF GOLD AND LAPIS LAZULI BLUE
GLASS. (B) TWO SISTRA OF GILT WOOD AND BRONZE.

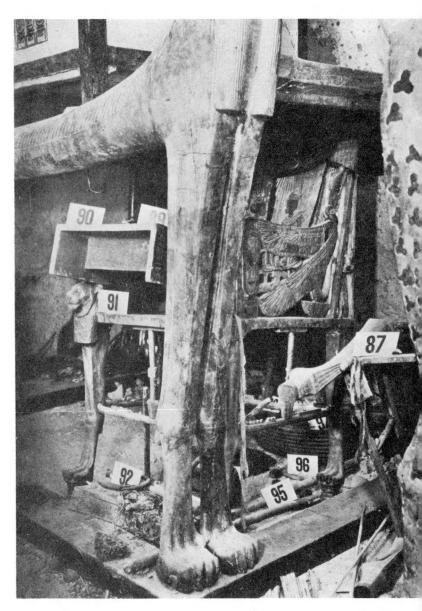

PLATE XXIV

THRONE AND FOOTSTOOL BENEATH THE THOUERIS COUCH.

bundles.[1] Below this couch stood another of the great artistic treasures of the tomb—perhaps the greatest so far taken out—a throne, overlaid with gold from top to bottom, and richly adorned with glass, faience, and stone inlay (*see* Plate XXIV). Its legs, fashioned in feline form, were surmounted by lions' heads, fascinating in their strength and simplicity. Magnificent crowned and winged serpents formed the arms, and between the bars which supported the back there were six protective cobras, carved in wood, gilt and inlaid. It was the panel of the back, however, that was the chief glory of the throne, and I have no hesitation in claiming for it that it is the most beautiful thing that has yet been found in Egypt. A photograph, which without colour gives but a very inadequate idea of its beauty, is shown on Plate II.

The scene is one of the halls of the palace, a room decorated with flower-garlanded pillars, frieze of *uræi* (royal cobras), and dado of conventional " recessed " panelling. Through a hole in the roof the sun shoots down his life-giving protective rays. The king himself sits in an unconventional attitude upon a cushioned throne, his arm thrown carelessly across its back. Before him stands the girlish figure of the queen, putting, apparently, the last touches to his toilet : in one hand she holds a small jar of scent or ointment, and with the other she gently anoints his shoulder or adds a touch of perfume to his collar. A simple homely little composition, but how instinct with life and feeling it is, and with what a sense of movement !

[1] These, on our first entrance into the tomb, were mistaken for rolls of papyrus.

The colouring of the panel is extraordinarily vivid and effective. The face and other exposed portions of the bodies, both of king and queen, are of red glass, and the head-dresses of brilliant turquoise-like faience. The robes are of silver, dulled by age to an exquisite bloom. The crowns, collars, scarves, and other ornamental details of the panel are all inlaid, inlay of coloured glass and faience, of carnelian, and of a composition hitherto unknown—translucent fibrous calcite, underlaid with coloured paste, in appearance for all the world like *millefiori* glass. As background we have the sheet gold with which the throne was covered. In its original state, with gold and silver fresh and new, the throne must have been an absolutely dazzling sight—too dazzling, probably, for the eye of a Westerner, accustomed to drab skies and neutral tints : now, toned down a little by the tarnishing of the alloy, it presents a colour scheme that is extraordinarily attractive and harmonious.

Apart altogether from its artistic merit, the throne is an important historical document, the scenes upon it being actual illustrations of the politico-religious vacillations of the reign. In original conception—witness the human arms on the sun-disk in the back panel—they are based on pure Tell el Amarna Aten worship. The cartouches, however, are curiously mixed. In some of them the Aten element has been erased and the Amen form substituted, whereas in others the Aten remains unchallenged. It is curious, to say the least of it, that an object which bore such manifest signs of heresy upon it should be publicly buried in this, the stronghold of the Amen faith, and it is perhaps not without significance that on

this particular part of the throne there were remains of a linen wrapping. It would appear that Tut·ankh·Amen's return to the ancient faith was not entirely a matter of conviction. He may have thought the throne too valuable a possession to destroy, and have kept it in one of the more private apartments of the palace; or, again, it is possible that the alteration in the Aten names was sufficient to appease the sectarians, and that there was no need for secrecy.

Upon the seat of the throne rested the footstool that originally stood before it, a stool of gilded wood and dark blue faience, with panels on the top and sides on which were represented captives, bound and prone. This was a very common convention in the East—" until I make thine enemies thy footstool," sings the Psalmist—and we may be sure that on certain occasions convention became actual fact.

Before the couch there were two stools, one of plain wood painted white, the other of ebony, ivory, and gold, its legs carved in the shape of ducks' heads, its top made in the semblance of leopard skin, with claws and spots of ivory—the finest example we know of its kind. Behind it, resting against the south wall of the chamber, there were a number of important objects. First came a shrine-shaped box with double doors, fastened by shooting bolts of ebony. This was entirely cased with thick sheet-gold, and on the gold, in delicate low relief, there were a series of little panels (shown on Plate LXVIII), depicting, in delightfully naïve fashion, a number of episodes in the daily life of king and queen. In all of these scenes the dominant note is that of friendly relationship between the husband and the

wife, the unselfconscious friendliness that marks the Tell el Amarna school, and one would not be surprised to find that here, too, there had been a change in the cartouches from the Aten to the Amen. Within the shrine there was a pedestal, showing that it had originally contained a statuette : it may well have been a gold one, an object, unfortunately, too conspicuous for the plunderers to overlook. It also contained a necklace of enormous beads, gold, carnelian, green feldspar and blue glass, to which was attached a large gold pendant in the shape of a very rare snake goddess ; and considerable portions of the corslet already referred to in our description of one of the earlier boxes.

Beside this shrine there was a large *shawabti* statuette of the king, carved, gilded, and painted, and a little farther along, peering out from behind the overturned body of a chariot, a statue of peculiar form, cut sharp off at waist and elbows. This was exactly life-size, and its body was painted white in evident imitation of a shirt ; there can be very little doubt that it represents a mannequin, to which the king's robes, and possibly his collars, could be fitted (Plate XXV). There were also in this same quarter of the chamber another toilet box and the scattered pieces of a gilt canopy or shrine. These last were of extremely light construction, and were made to fit rapidly one to another. The canopy was probably a travelling one, carried in the king's train wherever he went, and set up at a moment's notice to shield him from the sun.

The rest of the south wall and the whole of the east, as far as the entrance doorway, were taken up by the parts of no fewer than four chariots. As

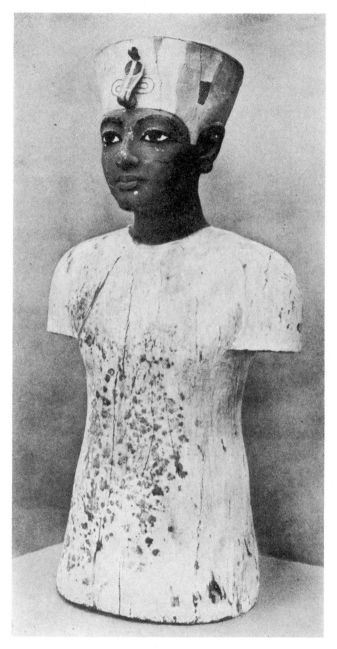

PLATE XXV

THE KING'S MANNEQUIN

This figure is of carved wood, covered with gesso and painted. It
was probably used either for the king's jewellery or robes.

the photograph shows, they were heaped together in terrible confusion, the plunderers having evidently turned them this way and that, in their endeavours to secure the more valuable portions of the gold decoration which covered them. Theirs not the whole responsibility, however. The entrance passage was far too narrow to admit the ingress of complete chariots, so, to enable them to get into the chamber, the axles were deliberately sawn in two, the wheels dismounted and piled together, and the dismembered bodies placed by themselves.

In the re-assembling and restoration of these chariots we have a prodigious task ahead of us, but the results will be gorgeous enough to justify any amount of time that is bestowed upon them. From top to bottom they are covered with gold, every inch of which is decorated, either with embossed patterns and scenes upon the gold itself, or with inlaid designs in coloured glass and stone. The actual woodwork of the chariots is in good condition and needs but little treatment, but with the horse-trappings and other leather parts it is quite another story, the untanned leather having been affected by the damp and turned into a black, unpleasant-looking glue. Fortunately these leather parts were, in almost every instance, plated with gold, and from this gold, which is well preserved, we hope to be able to make a reconstruction of the harness. Mixed with the chariot parts there were a number of miscellaneous smaller objects, including alabaster jars, more sticks and bows, bead sandals, baskets, and a set of four horsehair fly-whisks, with lion-head handles of gilded wood.

We have now made a complete tour of the Ante-

chamber—a fairly comprehensive one, it seemed—
and yet we find, by reference to our notes, that out
of some six or seven hundred objects which it con-
tained we have mentioned a scant hundred. Nothing
but a complete catalogue, transcribed from our
register cards, would give an adequate idea of the
extent of the discovery, and in the present volume
that is naturally out of the question. We must con-
fine ourselves here to a more or less summary descrip-
tion of the principal finds, and reserve a detailed study
of the objects for later publications. It would be
impossible, in any case, to attempt such an account
at the present moment, for there are months, possibly
years, of reconstructive work ahead of us, if the
material is to be treated as it deserves. We must
remember, too, that we have dealt so far with but
a single chamber. There are inner chambers still
untouched, and we hope to find among their contents
treasures far surpassing those with which the present
volume is concerned.

CHAPTER VIII

CLEARING THE ANTECHAMBER

CLEARING the objects from the Antechamber was like playing a gigantic game of spillikins. So crowded were they that it was a matter of extreme difficulty to move one without running serious risk of damaging others, and in some cases they were so inextricably tangled that an elaborate system of props and supports had to be devised to hold one object or group of objects in place while another was being removed (*see* Plate XXVI). At such times life was a nightmare. One was afraid to move lest one should kick against a prop and bring the whole thing crashing down. Nor, in many cases, could one tell without experiment whether a particular object was strong enough to bear its own weight. Certain of the things were in beautiful condition, as strong as when they first were made, but others were in a most precarious state, and the problem constantly arose whether it would be better to apply preservative treatment to an object *in situ*, or to wait until it could be dealt with in more convenient surroundings in the laboratory. The latter course was adopted whenever possible, but there were cases in which the removal of an object without treatment would have meant almost certain destruction.

There were sandals, for instance, of patterned bead-work, of which the threading had entirely rotted away. As they lay on the floor of the chamber they

looked in perfectly sound condition, but, try to pick one up, and it crumbled at the touch, and all you had for your pains was a handful of loose, meaningless beads. This was a clear case for treatment on the spot—a spirit stove, some paraffin wax, an hour or two to harden, and the sandal could be removed intact, and handled with the utmost freedom. The funerary bouquets again (*see* Plate XXVII): without treatment as they stood they would have ceased to exist ; subjected to three or four sprayings of celluloid solution they bore removal well, and were subsequently packed with scarcely any injury. Occasionally, particularly with the larger objects, it was found better to apply local treatment in the tomb, just sufficient to ensure a safe removal to the laboratory, where more drastic measures were possible. Each object presented a separate problem, and, as I said before, there were cases in which only experiment could show what the proper treatment was to be.

It was slow work, painfully slow, and nerve-racking at that, for one felt all the time a heavy weight of responsibility. Every excavator must, if he have any archæological conscience at all. The things he finds are not his own property, to treat as he pleases, or neglect as he chooses. They are a direct legacy from the past to the present age, he but the privileged intermediary through whose hands they come ; and if, by carelessness, slackness, or ignorance, he lessens the sum of knowledge that might have been obtained from them, he knows himself to be guilty of an archæological crime of the first magnitude. Destruction of evidence is so painfully easy, and yet so hopelessly irreparable. Tired or pressed for time, you shirk a tedious piece of

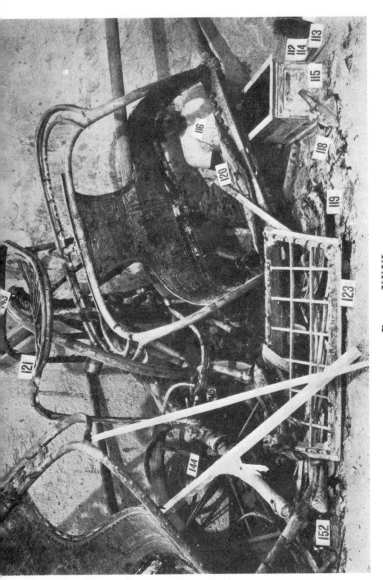

Plate XXVI

VIEW OF CHARIOTS, ILLUSTRATING THE PROCESS OF CLEARING.

cleaning, or do it in a half-hearted, perfunctory sort of way, and you will perhaps have thrown away the one chance that will ever occur of gaining some important piece of knowledge.

Too many people—unfortunately there are so-called archæologists among them—are apparently under the impression that the object bought from a dealer's shop is just as valuable as one which has been found in actual excavation, and that until the object in question has been cleaned, entered in the books, marked with an accession number, and placed in a tidy museum case, it is not a proper subject for study at all. There was never a greater mistake. Field-work is all-important, and it is a sure and certain fact that if every excavation had been properly, systematically, and conscientiously carried out, our knowledge of Egyptian archæology would be at least 50 per cent. greater than it is. There are numberless derelict objects in the storerooms of our museums which would give us valuable information could they but tell us whence they came, and box after box full of fragments which a few notes at the time of finding would have rendered capable of reconstruction.

Granting, then, that a heavy weight of responsibility must at all times rest upon the excavator, our own feelings on this occasion will easily be realized. It had been our privilege to find the most important collection of Egyptian antiquities that had ever seen the light, and it was for us to show that we were worthy of the trust. So many things there were that might go wrong. Danger of theft, for instance, was an ever-present anxiety. The whole countryside was agog with excitement about the tomb; all sorts of

extravagant tales were current about the gold and jewels it contained; and, as past experience had shown, it was only too possible that there might be a serious attempt to raid the tomb by night. This possibility of robbery on a large scale was negatived, so far as was humanly possible, by a complicated system of guarding, there being present in The Valley, day and night, three independent groups of watchmen, each answerable to a different authority —the Government Antiquities Guards, a squad of soldiers supplied by the Mudir of Kena, and a selected group of the most trustworthy of our own staff. In addition, we had a heavy wooden grille at the entrance to the passage, and a massive steel gate at the inner doorway, each secured by four padlocked chains; and, that there might never be any mistake about these latter, the keys were in the permanent charge of one particular member of the European staff, who never parted with them for a moment, even to lend them to a colleague. Petty or casual theft we guarded against by doing all the handling of the objects ourselves.

Another and perhaps an even greater cause for anxiety was the condition of many of the objects. It was manifest with some of them that their very existence depended on careful manipulation and correct preservative treatment, and there were moments when our hearts were in our mouths. There were other worries, too—visitors, for instance, but I shall have quite a little to say about them later—and I fear that by the time the Antechamber was finished our nerves, to say nothing of our tempers, were in an extremely ragged state. But here am I talking about finishing before we have even begun.

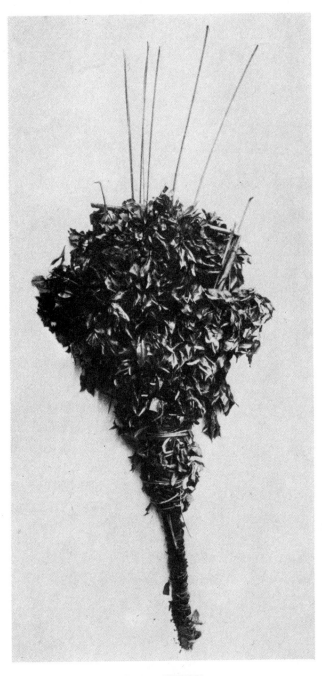

PLATE XXVII

FUNERARY BOUQUET.

We must make a fresh start. It is not time to lose our tempers yet.

Obviously, our first and greatest need was photography. Before anything else was done, or anything moved, we must have a series of preliminary views, taken in panorama, to show the general appearance of the chamber. For lighting we had available two movable electric standards, giving 3,000 candle-power, and it was with these that all the photographic work in the tomb was done. Exposures were naturally rather slow, but the light was beautifully even, much more so than would have been afforded by flashlight—a dangerous process in such a crowded chamber—or reflected sunlight, which were the two possible alternatives. Fortunately for us, there was an uninscribed and empty tomb close by—the Davis cache tomb of Akh·en·Aten. This we got permission from the Government to use as a dark room, and here Burton established himself. It was not too convenient in some ways, but it was worth while putting up with a little inconvenience to have a dark room so close, for in the case of experimental exposures he could slip across and develop without moving his camera out of position. Moreover, these periodic dashes of his from tomb to tomb must have been a godsend to the crowd of curious visitors who kept vigil above the tomb, for there were many days during the winter in which it was the only excitement they had.

Our next step, after these preliminary photographs had been taken, was to devise an efficient method of registering the contents of the chamber, for it would be absolutely essential, later on, that we should have a ready means of ascertaining the

exact part of the tomb from which any particular object might have come. Naturally, each object, or closely allied group of objects, would be given its own catalogue number, and would have that number securely attached to it when it was moved away from the chamber, but that was not enough, for the number might not indicate position. So far as possible, the numbers were to follow a definite order, beginning at the entrance doorway and working systematically round the chamber, but it was very certain that many objects now hidden would be found in the course of clearing, and have to be numbered out of turn. We got over the difficulty by placing printed numbers on every object and photographing them in small groups. Every number showed in at least one of the photographs, so that, by duplicating prints, we were able to place with the notes of every single object in our filing cabinets a print which showed at a glance its actual position in the tomb.

So far, so good, as far as the internal work in the tomb was concerned. Outside it, we had a still more difficult problem to solve, that of finding adequate working and storage space for the objects as they were removed. Three things were absolutely essential. In the first place we must have plenty of room. There would be boxes to unpack, notes and measurements to be taken, repairs to be carried out, experiments with various preservative materials to be made, and obviously we should require considerable table accommodation as well as ordinary storage space. Then, secondly, we must have a place that we could render thief-proof, for, as things were moved, the laboratory would come to be almost as great a source of danger as the tomb itself. Lastly, we must have

seclusion. This may seem a less obvious need than the others, but we foresaw, and the winter's happenings proved us to be right, that unless we were out of sight of visitors' ordinary haunts we should be treated as a side-show, and should be unable to get any work done at all. Eventually we solved the problem by getting permission from the Government to take over the tomb of Seti II (No. 15 in The Valley catalogue). This certainly fulfilled the third of our requirements. It is not a tomb ordinarily visited by tourists, and its position, tucked away in a corner at the extreme end of The Valley, was exactly suitable to our purpose. No other tomb lay beyond it, so, without causing inconvenience to anyone, we could close to ordinary traffic the path that led to it, and thus secure complete privacy for ourselves.

It had other advantages, too. For one thing, it was so well sheltered by overhanging cliffs that at no time of day did the sun ever penetrate its doors, thus remaining comparatively cool even in the hottest of summer weather. There was also a considerable amount of open space in front of it, and this we utilized later as an open-air photographic studio and a carpenter's shop. We were somewhat restricted as to space, for the tomb was so long and narrow that all our work had to be done at the upper end of it, the lower part being useless except for storage purposes. It had also the disadvantage of being rather a long way from the scene of operations. These, however, were but minor drawbacks compared with the positive advantages which the tomb offered. We had a reasonable amount of room, we had privacy, and safety we ensured by putting up a many-padlocked steel gate, one and a half tons in weight.

One other point with regard to the laboratory work the reader should bear in mind. We were five hundred miles from anywhere, and, if we ran short of preservative materials, there might be considerable delay before we could secure a fresh supply. The Cairo shops furnished most of our needs, but there were certain chemicals of which we exhausted the entire Cairo stock before the winter was over, and other things which, in the first instance, could only be procured in England. Constant care and forethought were therefore necessary to prevent shortage and the consequent holding up of the work.

By December 27th all our preparations were made, and we were ready to make a start on the actual removal of the objects. We worked on a regular system of division of labour. Burton came first with his photographs of the numbered groups of objects; Hall and Hauser followed with their scale plan of the chamber, every object being drawn on the plan in projection; Callender and I did the preliminary noting and clearing, and superintended the removal of the objects to the laboratory; and there Mace and Lucas received them, and were responsible for the detail-noting, mending, and preservation.

The first object to be removed was the painted wooden casket. Then, working from north to south, and thus putting off the evil day when we should have to tackle the complicated tangle of chariots, we gradually disencumbered the great animal couches of the objects which surrounded them. Each object as it was removed was placed upon a padded wooden stretcher and securely fastened to it with bandages. Enormous numbers of these stretchers were required, for, to avoid double handling, they were in almost

every case left permanently with the object, and not re-used. From time to time, when a sufficient number of stretchers had been filled—about once a day, on an average—a convoy was made up and dispatched under guard to the laboratory. This was the moment for which the crowd of watchers above the tomb were waiting. Out came the reporters' note-books, *click, click, click* went the cameras in every direction, and a lane had to be cleared for the procession to pass through. I suppose more films were wasted in The Valley last winter than in any other corresponding period of time since cameras were first invented. We in the laboratory had occasion once for a piece of old mummy cloth for experimental purposes ; it was sent up to us in a stretcher, and it was photographed eight times before it got to us !

The removal and transport of the smaller objects was a comparatively simple matter, but it was quite otherwise when it came to the animal couches and the chariots. Each of the former was constructed in four pieces—the two animal sides, the bed proper, and the base to which the animals' feet were socketed. They were manifestly much too large to negotiate the narrow entrance passage, and must have been brought into the tomb in sections and assembled there. Indeed, strips of newer gold round the joints show where the damage they had incurred in handling had been made good after deposition. It was obvious that to get the couches out of the tomb we must take them apart again ; no easy matter, for after three thousand years the bronze hooks had naturally set tight in the staples, and would not budge. We got them apart eventually, and with

scarcely any damage, but it took no fewer than five of us to do it. Two supported the central part of the couch, two were responsible for the well-being of the animals, while the fifth, working from underneath, eased up the hooks, one after the other, with a lever.

Even when taken apart there was none too much room to get the side animals through the passage, and they needed very careful handling. However, we got them all out without accident, and packed them straight into boxes we had in readiness for them just outside the entrance to the tomb.

Most difficult of all to move were the chariots, which had suffered considerably from the treatment to which they had been subjected. It had not been possible to get them into the tomb whole in the first instance, for they were too wide for the entrance passage, and the wheels had had to be removed and the axles sawn off at one end. They had evidently been moved out of position and turned upside down by the plunderers, and in the subsequent tidying up the parts had been loosely stacked one upon another. Egyptian chariots are of very light construction, and the rough usage which they had undergone made these extremely difficult to handle. There was another complication, in that the parts of the harness were made of undressed leather. Now this, if exposed to humidity, speedily resolves itself into glue, and that was what had happened here—the black glutinous mass which represented the trappings having run down over everything and dropped, not only on the other parts of the chariots themselves, but upon other objects which had nothing to do with them. Thus the leather has almost entirely perished, but, fortunately, as I have already stated, we have for

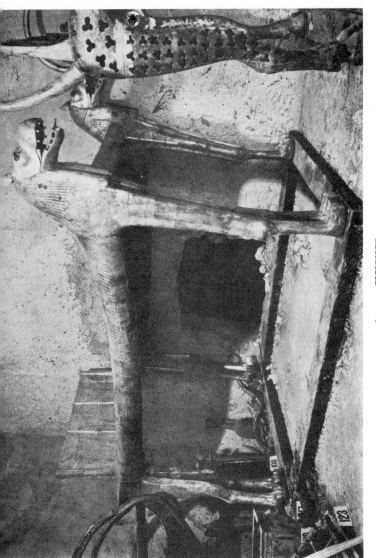

Plate XXVIII

THOUERIS COUCH.

(Note plunderers' hole to the Annexe.)

reconstructional purposes the gold ornamentation with which it was covered.

Seven weeks in all it took us to clear the Antechamber, and thankful indeed were we when it was finished, and that without any kind of disaster befalling us. One scare we had. For two or three days the sky was very black, and it looked as though we were in for one of the heavy storms that occasionally visit Thebes. On such occasions rain comes down in torrents, and if the storm persists for any length of time the whole bed of The Valley becomes a raging flood. No power on earth could have kept our tomb from being flooded under these conditions, but, fortunately, though there must have been heavy rain somewhere in the district, we escaped with but a few drops. Certain correspondents indulged in some highly imaginative writing on the subject of this threatened storm. As a result of this and other distorted news we received a somewhat cryptic cable, sent presumably by a zealous student of the occult. It ran : " In the case of further trouble, pour milk, wine and honey on the threshold." Unfortunately, we had neither wine nor honey with us, so were unable to carry out the directions. In spite of our negligence, however, we escaped the further trouble. Perhaps we were given absent treatment.

In the course of our clearing we naturally accumulated a good deal of evidence with regard to the activities of the original tomb-plunderers, and this will be as good a place as any to give a statement of the conclusions at which we arrived.

In the first place, we know from the sealings on the outer doorway that all the plundering was done within a very few years of the king's burial. We

also know that the plunderers entered the tomb at least twice. There were broken scattered objects on the floor of the entrance passage and staircase, proving that at the time of the first attempt the passage-way between the inner and the outer sealed doors was empty. It is, I suppose, just possible that this preliminary plundering was done immediately after the funeral ceremonies. Thereafter the passage was entirely filled with stones and rubbish, and it was through a tunnel excavated in the upper left-hand corner of this filling that the subsequent attempts were made. At this final attempt the thieves had penetrated into all the chambers of the tomb, but their tunnel was only a narrow one, and clearly they could not have got away with any except the smaller objects.

Now as to internal evidence of the damage they had been able to effect. To begin with, there was a strange difference between the respective states in which the Antechamber and the Annexe had been left. In the latter, as we have described in the preceding chapter, everything was in confusion, and there was not a vacant inch of floor-space. It was quite evident that the plunderers had turned everything topsy-turvy, and that the present state of the chamber was precisely that in which they had left it. The Antechamber was quite different. There was a certain amount of confusion, it was true, but it was orderly confusion, and had it not been for the evidence of plundering afforded by the tunnel and the re-sealed doorways, one might have imagined at first view that there never had been any plundering, and that the confusion was due to Oriental carelessness at the time of the funeral.

Clearing the Antechamber

However, when we commenced clearing, it quickly became manifest that this comparative orderliness was due to a process of hasty tidying-up, and that the plunderers had been just as busy here as they had in the Annexe. Parts of the same object were found in different quarters of the chamber; objects that should have been in boxes were lying on the floor or upon the couches; on the lid of one of the boxes there was a collar, intact but crumpled; behind the chariots, in an entirely inaccessible place, there was a box-lid, the box to which it belonged being far away, near the innermost door. Quite clearly the plunderers had scattered things here just as they had done in the Annexe, and someone had come after them and rearranged the chamber.

Later, when we came to unpack the boxes, we found still more circumstantial evidence. One, the long white box at the north end of the chamber, was half full of sticks, bows and arrows, and above, stuffed tightly in upon them, there was a mixed collection of the king's under-linen. Yet the metal points had been broken from all the arrows, and a few were found dropped upon the floor. Other sticks and bows that obviously belonged to this box were likewise scattered in the chamber. In another box there were a number of decorated robes, bundled together and thrust in anyhow, and mixed with them several pairs of sandals. So tightly had the contents of the box been stuffed, that the metal toe-thong of one of the sandals had pierced right through its own leather sole and penetrated that of another which lay beneath it. In still another box, jewellery and tiny statuettes had been packed on top of faience libation vases. Others, again, were half empty, or

contained a mere jumble of odds and ends of cloth.

There was, moreover, certain evidence that this confusion was due to hasty repacking, and had nothing to do with the original arrangement of the boxes, for on the lids of several there were neat little dockets stating clearly what the contents should have been, and in only one case did the docket bear any sort of relation to the contents as they actually were. This particular docket called for " 17 (unknown objects) of lapis lazuli colour." Within the box there were sixteen libation vases of dark blue faience, and a seventeenth was on the floor of the chamber some distance away. Eventually, in our final study of the material these dockets will be of great value. We shall be able, in a great many cases, to apportion out the objects to the boxes which originally contained them, and shall know exactly what is missing.

The best evidence of all was supplied by a very elaborate garment of faience, gold and inlay, comprising in one piece corslet, collar and pectoral. The largest portion of it was found in the box which contained the faience vases just mentioned; the pectoral and most of the collar were tucked away in the small gold shrine; and isolated pieces of it turned up in several other boxes, and were scattered all over the floor. There is nothing at present to show which of the boxes it originally belonged to, or even that it actually belonged to any of them. It is quite possible that the plunderers brought it from the innermost chamber to the better light of the Antechamber, and there deliberately pulled it to pieces.

From the facts at our disposal we can now re-

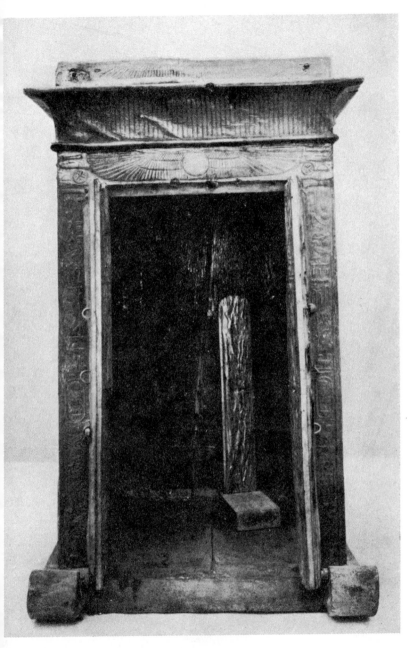

PLATE XXIX

PEDESTAL OF MISSING STATUETTE IN THE SMALL GOLDEN SHRINE.

construct the whole sequence of events. A breach was first made in the upper left-hand corner of the first sealed door, just large enough to admit a man, and then the tunnelling began, the excavators working in a chain, passing the stones and baskets of earth back from one to another. Seven or eight hours' work might suffice to bring them to the second sealed door; a hole in this, and they were through. Then in the semi-darkness began a mad scramble for loot. Gold was their natural quarry, but it had to be in portable form, and it must have maddened them to see it glinting all around them, on plated objects which they could not move, and had not time to strip. Nor, in the dim light in which they were working, could they always distinguish between the real and the false, and many an object which they took for solid gold was found on closer examination to be but gilded wood, and was contemptuously thrown aside. The boxes were treated in very drastic fashion. Without exception they were dragged out into the centre of the room and ransacked, their contents being strewn about all over the floor. What valuables they found in them and made away with we may never know, but their search can have been but hurried and superficial, for many objects of solid gold were overlooked. One very valuable thing we know they did secure. Within the small gold shrine there was a pedestal of gilded wood, made for a statuette, with the imprint of the statuette's feet still marked upon it (Plate XXIX). The statuette itself was gone, and there can be very little doubt that it was a solid gold one, probably very similar to the gold statuette of Thothmes III, in the image of Amen, in the Carnarvon collection.

Next, the Antechamber having been thoroughly worked over, the thieves turned their attention to the Annexe, knocking a hole in its doorway just big enough to let them through, and overturning and ransacking its contents quite as thoroughly as they had done those of the outer chamber.

Then, and apparently not until then, they directed themselves towards the burial chamber, and made a very small hole in the sealed doorway which screened it from the Antechamber. How much damage they did there we shall know in due time, but, so far as we can tell at present, it was less than in the outer chambers. They may, indeed, have been disturbed at this particular stage in the proceedings, and there is a very interesting little piece of evidence that seems to bear the theory out.

It may be remembered that in our description of the objects in the Antechamber (Chapter VII) we mentioned that one of the boxes contained a handful of solid gold rings tied up in a fold of cloth. They were just the things to attract a thief, for their intrinsic value was considerable, and yet they could very easily be hidden away. Now, every visitor to Egypt will remember that if you give money to a *fellah* his ordinary proceeding will be to undo a portion of his head-shawl, put the coins in a fold of it, twist it round two or three times to hold the coins tight in place, and make it finally secure by looping the bag thus formed into a knot. These rings had been secured in exactly the same way—the same loose fold in the cloth, the same twisting round to form the bag, and the same loose knot. This, unquestionably, was the work of one of the thieves. It was not his head-shawl that he had used—the

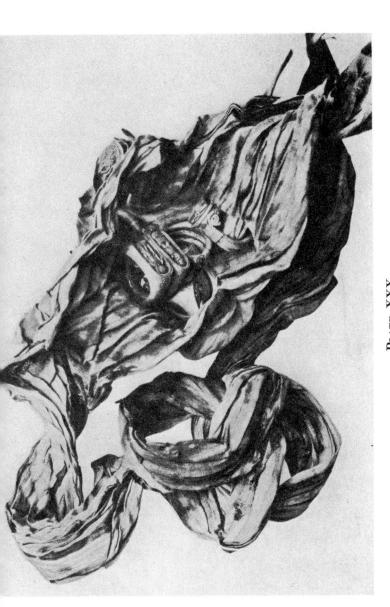

PLATE XXX

PLUNDERERS' LOOT: EIGHT GOLD RINGS TIED IN A SCARF.

fellah of the period wore no such garment—but one of the king's scarves which he had picked up in the tomb, and he had fastened them thus for convenience in carrying (Plate XXX). How comes it then that the precious bundle of rings was left in the tomb, and not carried off? It was the very last thing that a thief would be likely to forget, and, in case of sudden alarm, it was not heavy enough to impede his flight, however hurried that might be. We are almost forced to the conclusion that the thieves were either trapped within the tomb, or overtaken in their flight—traced, in any case, with some of the plunder still upon them. If this be so, it explains the presence of certain other pieces of jewellery and gold-work too valuable to leave and too big to overlook.

In any case, the fact that a robbery had been committed got to the ears of the officials concerned, and they came to the tomb to investigate and make the damage good. For some reason they seem to have been in almost as great a hurry as the thieves, and their work of reparation was sadly scamped. The Annexe they left severely alone, not even taking the trouble to fill up the hole in the doorway. In the Antechamber the smaller objects with which the floor was covered were swept up, bundled together, and jammed—there is no other word—back into the boxes, no attempt being made to sort the material, or to put the objects into the boxes which had been originally intended for them. Some of the boxes were packed tight, others were left almost empty, and on one of the couches there were deposited two large bundles of cloth in which a miscellaneous collection of material had been wrapped. Nor even was all the small material gathered up. The sticks,

bows and arrows were left in scattered groups ; on the lid of a box were thrown a crumpled collar of pendants, and a pad of faience rings ; and on the floor, one on one side of the chamber and one on the other, there was a pair of fragile bead-work sandals. The larger objects were pushed carelessly back against the walls, or stacked one upon another. Certainly no respect was shown, either to the objects themselves, or to the king whose property they were, and one wonders why, if they tidied up so badly, they took the trouble to tidy up at all. One thing we must credit them with. They did not do any pilfering, as they might easily have done, on their own account. We can be reasonably sure of that from the valuable objects, small and easily concealed, which they repacked into the boxes.

The Antechamber finished—so far, at least, as they intended to finish it—the hole in the innermost doorway was refilled, plastered, and stamped with the royal necropolis seal. Then, retracing their steps, they closed and sealed the Antechamber door, filled up the plunderers' tunnel through the passage-blocking, and made good the outer doorway. What further steps they took to prevent repetition of the crime we do not know, but probably they buried the whole entrance to the tomb deep out of sight. Better political conditions in the country might have prevented it for a time, but in the long run nothing but ignorance of its whereabouts could have saved it from further attempts at plundering ; and very certain it is that, between the time of this re-closing and that of our discovery, no hand had touched the seals upon the door.

CHAPTER IX

VISITORS AND THE PRESS

ARCHÆOLOGY under the limelight is a new and rather bewildering experience for most of us. In the past we have gone about our business happily enough, intensely interested in it ourselves, but not expecting other folk to be more than tepidly polite about it, and now all of a sudden we find the world takes an interest in us, an interest so intense and so avid for details that special correspondents at large salaries have to be sent to interview us, report our every movement, and hide round corners to surprise a secret out of us. It is, as I said, a little bewildering for us, not to say embarrassing, and we wonder sometimes just exactly how and why it has all come about. We may wonder, but I think it would puzzle anyone to give an exact answer to the question. One must suppose that at the time the discovery was made the general public was in a state of profound boredom with news of reparations, conferences and mandates, and craved for some new topic of conversation. The idea of buried treasure, too, is one that appeals to most of us. Whatever the reason, or combination of reasons, it is quite certain that, once the initial *Times* dispatch had been published, no power on earth could shelter us from the light of publicity that beat down upon us. We were helpless, and had to make the best of it.

The embarrassing side of it was soon brought

home to us in no uncertain manner. Telegrams poured in from every quarter of the globe. Within a week or two letters began to follow them, a deluge of correspondence that has persisted ever since. Amazing literature some of it. Beginning with letters of congratulation, it went on to offers of assistance, ranging all the way from tomb-planning to personal valeting ; requests for souvenirs—even a few grains of sand from above the tomb would be received so thankfully ; fantastic money offers, from moving-picture rights to copyright on fashions of dress ; advice on the preservation of antiquities, and the best method of appeasing evil spirits and elementals ; press clippings; tracts; would-be facetious communications; stern denunciations of sacrilege; claims of relationship—surely you must be the cousin who lived in Camberwell in 1893, and whom we have never heard of since ; and so on and so on. Fatuous communications of this sort came tumbling in upon us at the rate of ten or fifteen a day right through the winter. There is a whole sackful of them, and an interesting psychological study they would make if one had the time to give to them. What, for instance, is one to make of a person who solemnly inquires whether the discovery of the tomb throws any light on the alleged Belgian atrocities in the Congo ?

Next came our friends the newspaper correspondents, who flocked to The Valley in large numbers and devoted all their social gifts—and they were considerable—towards dispelling any lingering remains of loneliness or desert boredom that we might still have left to us. They certainly did their work with some thoroughness, for each owed it to him-

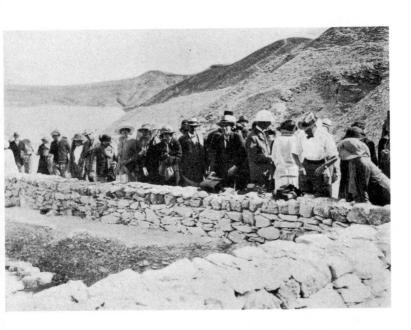

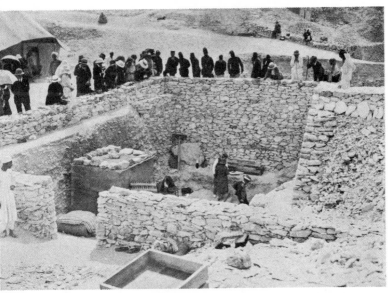

PLATE XXXI

VISITORS ABOVE THE TOMB.

self and to his paper to get daily information, and we in Egypt were delighted when we heard Lord Carnarvon's decision to place the whole matter of publicity in the hands of *The Times*.

Another, and perhaps the most serious of all the embarrassments that notoriety brought upon us, was the fatal attraction the tomb had for visitors. It was not that we wanted to be secretive, or had any objection to visitors as such—as a matter of fact, there are few things more pleasant than showing one's work to appreciative people—but as the situation developed it became very clear that, unless something was done to discourage it, we should spend the entire season playing showmen, and never get any work done at all. It was surely a new chapter in the history of The Valley. Tourist visitors it had always known, but heretofore it had been a business proceeding and not a garden party. Armed with guide-books, they had conscientiously visited as many tombs as time, or their dragoman, would allow them, bustled through their lunch, and been hurried off to a further debauch of sight-seeing elsewhere.

This winter, dragoman and time schedules were disregarded alike, and many of the ordinary sights were left unvisited. The tomb drew like a magnet. From a very early hour in the morning the pilgrimage began. Visitors arrived on donkeys, in sand-carts, and in two-horse cabs, and proceeded to make themselves at home in The Valley for the day. Round the top of the upper level of the tomb there was a low wall, and here they each staked out a claim and established themselves, waiting for something to happen. Sometimes it did, more often it did not, but it seemed to make no difference to their patience.

There they would sit the whole morning, reading, talking, knitting, photographing the tomb and each other, quite satisfied if at the end they could get a glimpse of anything. Great was the excitement, always, when word was passed up that something was to be brought out of the tomb. Books and knitting were thrown aside, and the whole battery of cameras was cleared for action and directed at the entrance passage. We were really alarmed sometimes lest the whole wall should give way, and a crowd of visitors be precipitated into the mouth of the tomb. From above, it must really have been an imposing spectacle to see strange objects like the great gilt animals from the couches emerging gradually from the darkness into the light of day. We who were bringing them up were much too anxious about their safety in the narrow passage to think about such things ourselves, but a preliminary gasp and then a quick buzz of exclamations brought home to us the effect it had upon the watchers above.

To these, the casual visitors who contented themselves with watching from the top, there could be no objection, and, whenever possible, we brought things out of the tomb without covers for their special benefit. Our real embarrassment was caused by the numbers of people who, for one reason or another, had to be shown over the tomb itself. This was a difficulty that came upon us so gradually and insidiously that for a long time we none of us realized what the inevitable result must be, but in the end it brought the work practically to a standstill. At the beginning we had, of course, the formal inspections of the departmental officials concerned. These, naturally, we welcomed. In the same way we were

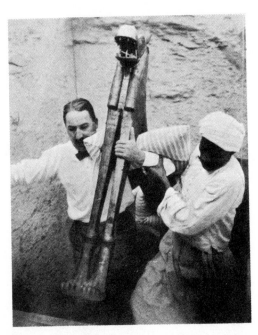

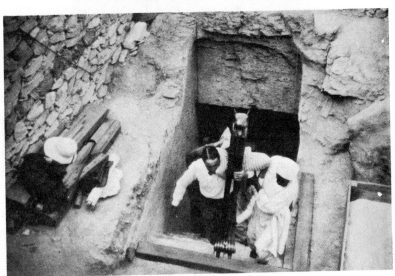

PLATE XXXII

THOUERIS COUCH BEING TAKEN OUT OF THE TOMB.

always glad to receive other archæologists. They had a right to visit the tomb, and we were delighted to show them everything there was to be seen. So far there was no difficulty, and there never would be any difficulty. It was with the letters of introduction that the trouble began. They were written, literally in hundreds, by our friends—we never realized before how many we had—by our friends' friends, by people who had a real claim upon us, and by people who had less than none; for diplomatic reasons, by Ministers or departmental officials in Cairo ; to say nothing of self-written introductions, which either bluntly demanded admittance to the tomb or showed quite clearly and ingeniously how unreasonable it would be to refuse them. One ingenious person even intercepted a telegraph boy, and tried to make the delivery of the message an excuse for getting in. The desire to visit the tomb became an obsession with the tourist, and in the Luxor hotels the question of ways and means became a regular topic of conversation. Those who had seen the tomb boasted of the fact openly, and to many of those who had not it became a matter of personal pride to effect an introduction somehow. To such lengths were things carried that certain tourist agencies in America actually advertised a trip to Egypt to see the tomb.

All this, as may be imagined, put us in a very awkward position. There were certain visitors whom for diplomatic reasons we had to admit, and others whom we could not refuse without giving serious offence, not only to themselves, but to the third parties whose introduction they brought. Where were we to draw the line ? Obviously something had

to be done, for, as I said, the whole of the work in the tomb was being rapidly brought to a standstill. Eventually we solved the difficulty by running away. Ten days after the opening of the sealed door we filled up the tomb, locked and barred the laboratory, and disappeared for a week. This made a complete break. When we resumed work the tomb itself was irrevocably buried, and we made it a fixed rule that no visits were to be made to the laboratory at all.

Now this whole question of visitors is a matter of some delicacy. We have already got into a good deal of hot water over it, and have been accused of lack of consideration, ill manners, selfishness, boorishness, and quite a number of other things ; so perhaps it would be as well to make a clear statement of the difficulties involved. These are two. In the first place, the presence of a number of visitors creates serious danger to the objects themselves, danger that we, who are responsible for them, have no right to let them undergo. How could it be otherwise ? The tomb is small and crowded, and sooner or later—it actually happened more than once last year—a false step or hasty movement on the part of a visitor will do some piece of absolutely irreparable damage. It is not the fault of the visitor, for he does not and cannot know the exact position or condition of every object. It is our fault, for letting him be there. The unfortunate part of it is that the more interested and the more enthusiastic the visitor is, the more likely he is to be the cause of damage : he gets excited, and in his enthusiasm over one object he is very liable to step back into or knock against another. Even if no actual damage is caused, the passage of large parties of visitors through the

tomb stirs up the dust, and that in itself is bad for the objects.

That is the first and obvious danger. The second, due to the loss of actual working time that visitors cause, is not so immediately apparent, but it is in some ways even more serious. This will seem a terribly exaggerated view to the individual visitor, who will wonder what difference the half-hour that he or she consumed could make to the whole season's work. Perfectly true, so far as that particular half-hour is concerned, but what of the other nine visitors, or groups of visitors, who come on the same day ? By strict arithmetic he and they have occupied five hours of our working day ; in actual fact, it is considerably more than five, for in the short intervals between visitors it is impossible to settle down to any serious piece of work. To all intents and purposes a complete day has been lost. Now, there were many days last season in which we actually did have ten parties of visitors, and if we had given way to every demand, and avoided any possibility of giving offence, there would not have been a day in which we did not far exceed the ten. In other words, there would have been whole weeks at a time in which no work was done at all. As it actually worked out last winter, we gave visitors a quarter of our working season. This resulted in our having to prolong our work into the hot weather a whole month longer than we had intended, and the heat of The Valley in May is not a thing to look forward to with equanimity, and is anything but inducive to good work.

There was much more at stake, however, than our own personal inconvenience : there was actual

danger for the objects themselves. Delicate antiquities are extremely sensitive to any change of temperature, and have to be watched most carefully. In the present case the change from the close atmosphere of the Antechamber to the variable temperature outside, and the dry airiness of the tomb we used as a laboratory, was a very appreciable one, and certain of the objects were affected by it. It was extremely important that preservatives should be applied at the very first possible moment, and in some cases there was need of experimental treatment which had to be watched very carefully. The danger of constant interruption is obvious, and I need not labour the point. What would a chemist think if you asked him to break off a delicate experiment to show you round his laboratory? What would be the feelings of a surgeon if you interrupted him in the middle of an operation? And what about the patient? For the matter of that, what would a business man say—what wouldn't he say?—if he had a succession of ten parties of visitors in the course of the morning, each expecting to be shown all over the office?

Yet, surely, the claims of archæology for consideration are just as great as those of any other form of scientific research, or even—dare I say it?—of that of the sacred science of money-making itself. Why, because we carry on our work in unfrequented regions instead of in a crowded city, are we to be considered churlish for objecting to constant interruptions? I suppose the reason really is that in popular opinion archæology is not work at all. Excavation is a sort of super-tourist amusement, carried out with the excavator's own money if he is rich

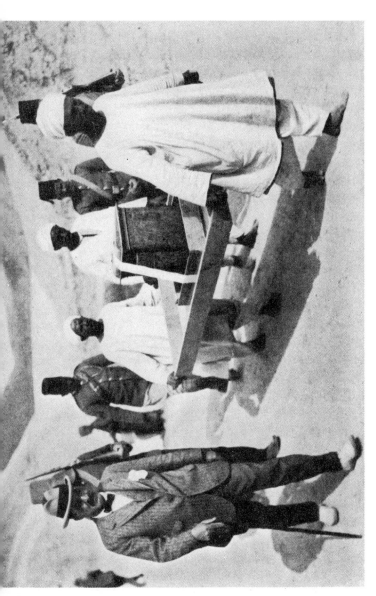

PLATE XXXIII

CONVOY OF ANTIQUITIES TO THE LABORATORY.

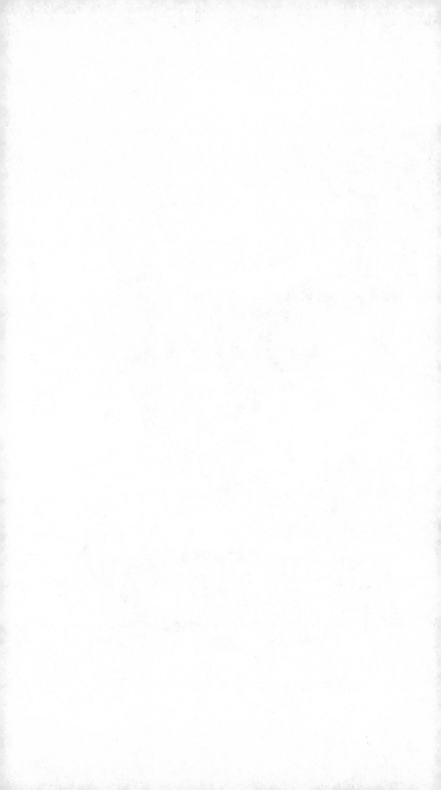

enough, or with other people's money if he can persuade them to subscribe it, and all he has to do is to enjoy life in a beautiful winter climate and pay a gang of natives to find things for him. It is the dilettante archæologist, the man who rarely does any work with his own hands, but as often as not is absent when the actual discovery is made, who is largely responsible for this opinion. The serious excavator's life is frequently monotonous and, as I hope to show in the next chapter, quite as hard-working as that of any other member of society.

I have written more than I intended on this subject, but really it is a very serious matter for us. We have an opportunity in this tomb such as no archæologists ever had before, but if we are to take full advantage of it—and failure to do so will earn for us the just execration of every future generation of archæologists—it is absolutely essential that we be left to carry on the work without interruption. It is not as if our visitors were all keen on archæology, or even mildly interested in it. Too many of them are attracted by mere curiosity, or, even worse, by a desire to visit the tomb because it is the thing to do. They want to be able to talk at large about it to their friends at home, or crow over less fortunate tourists who have not managed to secure an introduction themselves. Can you imagine anything more maddening, when you are completely absorbed in a difficult problem, than to give up half an hour of your precious time to a visitor who has pulled every conceivable kind of wire to gain admittance, and then to hear him say quite audibly as he goes away : " Well, there wasn't much to see, after all " ? That actually happened last winter—and more than once.

In the coming season there will in any case be much less for visitors to see. It will be absolutely impossible to get into the burial chamber, for every available inch of space will be occupied by scaffolding, and the removal of the shrine, section by section, will be much too ticklish an operation to admit of interruptions. In the laboratory we propose to deal with only one object at a time, which will be packed and got rid of as soon as we have finished with it. Six cases of objects from the tomb are already on exhibition in the Cairo Museum, and we would earnestly beg visitors to Egypt to content themselves with these, and with what they can see from the outside of the tomb, and not to set their hearts on getting into the tomb itself. Those who are genuinely interested in archæology for its own sake will be the first to realize that the request is a reasonable one. The others, the idly curious, who look on the tomb as a side-show, and Tut·ankh·Amen as a mere topic of conversation, have no rights in the matter, and need no consideration. Whatever our discoveries next season may be, we trust that we may be allowed to deal with them in a proper and dignified manner.

CHAPTER X

WORK IN THE LABORATORY

THIS chapter is dedicated to those—and they are many—who think that an excavator spends his time basking in the sun, pleasantly exhilarated by watching other people work for him, and otherwise relieved from boredom by having baskets full of beautiful antiquities brought up from the bowels of the earth from time to time for him to look at. His actual life is very different, and, as there can be but few who know the details of it, it will be worth our while to give a general outline here before going into the question of the laboratory work of the past season. Incidentally, it will help to explain why this careful laboratory work was necessary.

In the first place, it must be clearly understood that there is never any question of having basketfuls of objects brought to the excavator for him to look at; the first and most important rule in excavating is that the archæologist must remove every antiquity from the ground with his own hands. So much depends upon it. Quite apart from the question of possible damage that might be caused by clumsy fingers, it is very essential that you see the object *in situ*, to gain any evidence you can from the position in which it lies, and the relationship it bears to objects near it. For example, there may very likely be dating evidence. How many

pieces there are in museums with vague " probably Middle Kingdom " kind of labels, which, by reference to the objects with which they were found, might easily have been assigned accurately to the Dynasty to which they belonged, or even to the reign of some particular king. There will, again, be evidence of arrangement to be secured, evidence that may show the use for which some particular object was made, or give the details for its ultimate reconstruction.

Take, for instance, the tiny fragments of serrated flint which are found in such enormous quantities in town sites of the Middle Kingdom. We can guess their use, and with the label " sickle flints " they make not uninteresting museum material. Now find, as I have done, a complete sickle lying in the ground, its wooden parts in such condition that a touch will destroy the evidence of its ever having been a sickle at all. Two courses are open to you. By careful handling and the use of preservatives you may be able to get your sickle out of the ground intact, or, if it is too far gone for that, you can at least take the measurements and notes that will enable you to construct the wood anew. In either case you get a complete museum object, worth, archæologically, a thousand times more than the handful of disconnected pieces of flint that you would otherwise have secured. This is a simple illustration of the importance of field evidence : we shall have other and more striking instances to record when we come to deal with the different classes of material.

One other matter before we pass on. By noting the exact position of an object, or group of objects, you can not infrequently secure evidence that will

enable you to make a find of similar objects else-where. Foundation deposits are a case in point. In every construction the arrangement of the deposits followed a regular system, and, having found one, it is a simple matter to put your finger upon the others.

An excavator, then, must see every object in position, must make careful notes before it is moved, and, if necessary, must apply preservative treatment on the spot. Obviously, under these conditions it is all-important for you to keep in close touch with your excavations. Holiday trips and days off are out of the question. While the work is actually running you must be on the spot all day, and avail-able at all hours of the day. Your workmen must know where to find you at any given moment, and must have a perfectly clear understanding that the news of a discovery must be passed on to you without any delay.

In the case of an important discovery you will probably know something has happened before you actually get the report, for—in Egypt particularly—the news will have spread almost instantaneously, and have had a curious psychological effect upon your entire gang of workmen. They will be working differently, not necessarily harder, but differently, and much more silently. The ordinary work-songs will have ceased. A smaller discovery you will frequently sense in advance from the behaviour of the man who brings the message. Nothing would induce him to come straight to you and tell you openly what he has found. At all costs he must make a mystery of it, so he hovers about in a thoroughly self-conscious manner, thereby adver-

tising to the world at large exactly what has happened, and eventually makes himself still more conspicuous by beckoning you aside and whispering his news. Even then it will be difficult to get any but the vaguest of reports out of him, and it will probably not be until you have reached the actual spot that you find out exactly what has been found. This is due largely to an Egyptian's love of mystery for its own sake. The same man will tell his friends all about the find on the first opportunity, but it is part of the game to pretend that they must know nothing about it at the time. Partly, too, to excitement. Not that he takes any real interest in the objects themselves, but because he looks on them in the light of a gamble. Most excavators work on what is known as the *baksheesh* system : that is to say, they pay their workmen rewards, over and above their wages, for anything they find. It is not an ideal arrangement, but it has two advantages : it helps to ensure the safety of the objects, particularly the small, easily concealed ones, which may be most valuable to you for dating purposes ; and it makes the men keener about their work, and more careful about the manner in which they carry it out, the reward being more for the safe handling than for the value of the object.

For these, and for many other reasons which we could mention, it is all-important for you to keep close to your work, and, even if nothing is being found at the moment, you will not have much time to be idle. To begin with, every tomb, every building, every broken wall even, must be noted, and if you are dealing with pit-tombs this may involve considerable gymnastic exercise. The pits may range

anywhere from ten to a hundred and twenty feet in depth, and I calculated once that in the course of a single season I had climbed, hand over hand, up half a mile of rope. Then there is photography. Every object of any archæological value must be photographed before it is moved, and in many cases a series of exposures must be made to mark the various stages in the clearing. Many of these photographs will never be used, but you can never tell but that some question may arise, whereby a seemingly useless negative may become a record of the utmost value. Photography is absolutely essential on every side, and it is perhaps the most exacting of all the duties that an excavator has to face. On a particular piece of work I have taken and developed as many as fifty negatives in a single day.

Whenever possible, these particular branches of the work—surveying and photography—should be in the hands of separate experts. The man in charge will then have time to devote himself to what we may call the finer points of excavation. He will be able to play with his work, as a brother digger expressed it. In every excavation puzzles and problems constantly present themselves, and it is only by going constantly over the ground, looking at it from every point of view, and scrutinizing it in every kind of light, that you will be able to arrive at a solution of some of these problems. The meaning of a complex of walls, the evidence of reconstruction of a building, or of a change in plan on the part of the original architect, the significance of a change of level, where the remains of a later period have been superimposed upon those of an earlier one, the purport of some peculiarity in the surface debris,

or in the stratification of a mound—these and a score of others are the questions that an excavator has to face, and it is upon his ability to answer them that he will stand or fall as an archæologist.

Then, again, if he is freed from the labour of survey and photography, he will be able to devote more time and thought to the general organization of the work, and by that means to effect considerable economies both in time and money. Many a hundred pounds has been wasted by lack of system, and many an excavator has had to clear away his own dumps because he failed in the first instance to exercise a little forethought. The question of the distribution of the workmen is one that needs careful attention, and great wastage of labour can be avoided by moving men around from one place to another exactly when and where they are wanted, and never leaving more on a particular section of the work than are actually needed to keep it running smoothly. The number of labourers that an excavator can keep up with single-handed will depend naturally on the conditions of the work. On a big and more or less unproductive undertaking, such as pyramid clearing, he can look after an almost indefinite number. On rock-cut tombs he can perhaps keep pace with fifty ; whereas on shallow graves—a pre-dynastic cemetery, for example—ten will keep him uncomfortably busy. The number of men who can be employed is also largely dependent on the type of site and formation of the locality of the excavation.

So much for the outdoor duties, the actual conduct of his excavations. There are plenty of other jobs to be done, and his off hours and evenings will be very fully occupied if he is to keep on terms

with his work. His notes, his running plans, and the registration of the objects must be kept thoroughly up to date. There are the photographs to be developed, prints to be made, and a register kept, both of negatives and prints. There will be broken objects to be mended, objects in delicate condition to be treated, restorations to be considered, and bead-work to be re-threaded. Then comes the indoor photography, for each individual object must be photographed to scale, and in some cases from several points of view. The list could be extended almost indefinitely, and would include a number of jobs that would seem to have but a remote connexion with archæology, such as account-keeping, doctoring the men, and settling their disputes. The workmen naturally have one day a week off, and the excavator will very likely begin the season with the idea that he too will take a weekly holiday. He will usually be obliged to abandon the idea after the first week, for he will find in this off day too good an opportunity to waste of catching up with the hundred and one jobs that have got ahead of him.

Such, in broad outline, is the life of the excavator. There are certain details of his work, more particularly those which have to do with note-taking and first-aid preservation of the different classes of objects, which we should like to dwell on at somewhat greater length. These are subjects which the ordinary reader will probably know little about, and they will be well illustrated in our description of the laboratory work of the past season.

Woodwork, for instance, is seldom in good condition and presents many problems. Damp and the

white ant are its chief foes, and in unfavourable conditions nothing will be left of the wood but a heap of black dust, or a shell which crumbles at the touch. In the one case an entry in your notes to the effect that wood has been present is the most that you can do, but in the other there will generally be a certain amount of information to be gleaned. Measurements can certainly be secured ; and the painted remains of an inscription, which may give you the name of the owner of the object, and which a single breath of wind or touch of the surface would be sufficient to efface, can be copied, if taken in hand without delay. Again, there will be cases in which the wooden frame or core of an object has decayed away, leaving scattered remains of the decoration —ivory, gold, faience, or what not—which originally covered its surface. By careful notes of the exact relative positions of this fallen decoration, supplemented by a subsequent fitting and piecing together, it will often be possible to work out the exact size and shape of the object. Then, by applying the original decoration to a new wooden core, you will have, instead of a miscellaneous collection of ivory, gold and faience fragments, useless for any purpose, an object which for all practical purposes is as good as new. Preservation of wood, unless it be in the very last stage of decay, is always possible by application of melted paraffin wax ; by this means an object, which otherwise would have fallen to pieces, can be rendered perfectly solid and fit to handle.

The condition of wood naturally varies according to the site, and, fortunately for us, Luxor is in this respect perhaps the most favourable site in the whole of Egypt. We had trouble with the wood from the

present tomb, but it arose, not from the condition in which we originally found it, but from subsequent shrinkage owing to change of atmosphere. This in an object of plain wood is not such a serious matter, but the Egyptians were extremely fond of applying a thin layer of gesso, on which prepared surface they painted scenes or made use of an overlay of gold foil. Naturally, as the wood shrank the gesso covering began to loosen up and buckle, and there was considerable danger that large parts of the surface might be lost. The problem is a difficult one. It is a perfectly easy matter to fix paint or gold foil to the gesso, but ordinary preservatives will not fix gesso to the wood. Here again, as we shall show, we had recourse eventually to paraffin wax.

The condition of textiles varies. Cloth in some cases is so strong that it might have come fresh from the loom, whereas in others it has been reduced by damp almost to the consistency of soot. In the present tomb the difficulty of handling it was considerably increased, both by the rough usage to which it had been subjected, and by the fact that so many of the garments were covered with a decoration of gold rosettes and bead-work.

Bead-work is in itself a complicated problem, and will perhaps tax an excavator's patience more than any other material with which he has to deal. There is so much of it. The Egyptians were passionately fond of beads, and it is by no means exceptional to find upon a single mummy an equipment consisting of a number of necklaces, two or three collars, a girdle or two, and a full set of bracelets and anklets. In such a case many thousands of beads will have been employed. Therein lies the test of patience,

for in the recovery and restoration of this bead-work every single bead will have to be handled at least twice. Very careful work will be necessary to secure the original arrangement of the beads. The threads that held them together will all have rotted away, but nevertheless they will be lying for the most part in their correct relative positions, and by carefully blowing away the dust it may be possible to follow the whole length of necklace or collar, and secure the exact order of the beads. Re-threading may be done *in situ* as each section is laid bare—on a many-stringed girdle I once had twelve needles and thread going simultaneously—or, better still, the beads may be transferred one by one to a piece of cardboard on which a thin layer of plasticine has been spread. This has the advantage that gaps of the required length can be left for missing or doubt-fully placed beads.

In very elaborate objects, where it is not possible to thread the beads as they are found, careful notes must be made, the re-stringing being done later, not in exact order, bead for bead, but in accordance with the original pattern and design. A tedious business this re-stringing will be, and a good deal of experimental work will probably be necessary before you arrive at the correct method of dealing with the particular problem. In a collar, for example, it may be necessary to have three independent thread-ing strings to every bead, if the rows are to lie smoothly in place. Restoration of missing or broken parts will sometimes be necessary if a reconstruction is to be effected. I once found a set of bracelets and anklets in which the rows of beads had been separated by perforated bars of wood covered with

gold foil. The wood of which these separators was composed had entirely gone, leaving the gold foil shells ; so I cut new pieces of wood to the shape, burnt out perforation holes with a red-hot needle, and covered the new bars with the original gold. Such restorations, based on actual evidence, are perfectly legitimate, and well worth the trouble. You will have secured for your museum, in place of a trayful of meaningless beads, or, worse still, a purely arbitrary and fanciful reconstruction, an object, attractive in itself, which has very considerable archæological value.

Papyrus is frequently difficult to handle, and in its treatment more crimes have been committed than in any other branch of archæology. If in fairly sound condition it should be wrapped in a damp cloth for a few hours, and then it can easily be straightened out under glass. Rolls that are torn and brittle, sure to separate into a number of small pieces during the process of unwrapping, should never be tackled unless you have plenty of time and space at your disposal. Careful and systematic work will ensure the correct spacing of almost all the fragments, whereas a desultory sorting, carried out in the intervals of other work, and perhaps by various hands, will never achieve a satisfactory result, and may end in the destruction of much valuable evidence. If only the Turin papyrus, for instance, had received careful treatment when it was first found, what a wealth of information it would have given us, and what heart-burnings we should have been saved !

Stone, as a rule, presents few difficulties in the field. Limestone will certainly contain salt, which

must be soaked out of it, but this is a problem that can be taken in hand later in the museum, and need not detain us here. In the same way faience, pottery, and metal objects can usually be left for later treatment. We are only concerned here with work that must be carried out on the spot.

Detailed and copious notes should be taken at every stage of this preliminary work. It is difficult to take too many, for, though a thing may be perfectly clear to you at the moment, it by no means follows that it will be when the time comes for you to work over your material. In tomb-work as many notes as possible should be made while everything is still in position. Then, when you begin clearing, card and pencil should be kept handy, and every fresh item of evidence should be noted immediately you run across it. You are tempted so often to put off making the note until you have finished the actual piece of work on which you are engaged, but it is dangerous. Something will intervene, and as likely as not that particular note will never be made at all.

Now let us move to the laboratory, and put into practice some of the theories that we have been elaborating. It will be remembered that it was the tomb of Seti II (No. 15 in the Wilkinson catalogue of tomb numbers) that had been selected for us, and here we had established ourselves with our note-cards and our preservatives. The tomb was long and narrow, so that only the first bay could be used for practical work, the inner darker part being serviceable merely as storage space. As the objects were brought in they were deposited, still in their stretchers, in the middle section, and covered up

until they should be wanted. Each in turn was brought up to the working bay for examination. There, after the surface dust had been cleared off, measurements, complete archæological notes, and copies of inscriptions were entered on the filing cards. The necessary mending and preservative treatment followed, after which it was taken just outside the entrance for scale photographs to be made. Finally, having passed through all these stages, the object was stored away in the innermost recesses of the tomb to await the final packing.

In the majority of cases no attempt at final treatment was made. It was manifestly impossible, for months, probably years, of reconstructive work are necessary if full use is to be made of the material. All we could do here was to apply preliminary treatment, sufficient in any event to enable the object to support a journey in safety. Final restorations must be made in the museum, and they will need a far more fully equipped laboratory and a much larger staff of skilled helpers than we could ever hope to achieve in The Valley.

As the season advanced, and the laboratory grew more and more crowded, it became increasingly difficult to keep track of the work, and it was only by close attention to detail, and strict adherence to a very definite order of procedure, that we managed to keep clear of complications. As each object arrived its registration number was noted in an entry book, and in the same book a record was kept of the successive stages of its treatment. Each of the primary objects had been given its own registration number in the tomb, but as these were worked over in the laboratory an elaborate system

of sub-numbering became necessary. A box, for instance, might contain fifty objects, any one of which must be clearly identifiable at all times, and these we distinguished by letters of the alphabet, or, where necessary, by a combination of letters. Constant care was necessary to keep these smaller objects from being separated from their identification tickets, especially in cases where protracted treatment was required. Not infrequently it happened that the component parts of a single object, scattered in the tomb, were entered under two or more numbers, and in this case cross-references in the notes were necessary. Note-cards, as completed, were filed away in cabinets, and in these filing cabinets we had, by the end of the season, a complete history of every object from the tomb, including :—

(1) Measurements, scale drawings, and archæological notes.
(2) Notes on the inscriptions by Dr. Alan Gardiner.
(3) Notes by Mr. Lucas on the preservative treatment employed.
(4) A photograph, showing the position of the object in the tomb.
(5) A scale photograph, or series of photographs, of the object itself.
(6) In the case of boxes, a series of views, showing the different stages in the clearing.

So much for our system of work. Let us turn now to the individual treatment of a selected number of the antiquities. The first that required treatment in the laboratory was the wonderful painted casket (No. 21 in our register), and, if we had searched

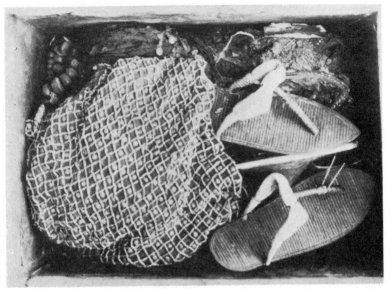

A

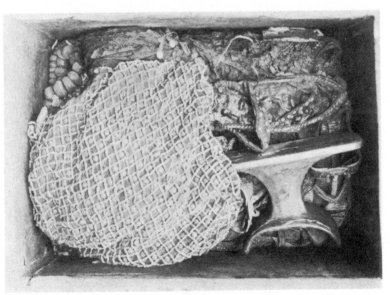

B

Plate XXXIV

PAINTED CASKET, No. 21.
Series showing the unpacking. First (A) and second (B) stages.

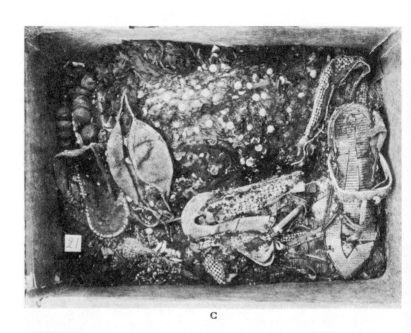

C

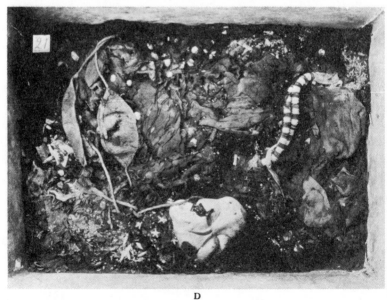

D

Plate XXXV

PAINTED CASKET, No. 21.
Series showing the unpacking. Third (c) and fourth (d) stages.

the whole tomb through, we should have been hard put to it to find a single object that presented a greater number of problems. For this reason it will be worth our while to give a detailed description of its treatment. Our first care was for the casket itself, which was coated with gesso, and covered from top to bottom with brilliantly painted scenes. With the exception of a slight widening of the joints owing to shrinkage, the wood was in perfect condition ; the gesso had chipped a little at the corners and along the cracks, but was still in a reasonably firm state, and the paint, though a little discoloured in places, was perfectly fast and showed no signs of rubbing. It seemed as though but little treatment was necessary. The surface dust was removed, the discoloration of the painted surfaces was reduced with benzine, and the whole exterior of the casket was sprayed with a solution of celluloid in amylacetate to fix the gesso to the wood, particular attention being paid to tender places at the cracks. At the moment this seemed to be all that was required, but it was our first experience of the wood and gesso combination from the tomb, and we were to be disillusioned. Three or four weeks later we noticed that the joint cracks were getting wider, and that the gesso in other places was showing a tendency to buckle. It was clear enough what was happening. Owing to the change of temperature from the close, humid atmosphere of the tomb to the dry airiness of the laboratory, the wood had begun to shrink once more, and the gesso, not being able to follow it, was coming away from the wood altogether. The position was serious, for we were in danger of losing large parts of the painted surface.

Drastic measures were necessary, and after much discussion we decided on the use of melted paraffin wax. Courage was needed to take the step, but we were thoroughly justified by the result, for the wax penetrated the materials and held everything firm, and, so far from the colours being affected, as we had feared, it seemed to make them more brilliant than before. We used this process later on a number of other objects of wood and gesso, and found it extremely satisfactory. It is important that the surface should be heated, and that the wax should be brought as near to boiling-point as possible; otherwise it will chill and refuse to penetrate. Failing an oven we found the Egyptian sun quite hot enough for the purpose. Surplus wax can be removed by the application of heat, or by the use of benzine. There is another advantage in the process, in that blisters in the gesso can be pressed down into place again while the wax is still warm, and will hold quite firmly. In very bad cases it may be necessary to fill the blister in from behind by means of hot wax applied by a pipette.

So much for the outside of the casket. Now let us remove the lid and see what the inside has in store for us. This is an exciting moment, for there are beautiful things everywhere, and, thanks to the hurried re-packing carried out by the officials, there is nothing to forewarn one as to what the contents of any individual box may be. In this particular case, by reference to the four views on Plates XXXIV and XXXV, the reader can himself follow the successive stages in the clearing, and it will give him some idea of the difficulty of handling the material if I explain that it took me three weeks of hard work to get

to the bottom of the box. The first photograph was taken immediately after the lid had been removed, and before anything was touched. On the right there is a pair of rush and papyrus sandals, in perfect condition ; below them, just showing, a gilt head-rest, and, lower again, a confused mass of cloth, leather, and gold, of which we can make nothing as yet. On the left, crumpled into a bundle, there is a magnificent royal robe, and in the upper corner there are roughly shaped beads of dark resin. The robe it was that presented us with our first problem, a problem that was constantly to recur— how best to handle cloth that crumbled at the touch, and yet was covered with elaborate and heavy decoration. In this particular case the whole surface of the robe is covered with a network of faience beads, with a gold sequin filling in every alternate square in the net. These—beads and sequins—had originally been sewn to the cloth, but are now loose. A great many of them are upside down, the releasing of the tension when the thread snapped having evidently caused them to spring. At the borders of the robe—they are underneath, and do not show in the photograph—there are bands of tiny glass beads of various colours, arranged in patterns. The upper layer of cloth was very deceptive in appearance. It looked reasonably solid, but if one tried to lift it, it fell to pieces in one's hand. Below, where it had been in contact with other things, the condition was much worse.

This question of cloth and its treatment was enormously complicated for us in the present tomb by the rough usage to which it had been subjected. Had it been spread out flat, or neatly folded, it

would have been a comparatively simple matter to deal with it. We should, as a matter of fact, have had an easier task if it had been allowed to remain strewn about the floor of the chamber, as the plunderers had left it. Nothing could have been worse for our purposes than the treatment it had undergone in the tidying-up process, in which the various garments had been crushed, bundled and interfolded, and packed tightly into boxes with a mixture of other and, in some cases, most incongruous objects.

In the case of this present robe it would have been perfectly simple to solidify the whole of the upper layer and remove it in one piece, but this was a process to which there were serious objections. It involved, firstly, a certain amount of danger to whatever might lie beneath, for in the unpacking of these boxes we had to be continually on our guard lest, in our enthusiasm over the treatment or removal of an object, we might inflict damage on a still more valuable one which lay under it. Then, again, if we made the upper part of the robe solid, we should seriously have reduced the chances of extracting evidence as to size and shape, to say nothing of the details of ornamentation. In dealing with all these robes there were two alternatives before us. Something had to be sacrificed, and we had to make up our minds whether it should be the cloth or the decoration. It would have been quite possible, by the use of preservatives, to secure large pieces of the cloth, but, in the process, we should inevitably have disarranged and damaged the bead ornamentation that lay below. On the other hand, by sacrificing the cloth, picking it carefully away

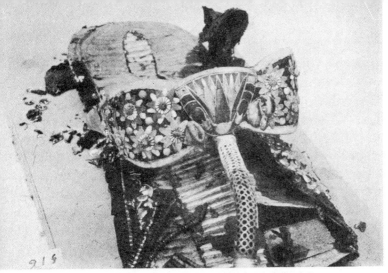

(A) The buckle of sandal (B) in elaborate gold work.

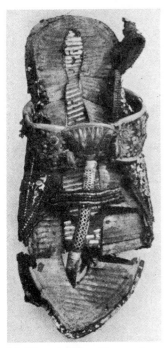

(B) The sandal, with toe-thong of open-work gold.

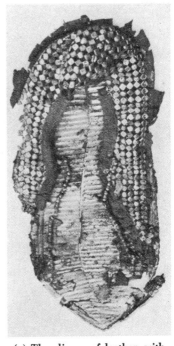

(c) The slipper of leather, with elaborate decoration of gold.

PLATE XXXVI

THE KING'S COURT SANDAL AND SLIPPER.

piece by piece, we could recover, as a rule, the whole scheme of decoration. This was the plan we usually adopted. Later, in the museum, it will be possible to make a new garment of the exact size, to which the original ornamentation—bead-work, gold sequins, or whatever it may be—can be applied. Restorations of this kind will be far more useful, and have a much greater archæological value, than a few irregularly shaped pieces of preserved cloth and a collection of loose beads and sequins.

The size of the robe from this casket can be worked out with reasonable accuracy from the ornamentation. At the lower hem there was a band, composed of tiny beads arranged in a pattern, a pattern of which we were able to secure the exact details. From this band there hung, at equal intervals, a series of bead strings with a large pendant at the end of each string. We can thus calculate the circumference of the hem by multiplying the space between the strings by the number of pendants. That gives us the width of the robe. Now we can calculate the total area of decoration from the number of gold sequins employed, and, if we divide this total area by our known circumference at the bottom, we shall arrive at a fairly accurate approximation of the height. This naturally presupposes that our robe is the same width throughout, a method of cutting borne out by a number of undecorated garments of which we were able to secure the exact measurements.

This has been a long digression, but it was necessary, to show the nature of the problem with which we had to deal. We can return to the casket now, and really begin to explore its contents. First of

all we removed the rush sandals, which were in beautifully firm condition, and presented no difficulties (Plate XXXIV, B). Next came the gilt head-rest, and then, very carefully, we removed the robe. One large portion of its upper surface we managed to take out whole by the aid of a celluloid solution, and short lengths of the band decorations of small beads we preserved in wax for future reference. The third photograph (Plate XXXV, c) shows what we may call the second layer of the casket's contents. Here, to begin with, were three pairs of sandals, or rather, to be accurate, two pairs of sandals and a pair of loose slippers. These were of leather, elaborately decorated with gold, and of wonderful workmanship (two of them are shown on Plate XXXVI). Unfortunately, their condition left much to be desired. They had suffered from their packing in the first place, but, worse than that, some of the leather had melted and run, gluing the sandals together and fastening them to other objects, making their extraction from the box a matter of extreme difficulty. So much of the leather had perished that the question of restoration became a serious problem. We secured the gold ornamentation that still remained in place with a solution of Canada balsam, and strengthened them generally as far as we could, but eventually it will probably be better to make new sandals and apply the old decoration to them.

Beneath the sandals there was a mass of decayed cloth, much of it of the consistency of soot, thickly spangled throughout with rosettes and sequins of gold and silver. This, sad to relate, represents a number of royal robes. The difficulty of trying to extract any intelligible record from it can be imag-

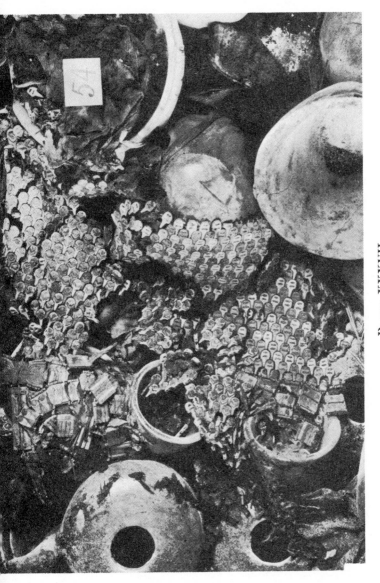

Plate XXXVII

BOX, No. 54.

View of interior showing scattered parts of Corslet resting on Faience Libation Vases.

ined, but a certain amount of assistance was given by the differences in the sizes and shapes of the sequins. There were at least seven distinct garments. One was an imitation leopard-skin cloak in cloth, with gilt head, and spots and claws of silver (*see* last photograph of the series, Plate XXXV, D); while two of the others were head-dresses, made in the semblance of hawks with outstretched wings, of the type shown in Plate LXXVIII. Bundled in with the actual garments there were a number of other objects—two faience collarettes of beads and pendants, two caps or bags of tiny bead-work which had almost entirely fallen to pieces, a wooden tag inscribed in hieratic " Papyrus (?) sandals of His Majesty," a glove of plain linen, an archer's gauntlet, tapestry woven in coloured thread, a double necklace of large flat faience beads (*see* Plate XXXV, D), and a number of linen belts or scarves. Below the garments there was a layer of rolls and pads of cloth, some of which were loin-cloths and others mere bandages ; and below these again, resting on the bottom of the box, there were two boards, perforated at one end for hanging, whose purpose is still doubtful.

With very few exceptions—the rush sandals are a case in point—the garments it contained were those of a child. Our first idea was that the king might have kept stored away the clothes he wore as a boy ; but later, on one of the belts, and on the sequins of one of the robes, we found the royal cartouche. He must, then, have worn them after he became king, from which it would seem to follow that he was quite a young boy when he succeeded to the throne. Another interesting piece of evidence in this connexion is supplied by the fact that on

the lid of one of the other boxes there is a docket which reads, " The King's side-lock (?) as a boy." The question raises an interesting historical point, and we shall be eager to see, when the time comes, the evidence of age that the mummy will supply. Certainly, whenever the king appears upon the tomb furniture, he is represented as little more than a youth.

One other point with regard to the robes found in this and other boxes. Many of them are decorated with patterns in coloured linen threads. Some of these are examples of tapestry weaving, similar to the fragments found in the tomb of Thothmes IV,[1] but there were also undoubted cases of applied needlework. The material from this tomb will be of extreme importance to the history of textile art, and it needs very careful study.

We shall not have space here to describe the unpacking of the other boxes, but all were in the same jumbled state, and all had the same queer mixture of incongruous objects. Many of them contained from fifty to sixty individual pieces, each requiring its own registration card, and there was never any lack of excitement in the unpacking, for you never knew when you might not happen upon a magnificent gold scarab, a statuette, or a beautiful piece of jewellery. It was slow work, naturally, for hours at a time had to be spent working out with brush and bellows the exact order and arrangement of collar, necklace, or gold decoration, covered, as they ordinarily were, with the dust of decayed cloth. The collars were a frequent source of trouble.

[1] Carter and Newberry, *Tomb of Thoutmosis* IV, Pls. I and XXVIII, Nos. 46526–46529.

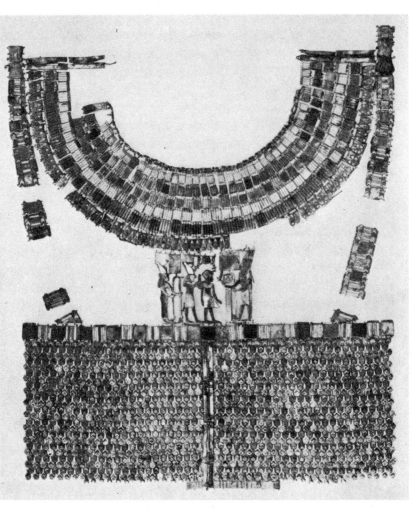

PLATE XXXVIII

RECONSTRUCTION OF CORSLET.

Work in the Laboratory

We found eight in all, of the Tell el Amarna leaf and flower type, and it needed great care and patience to work out the exact arrangement of the different types of pendants. One of these is shown on Plate XXXIX, laid out loosely on ground glass to be photographed. They still need quite a lot of treatment to bring them back to their original colours, and there will have to be a certain amount of restoration of the broken and missing parts before they are ready for the final re-stringing. In one case we were lucky, for an elaborate three-string necklace, with a gilt pectoral at one end and a scarab-pendant at the other, lay flat upon the bottom of a box, so that we were able to remove it bead by bead, and re-string it on the spot in its exact original order (Plate XL).

The most elaborate piece of reconstruction that we had to do was in connexion with the corslet, which has been referred to more than once. This was a very elaborate affair, consisting of four separate parts—the corslet proper, inlaid with gold and carnelian, with border bands and braces of gold and coloured inlay ; a collar with conventional imitation of beads in gold, carnelian, and green and blue faience ; and two magnificent pectorals of open-work gold with coloured inlay, one for the chest, the other to hang behind as make-weight. Corslets of this type are depicted commonly enough on the monuments, and were evidently frequently worn, but we have never before been lucky enough to find a complete example. Unfortunately, the parts of it were sadly scattered, and there were points in the reconstruction of which we could not be absolutely certain. Most of it was found in Box 54, but, as

we have already stated in Chapter VII, there were also parts of it in the small gold shrine and in Boxes 101 and 115, and single pieces from it were found scattered on the floor of the Antechamber, passage, and staircase. It was interesting working out the way in which it all fitted together, and the photographs on Plate XXXVIII show our tentative reconstruction.

In Plate XXXVII we see the corslet proper as it lay in Box 54, resting upon a number of faience libation vases. This gave us the pattern and arrangement, with its upper and lower bands of inlaid gold plaques, and we were also able to recover from it its exact height in two or three separate places, and the fact that it was not the same height all the way round. It showed us, besides, that the upper row of the collar was joined on to the gold plaque brace bands, and that the gold bars fitted at the shoulders to the top of the brace bands. The exact order of the collar was recovered from the parts found in the gold shrine. The pectorals were also in the gold shrine, lying beside the collar sections, and that they actually fitted to the collar was proved by the curve of their upper edges. There were other gold bars in addition to those for the shoulders, and the perforated thread-holes in these, corresponding exactly with the holes in the scales, showed that they must have belonged to the corslet proper. These bars and the shoulder-bars alike were held together by sliding pins, to be adjusted after the corslet was in position. Our present reconstruction is purely a tentative one put together for photographic purposes, but the only really doubtful point in it is whether the gold bars fit to the front and back of the corslet, as they are

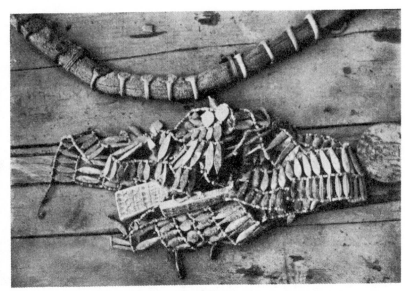

A

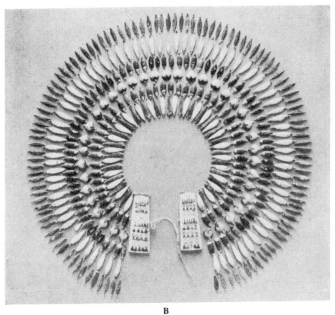

B

Plate XXXIX

(A) COLLAR RESTING ON LID OF BOX No. 54.
(B) RECONSTRUCTION OF THE COLLAR.

here shown, or to its sides. The reason we have placed them in this position is that the bars are of different sizes, and by no combination is it possible to make the two equal lengths which the sides would require. The front and back of the corslet, on the other hand, we know were of different lengths. There are still a number of pieces missing, and these we hope may still turn up in the innermost chamber or in the Annexe.

The greater part of our winter's work in the laboratory was concerned with the boxes, working out and sorting over their confused jumble of contents. The single, larger, objects were much easier to deal with. Some were in very good condition, requiring nothing but surface cleaning and noting, but there were others which needed a certain amount of attention, if only minor repairs to make them fit for transport. In all our mending we had constant recourse to our box of floor-sweepings, fragments recovered by sweeping up and sifting the last layer of dust from the floor both of the Antechamber and entrance passage, and not infrequently we found there the piece of inlay, or whatever it might be, for which we were looking. The chariots we have not yet made any attempt to deal with. That must be done in Cairo later on, for they are in a great many sections, and their sorting and treatment will require very considerable working space—much more space than we can possibly arrange for in The Valley. As I explained earlier in the chapter, the restoration and study of the material from this tomb will provide work for all of us for many years to come. In the field, preliminary work is as much as we can hope to do.

At the end of the season there came the question of packing, always an anxious business, but doubly so in this case owing to the enormous value of the material. Protection from dust as well as from actual damage was an important point, so every object was completely wrapped in cotton-wool or cloth, or both, before it was placed in its box. Delicate surfaces, such as the parts of the throne, the legs of the chairs and beds, or the bows and staves, were swathed in narrow bandages, in case anything should work loose in transit. Very fragile objects, like the funerary bouquets and the sandals, which would not bear ordinary packing, were laid in bran. Great care was taken to keep the antiquities in strictly classified groups, textiles all in one box, jewellery all in another, and so on. There may well be a delay of a year or two before some of the boxes are unpacked, and it will be a great saving of time and labour if all the objects of one type are in a single box. Eighty-nine boxes in all were packed, but to lessen the danger in transit these were enclosed within thirty-four heavy packing-cases.

Then came the question of transport. At the river bank a steam barge was waiting, sent by the Department of Antiquities, but between the laboratory and the river stretched a distance of five and a half miles of rough road, with awkward curves and dangerous gradients. Three possibilities of transport were open to us—camels, hand porterage and Décauville railway, and we decided on the third as least likely to jar the cases. They were loaded, accordingly, on a number of flat cars, and by the evening of May 13th they were ready to begin their journey down The Valley, the road by which they

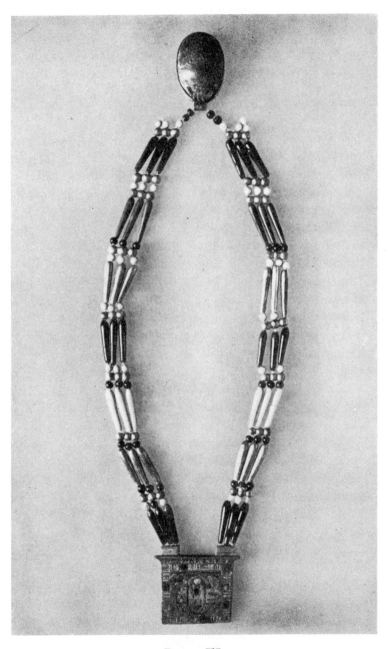

PLATE XL

NECKLACE RESTRUNG IN ORIGINAL ORDER.

had passed, under such different circumstances, three thousand years before.

At daybreak on the following morning the cars began to move. Now, when we talk of railways the reader must not imagine that we had a line laid down for us all the way to the river, for a permanent way would take many months to construct. We had, on the contrary, to lay it as we went, carrying the rails round in a continuous chain as the cars moved forward. Fifty labourers were engaged in the work, and each had his particular job, pushing the cars, laying the rails, or bringing up the spare ones from behind. It sounds a tedious process, but it is wonderful how fast the ground can be covered. By ten o'clock on the morning of the 15th—fifteen hours of actual work—the whole distance had been accomplished, and the cases were safely stowed upon the barge. There were some anxious moments in the rough Valley-road, but nothing untoward happened, and the fact that the whole operation was carried out in such short time, and without any kind of mishap, is a fine testimonial to the zeal of our workmen. I may add that the work was carried out under a scorching sun, with a shade temperature of considerably over a hundred, the metal rails under these conditions being almost too hot to touch.

On the river journey the cases were in charge of an escort of soldiers supplied by the Mudir of the Province, and after a seven-day journey all arrived safely in Cairo. There we unpacked a few of the more valuable objects, to be placed on immediate exhibition. The rest of the cases remain stored in the museum until such time as we shall be able to take in hand the question of final restorations.

CHAPTER XI

THE OPENING OF THE SEALED DOOR

BY the middle of February our work in the Antechamber was finished. With the exception of the two sentinel statues, left for a special reason, all its contents had been removed to the laboratory, every inch of its floor had been swept and sifted for the last bead or fallen piece of inlay, and it now stood bare and empty. We were ready at last to penetrate the mystery of the sealed door.

Friday, the 17th, was the day appointed, and at two o'clock those who were to be privileged to witness the ceremony met by appointment above the tomb. They included Lord Carnarvon, Lady Evelyn Herbert, H.E. Abd el Halim Pasha Suleman, Minister of Public Works, M. Lacau, Director-General of the Service of Antiquities, Sir William Garstin, Sir Charles Cust, Mr. Lythgoe, Curator of the Egyptian Department of the Metropolitan Museum, New York, Professor Breasted, Dr. Alan Gardiner, Mr. Winlock, the Hon. Mervyn Herbert, the Hon. Richard Bethell, Mr. Engelbach, Chief Inspector of the Department of Antiquities, three Egyptian inspectors of the Department of Antiquities, the representative of the Government Press Bureau, and the members of the staff—about twenty persons in all. By a quarter past two the whole company had assembled, so we removed our coats and filed down the sloping passage into the tomb.

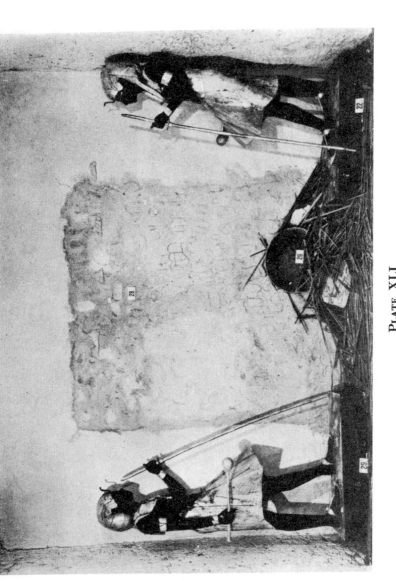

PLATE XLI

SENTINEL FIGURES GUARDING THE SEALED DOORWAY TO THE SEPULCHRAL CHAMBER.

The Opening of the Sealed Door

In the Antechamber everything was prepared and ready, and to those who had not visited it since the original opening of the tomb it must have presented a strange sight. We had screened the statues with boarding to protect them from possible damage, and between them we had erected a small platform, just high enough to enable us to reach the upper part of the doorway, having determined, as the safest plan, to work from the top downwards. A short distance back from the platform there was a barrier, and beyond, knowing that there might be hours of work ahead of us, we had provided chairs for the visitors. On either side standards had been set up for our lamps, their light shining full upon the doorway. Looking back, we realize what a strange, incongruous picture the chamber must have presented, but at the time I question whether such an idea even crossed our minds. One thought and one only was possible. There before us lay the sealed door, and with its opening we were to blot out the centuries and stand in the presence of a king who reigned three thousand years ago. My own feelings as I mounted the platform were a strange mixture, and it was with a trembling hand that I struck the first blow.

My first care was to locate the wooden lintel above the door : then very carefully I chipped away the plaster and picked out the small stones which formed the uppermost layer of the filling. The temptation to stop and peer inside at every moment was irresistible, and when, after about ten minutes' work, I had made a hole large enough to enable me to do so, I inserted an electric torch. An astonishing sight its light revealed, for there, within a yard of

the doorway, stretching as far as one could see and blocking the entrance to the chamber, stood what to all appearance was a solid wall of gold. For the moment there was no clue as to its meaning, so as quickly as I dared I set to work to widen the hole. This had now become an operation of considerable difficulty, for the stones of the masonry were not accurately squared blocks built regularly upon one another, but rough slabs of varying size, some so heavy that it took all one's strength to lift them : many of them, too, as the weight above was removed, were left so precariously balanced that the least false movement would have sent them sliding inwards to crash upon the contents of the chamber below. We were also endeavouring to preserve the seal-impressions upon the thick mortar of the outer face, and this added considerably to the difficulty of handling the stones. Mace and Callender were helping me by this time, and each stone was cleared on a regular system. With a crowbar I gently eased it up, Mace holding it to prevent it falling forwards ; then he and I lifted it out and passed it back to Callender, who transferred it on to one of the foremen, and so, by a chain of workmen, up the passage and out of the tomb altogether.

With the removal of a very few stones the mystery of the golden wall was solved. We were at the entrance of the actual burial-chamber of the king, and that which barred our way was the side of an immense gilt shrine built to cover and protect the sarcophagus. It was visible now from the Antechamber by the light of the standard lamps, and as stone after stone was removed, and its gilded surface came gradually into view, we could, as though

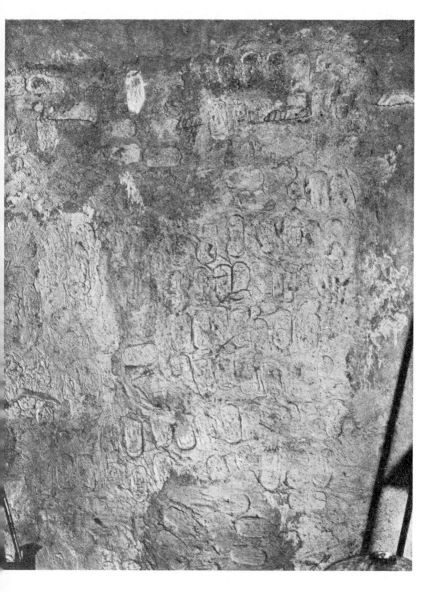

PLATE XLII

SEALED DOORWAY TO THE SEPULCHRAL CHAMBER.
(Showing the re-closing of the plunderers' hole at bottom.)

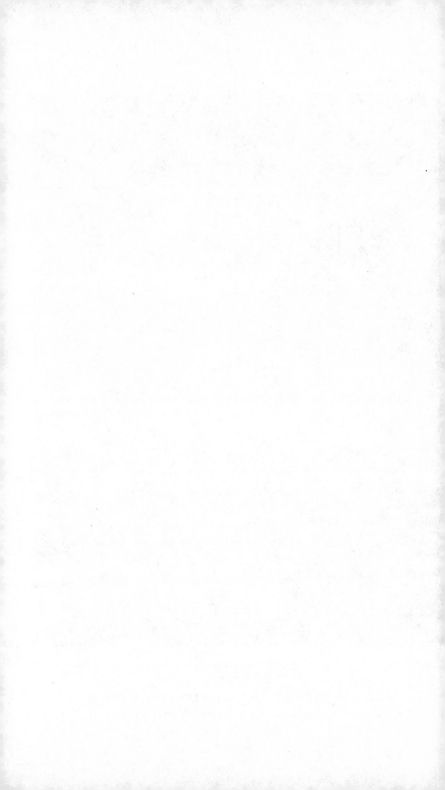

by electric current, feel the tingle of excitement which thrilled the spectators behind the barrier. The photographs on Plates XLIII and XLIV, taken during the progress of the work, will give the reader some idea of what they actually saw. We who were doing the work were probably less excited, for our whole energies were taken up with the task in hand —that of removing the blocking without an accident. The fall of a single stone might have done irreparable damage to the delicate surface of the shrine, so, directly the hole was large enough, we made an additional protection for it by inserting a mattress on the inner side of the door-blocking, suspending it from the wooden lintel of the doorway. Two hours of hard work it took us to clear away the blocking, or at least as much of it as was necessary for the moment; and at one point, when near the bottom, we had to delay operations for a space while we collected the scattered beads from a necklace brought by the plunderers from the chamber within and dropped upon the threshold. This last was a terrible trial to our patience, for it was a slow business, and we were all of us excited to see what might be within ; but finally it was done, the last stones were removed, and the way to the innermost chamber lay open before us.

In clearing away the blocking of the doorway we had discovered that the level of the inner chamber was about four feet lower than that of the Antechamber, and this, combined with the fact that there was but a narrow space between door and shrine, made an entrance by no means easy to effect. Fortunately, there were no smaller antiquities at this end of the chamber, so I lowered myself down,

and then, taking one of the portable lights, I edged cautiously to the corner of the shrine and looked beyond it. At the corner two beautiful alabaster vases blocked the way, but I could see that if these were removed we should have a clear path to the other end of the chamber ; so, carefully marking the spot on which they stood, I picked them up— with the exception of the king's wishing-cup they were of finer quality and more graceful shape than any we had yet found—and passed them back to the Antechamber. Lord Carnarvon and M. Lacau now joined me, and, picking our way along the narrow passage between shrine and wall, paying out the wire of our light behind us, we investigated further.

It was, beyond any question, the sepulchral chamber in which we stood, for there, towering above us, was one of the great gilt shrines beneath which kings were laid. So enormous was this structure (17 feet by 11 feet, and 9 feet high, we found afterwards) that it filled within a little the entire area of the chamber, a space of some two feet only separating it from the walls on all four sides, while its roof, with cornice top and torus moulding, reached almost to the ceiling. From top to bottom it was overlaid with gold, and upon its sides there were inlaid panels of brilliant blue faience, in which were represented, repeated over and over, the magic symbols which would ensure its strength and safety. Around the shrine, resting upon the ground, there were a number of funerary emblems, and, at the north end, the seven magic oars the king would need to ferry himself across the waters of the underworld. The walls of the chamber, unlike those of the Antechamber,

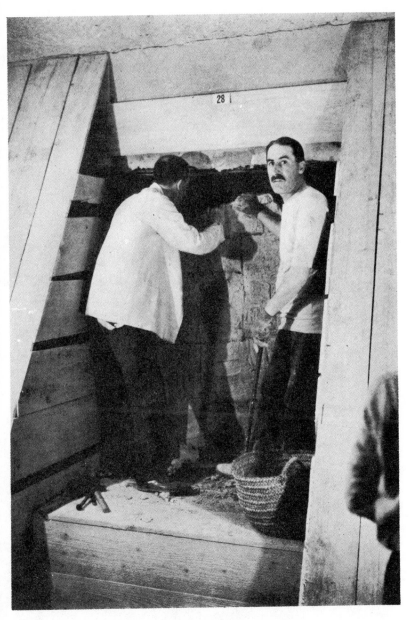

Plate XLIII

OPENING OF THE SEALED DOORWAY TO THE SEPULCHRAL
CHAMBER: CARNARVON AND CARTER.

PLATE XLIV

OPENING OF THE SEALED DOORWAY TO THE SEPULCHRAL
CHAMBER: CARTER AND MACE.

were decorated with brightly painted scenes and inscriptions, brilliant in their colours, but evidently somewhat hastily executed.

These last details we must have noticed subsequently, for at the time our one thought was of the shrine and of its safety. Had the thieves penetrated within it and disturbed the royal burial? Here, on the eastern end, were the great folding doors, closed and bolted, but not sealed, that would answer the question for us. Eagerly we drew the bolts, swung back the doors, and there within was a second shrine with similar bolted doors, and upon the bolts a seal, intact. This seal we determined not to break, for our doubts were resolved, and we could not penetrate further without risk of serious damage to the monument. I think at the moment we did not even want to break the seal, for a feeling of intrusion had descended heavily upon us with the opening of the doors, heightened, probably, by the almost painful impressiveness of a linen pall, decorated with golden rosettes, which drooped above the inner shrine. We felt that we were in the presence of the dead King and must do him reverence, and in imagination could see the doors of the successive shrines open one after the other till the innermost disclosed the King himself. Carefully, and as silently as possible, we re-closed the great swing doors, and passed on to the farther end of the chamber.

Here a surprise awaited us, for a low door, eastwards from the sepulchral chamber, gave entrance to yet another chamber, smaller than the outer ones and not so lofty. This doorway, unlike the others, had not been closed and sealed. We were able, from where we stood, to get a clear view of the whole of

the contents, and a single glance sufficed to tell us that here, within this little chamber, lay the greatest treasures of the tomb. Facing the doorway, on the farther side, stood the most beautiful monument that I have ever seen—so lovely that it made one gasp with wonder and admiration. The central portion of it consisted of a large shrine-shaped chest, completely overlaid with gold, and surmounted by a cornice of sacred cobras. Surrounding this, free-standing, were statues of the four tutelary goddesses of the dead—gracious figures with outstretched protective arms, so natural and lifelike in their pose, so pitiful and compassionate the expression upon their faces, that one felt it almost sacrilege to look at them. One guarded the shrine on each of its four sides, but whereas the figures at front and back kept their gaze firmly fixed upon their charge, an additional note of touching realism was imparted by the other two, for their heads were turned sideways, looking over their shoulders towards the entrance, as though to watch against surprise. There is a simple grandeur about this monument that made an irresistible appeal to the imagination, and I am not ashamed to confess that it brought a lump to my throat. It is undoubtedly the Canopic chest and contains the jars which play such an important part in the ritual of mummification.

There were a number of other wonderful things in the chamber, but we found it hard to take them in at the time, so inevitably were one's eyes drawn back again and again to the lovely little goddess figures. Immediately in front of the entrance lay the figure of the jackal god Anubis, upon his shrine, swathed in linen cloth, and resting upon a portable

sled, and behind this the head of a bull upon a stand —emblems, these, of the underworld. In the south side of the chamber lay an endless number of black shrines and chests, all closed and sealed save one, whose open doors revealed statues of Tut·ankh·Amen standing upon black leopards. On the farther wall were more shrine-shaped boxes and miniature coffins of gilded wood, these last undoubtedly containing funerary statuettes of the king. In the centre of the room, left of the Anubis and the bull, there was a row of magnificent caskets of ivory and wood, decorated and inlaid with gold and blue faience, one, whose lid we raised, containing a gorgeous ostrich-feather fan with ivory handle, fresh and strong to all appearance as when it left the maker's hand. There were also, distributed in different quarters of the chamber, a number of model boats with sails and rigging all complete, and, at the north side, yet another chariot.

Such, from a hurried survey, were the contents of this innermost chamber. We looked anxiously for evidence of plundering, but on the surface there was none. Unquestionably the thieves must have entered, but they cannot have done more than open two or three of the caskets. Most of the boxes, as has been said, have still their seals intact, and the whole contents of the chamber, in fortunate contrast to those of the Antechamber and the Annexe, still remain in position exactly as they were placed at the time of burial.

How much time we occupied in this first survey of the wonders of the tomb I cannot say, but it must have seemed endless to those anxiously waiting in the Antechamber. Not more than three at a time

could be admitted with safety, so, when Lord Carnarvon and M. Lacau came out, the others came in pairs : first Lady Evelyn Herbert, the only woman present, with Sir William Garstin, and then the rest in turn. It was curious, as we stood in the Antechamber, to watch their faces as, one by one, they emerged from the door. Each had a dazed, bewildered look in his eyes, and each in turn, as he came out, threw up his hands before him, an unconscious gesture of impotence to describe in words the wonders that he had seen. They were indeed indescribable, and the emotions they had aroused in our minds were of too intimate a nature to communicate, even though we had the words at our command. It was an experience which, I am sure, none of us who were present is ever likely to forget, for in imagination—and not wholly in imagination either—we had been present at the funeral ceremonies of a king long dead and almost forgotten. At a quarter past two we had filed down into the tomb, and when, three hours later, hot, dusty, and dishevelled, we came out once more into the light of day, the very Valley seemed to have changed for us and taken on a more personal aspect. We had been given the Freedom.

February 17th was a day set apart for an inspection of the tomb by Egyptologists, and fortunately most of those who were in the country were able to be present. On the following day the Queen of the Belgians and her son Prince Alexander, who had come to Egypt for that special purpose, honoured us with a visit, and were keenly interested in everything they saw. Lord and Lady Allenby and a num-

PLATE XLV

THE SHRINE WITHIN THE SEPULCHRE.

ber of other distinguished visitors were present on this occasion. A week later, for reasons stated in an earlier chapter, the tomb was closed and once again re-buried.

So ends our preliminary season's work on the tomb of King Tut·ankh·Amen. Now as to that which lies ahead of us. In the coming winter our first task, a difficult and anxious one, will be the dismantling of the shrines in the sepulchral chamber. It is probable, from evidence supplied by the Rameses IV papyrus, that there will be a succession of no fewer than five of these shrines, built one within the other, before we come to the stone sarcophagus in which the king is lying, and in the spaces between these shrines we may expect to find a number of beautiful objects. With the mummy—if, as we hope and believe, it remains untouched by plunderers—there should certainly lie the crowns and other regalia of a king of Egypt. How long this work in the sepulchral chamber will take we cannot tell at present, but it must be finished before we tackle the innermost chamber of all, and we shall count ourselves lucky if we can accomplish the clearing of both in a single season. A further season will surely be required for the Annexe with its confused jumble of contents.

Imagination falters at the thought of what the tomb may yet disclose, for the material dealt with in the present volume represents but a quarter—and that probably the least important quarter—of the treasure which it contains. There are still many exciting moments in store for us before we complete our task, and we look forward eagerly to the work that lies ahead. One shadow must inevitably rest

upon it, one regret, which all the world must share—the fact that Lord Carnarvon was not permitted to see the full fruition of his work; and in the completion of that work we, who are to carry it out, would dedicate to his memory the best that in us lies.

APPENDIX

DESCRIPTION OF THE OBJECTS

(Plates XLVI—LXXIX)

Plate XLVI

THE KING'S WISHING-CUP IN ALABASTER (CALCITE) OF LOTIFORM

The decoration of the bowl comprises a whorl of calices and sepals in low relief. The handles consist of lotus flowers and buds supporting the emblem of "Eternal Life." Upon the bowl are the prenomen and nomen of the king, and the legend around the rim reads:

"May he live, Horus 'Strong Bull fair of births,' the Two Goddesses 'Beautiful of ordinances, quelling the Two Lands,' Horus of Gold 'Wearing the diadems and propitiating the Gods,' The King of Upper and Lower Egypt, Lord of the Two Lands, Neb·Kheperu·Re, granted life." [1]

"Live thy *Ka*, and mayst thou spend millions of years, thou lover of Thebes, sitting with thy face to the north wind, and thy eyes beholding felicity." [2]

[1] The titulary of Tut·ankh·Amen.
[2] The wish.

PLATE XLVI

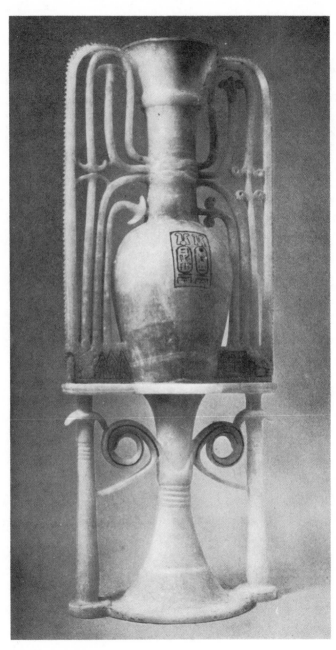

PLATE XLVII

PLATE XLVII

ALABASTER (CALCITE) PERFUME VASE RESTING
UPON AN ORNAMENTAL STAND

It is flanked by the emblem of "Myriads of
Years," and the bindings of papyrus and lotus
which symbolize the union of the "Two Lands" or
Kingdoms of Upper and Lower Egypt.

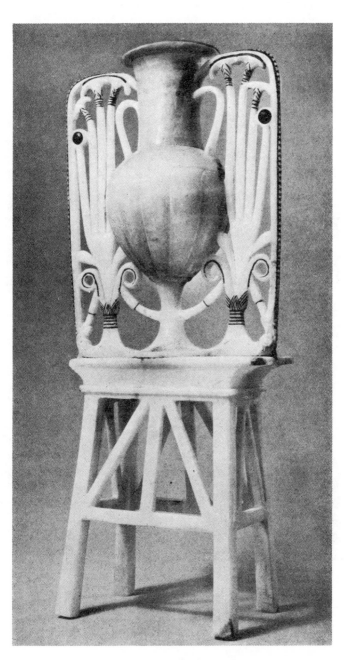

PLATE XLVIII

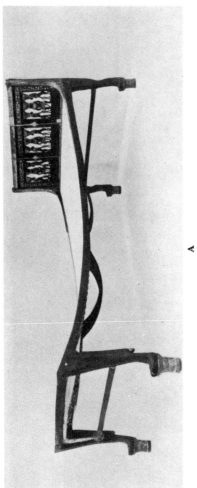

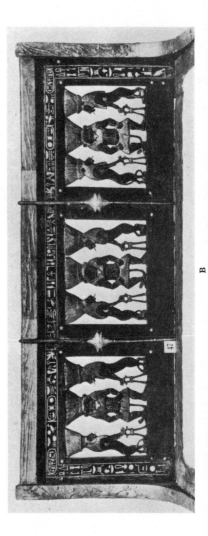

A

B

PLATE XLIX

(A) ONE OF THE KING'S BEDS CARVED IN SOLID
EBONY WITH STRING MESH

The fore and hind legs are of feline type.

(B) The open-work foot panel, of ebony, ivory
and gold, represents BES and THOUERIS, the tute-
lary gods of the household.

PLATE L

SCENE IN MINIATURE PAINTING UPON THE
RIGHT-HAND SIDE OF THE LID OF THE PAINTED
CASKET, No. 21

In the centre we see the king in his chariot
shooting desert fauna, among which can be identified
gazelle, hartebeest, wild-ass, ostrich, and striped
hyena, fleeing before His Majesty's hounds. Behind
the king are represented his fan-bearers, courtiers
and body-guard. In the field are depicted desert
flora.

(*See* pp. 110-111.)

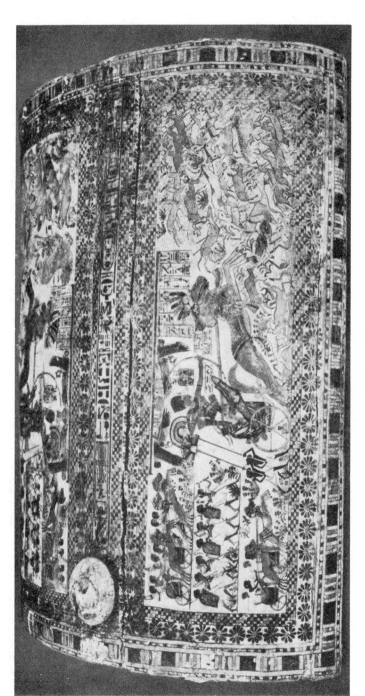

PLATE L

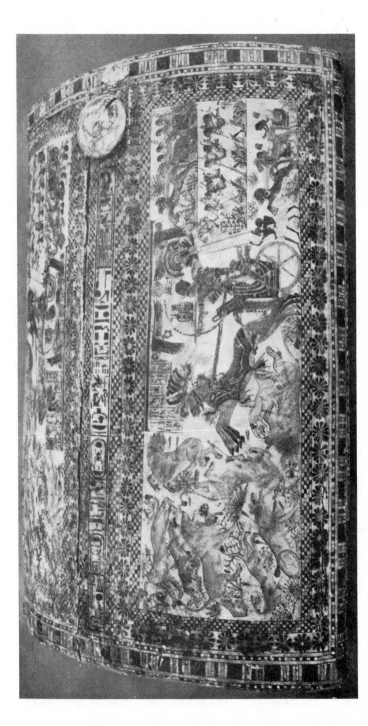

PLATE LI

SCENE IN MINIATURE PAINTING UPON THE
LEFT-HAND SIDE OF THE LID OF THE PAINTED
CASKET, No. 21

This is a similar composition to that in the pre-
ceding plate (L), but here Tut · ankh · Amen hunts
lions and lionesses. The minuteness of detail, sense
of movement, and agonized expression of the dying
animals rank this miniature painting as the finest
of its kind, far surpassing Persian examples.

(*See* pp. 110-111.)

PLATE LII

SCENE IN MINIATURE PAINTING UPON THE LEFT
SIDE PANEL OF THE PAINTED CASKET, No. 21

Here Tut·ankh·Amen is represented in his war
chariot, slaughtering his Southern or African foes.
He is supported by fan-bearers, charioteers and bow-
men, and above him are the protective vultures of
NEKHEBET, and the Sun's disk encircled by Royal
URAEI with pendant " ANKHS," the symbols of life.

(*See* pp. 110-111.)

PLATE LII

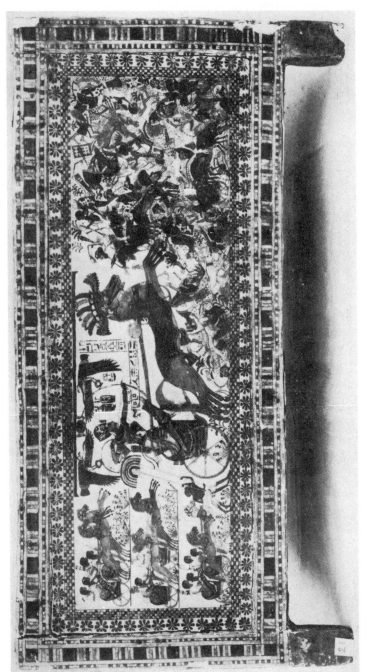

PLATE LIII

Plate LIII

SCENE IN MINIATURE PAINTING UPON THE RIGHT
SIDE PANEL OF THE PAINTED CASKET, No. 21

The scheme of ornamentation here is similar to
that on the left side panel (Plate LII), except that
the king is represented slaughtering his Northern or
Asiatic enemies. The whole mass of this ornament,
like that of the left panel, is made up of multi-
tudinous human figures in every kind of action—and
magnificent action. The king is shown in his chariot,
drawing his bow, his sheaves of arrows rattling at
his sides, and the slain falling under him as before
a pestilence.

(*See* pp. 110-111.)

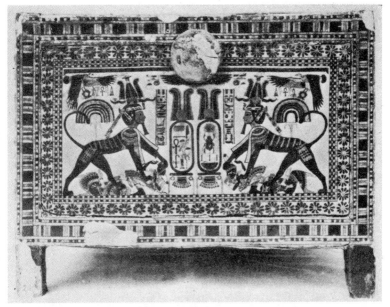

A

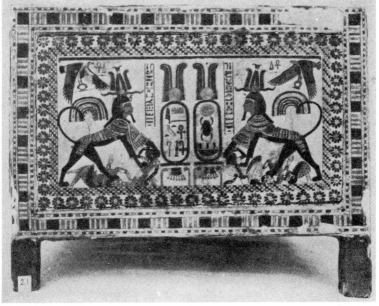

B

PLATE LIV

PLATE LV

LARGE CEDAR-WOOD CASKET INLAID AND VENEERED
WITH EBONY AND IVORY
(No. 32)

The casket has sliding poles to carry it by, fixed
in staples on the bottom.

PLATE LVI

(A) AN ALABASTER (CALCITE) CASKET
(No. 40)

The ornamentation is deeply incised and filled in with coloured pigments. The knobs are made of polished obsidian—a natural volcanic glass.

(B) DECORATED GILT CASKET
(No. 44)

The panels of the lid and four sides of the box are of blue faience overlaid with gilt gesso ornamentation. The devices on the side panels comprise the prenomen and nomen of the king, with pendant URAEI surmounted with sun-disks. On the lid are the banner-names of the king, and on the front of the casket are the symbols " HEH " of Eternity. The knobs are of violet faience with cartouches of the king inlaid in pale blue.

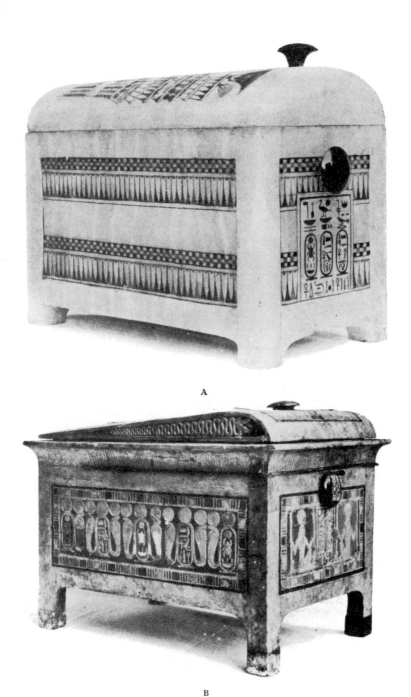

A

B

PLATE LVI

A

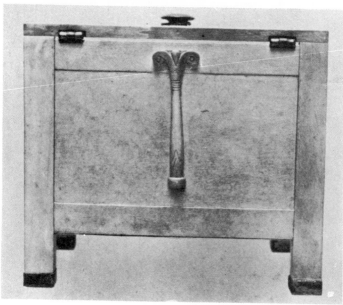

B

PLATE LVII

PLATE LVII

(A) A SOLID IVORY JEWEL BOX
(No. 54 ddd)

The knobs, hinges and feet casings are of gold. Carved on the front are Horus-name, prenomen and nomen of Tut·ankh·Amen.

(B) View showing on the back of the box a column with lotus capital symbolizing Upper Egypt.

PLATE LVIII

THE LARGE VAULTED-TOP BOX (No. 101)

It is of painted wood and bears in front the cartouches of Tut · ankh · Amen and that of his queen, Ankh · es · en · Amen. It contained the king's linen.

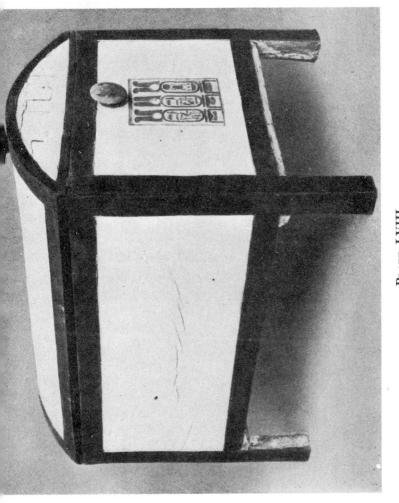

PLATE LVIII

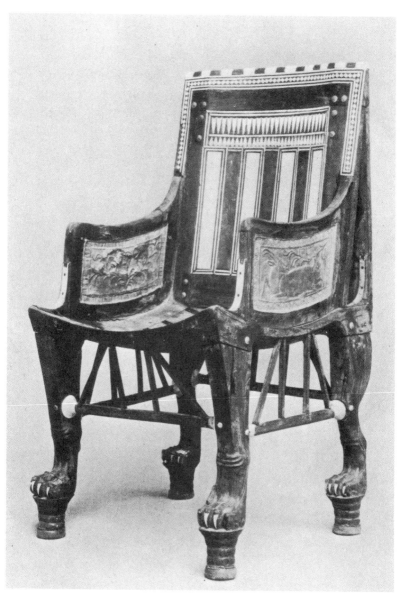

PLATE LIX

PLATE LIX

A CHILD'S CHAIR
(No. 39)

This small chair, probably the king's when a child, is carved of ebony and inlaid with ivory. It has antelope and floral devices of embossed gold on the panels of the arms.

PLATE LX

A CARVED CEDAR-WOOD CHAIR
(No. 87)

This magnificent cedar-wood chair has the winged solar disk, angle pieces and studs in embossed gold. The claws are of ivory, the foot-pieces sheathed with gold and bronze. The open-work gold-plated ornamentation between the seat and rails, torn away by the plunderers, represented the "Union of Upper and Lower Egypt" in the form of lotus and papyrus flowers symbolizing the binding together of these two countries.

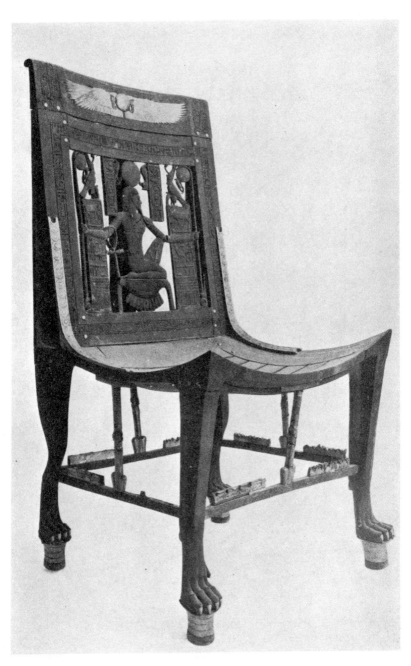

PLATE LX

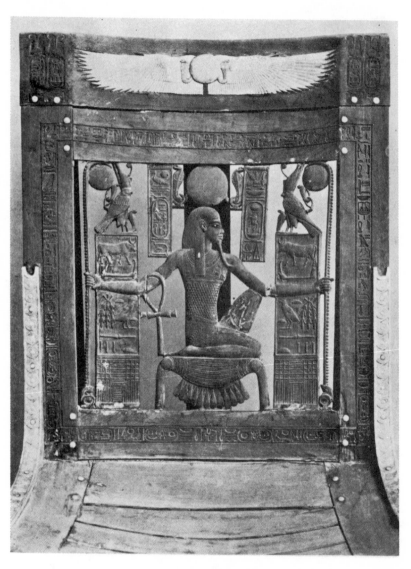

PLATE LXI

Plate LXI

THE OPEN-WORK PANEL OF THE BACK OF THE CARVED CEDAR-WOOD CHAIR, No. 87
(*See* Plate LX)

The carved open-work device comprises a central figure of " HEH " kneeling upon a " Nub "-sign symbolizing " Golden Eternity." In each hand are the emblems of " Myriads of Years," and on the right arm hangs the " Ankh," the symbol of " Life." On both sides of the central figure are the Horus-names of the king, surmounted by the Horus-hawk wearing the crowns of Upper and Lower Egypt, and before it the royal cobra. Surmounting the figure of " Golden Eternity " is the solar disk flanked by the prenomen and nomen of Tut · ankh · Amen. On the upper rail the winged solar disk is of embossed sheet gold.

PLATE LXII

THE KING'S GOLDEN THRONE
(No. 91)
(*See* Plates II, LXIII and LXIV)

A magnificent chair of wood overlaid with sheet gold and richly adorned with polychrome faience, glass and stone inlay, of El Amarna art. Its legs, of feline form, are surmounted by lions' heads in chased gold of beautiful simplicity. The arms are formed of crowned and winged serpents supporting with their wings the king's cartouches, and between the vertical bars which support the back there are six protective URAEI carved in wood, gilt and inlaid, with crowns and solar disks. The heads of these serpents are of violet faience, the crowns of silver and gold, and the disks of wood gilt. Behind, on the back panel, is a scene in relief of papyrus rushes and water-fowl (*see* Plate LXIV). On the front panel of the back of the throne is a beautiful and unique inlaid palace scene of the king and the queen (for description *see* Plate II, and pp. 46 and 117). The missing gold open-work device between the rail and seat of the throne, wrenched away for the metal by the tomb-robbers, consisted of papyrus and lotus flowers bound to the central " sma "-sign, and symbolized the " Union of the Two Lands," i.e. the Kingdoms of Upper and Lower Egypt.

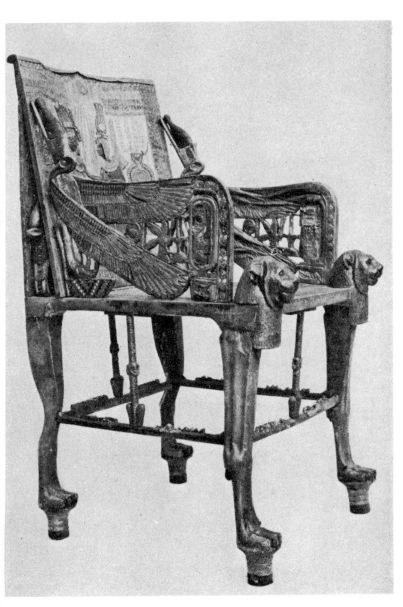

PLATE LXII

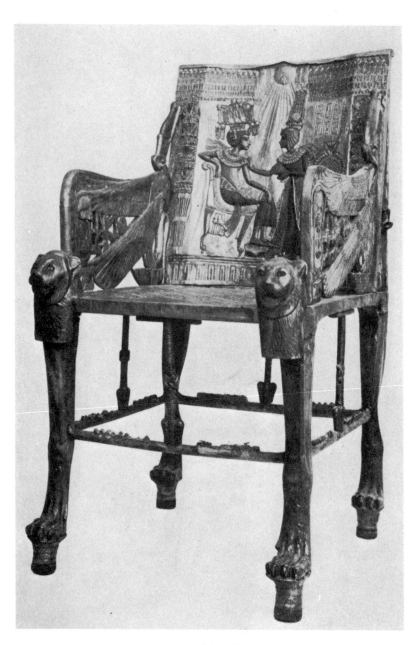

PLATE LXIII

PLATE LXIII

THE KING'S GOLDEN THRONE
(No. 91)

A magnificent chair of wood overlaid with sheet gold and richly adorned with polychrome faience, glass and stone inlay, of El Amarna art (*see* Plates II, LXII and LXIV).

THE KING'S GOLDEN THRONE
(No. 91)

A magnificent chair of wood overlaid with sheet gold and richly adorned with polychrome faience, glass and stone inlay, of El Amarna art (*see* Plates II, LXII and LXIII).

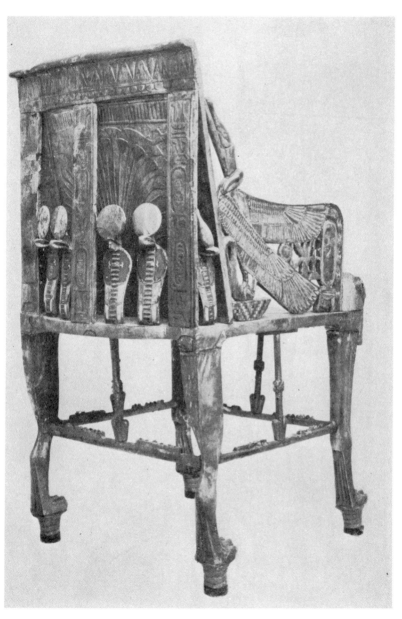

PLATE LXIV

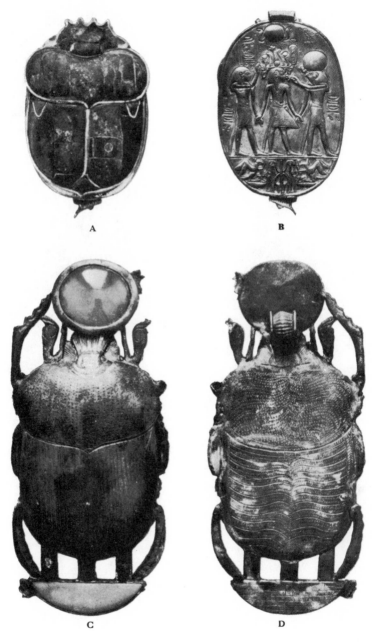

PLATE LXV

PLATE LXV

(A) A LARGE PENDANT SCARAB OF GOLD AND LAPIS
LAZULI BLUE GLASS

(B) BEZEL OF SCARAB

depicting the king between the god Atum (left) and
the sun-god Horus (right), the latter deity giving
Tut·ankh·Amen the symbol of life. Above the king
is the solar disk radiating life, and below is a decora-
tive device symbolical of the "Union of the Two
Kingdoms," Upper and Lower Egypt.

(C) A GOLD PENDANT

in the form of Kheperu·neb·Re, the first cartouche
of Tut·ankh·Amen. It is inlaid with carnelian and
coloured glass.

(D) THE CHASED BACK OF PENDANT (C)

Plate LXVI

(A) THE CENTRAL PECTORAL OF THE CORSLET

The device represents Tut · ankh · Amen (in the centre) being introduced by a god and goddess to the Theban deity Amen.

(B) THE BACK PENDANT OF THE CORSLET OF GOLD RICHLY INLAID

The device includes the winged " Kheper "-beetle supporting the solar disk, and has the talons and tail of the solar hawk holding symbols of life. Pendant to the beetle are two royal cobras wearing the White Crown of Upper Egypt and the Red Crown of Lower Egypt, and upon them hang the symbols of life (*see* Plate XXXVIII, and pp. 116, 136 and 173).

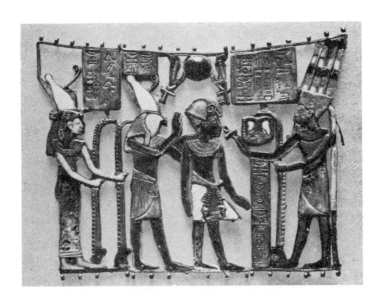

A

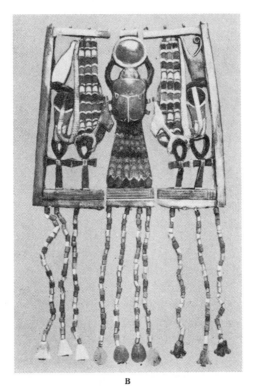

B

PLATE LXVI

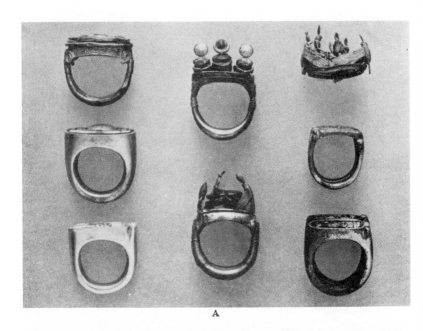

A

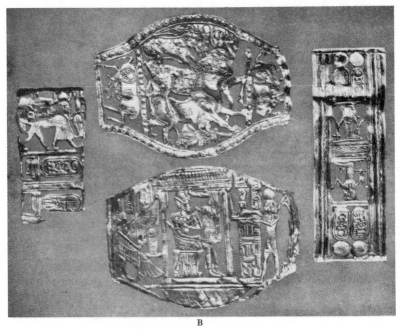

B

PLATE LXVII

Plate LXVII

(A) SEVEN FINGER-RINGS AND AN ORNAMENTAL FINGER-RING BEZEL

These rings are of solid gold and are richly decorated with inlay (*see* Plate XXX, and p. 138).

(B) GOLD BUCKLES OF OPEN-WORK SHEET GOLD, WITH APPLIED PATTERN IN TINY GRANULES

One device is a hunting scene; in the other Tut·ankh·Amen is seated upon his throne.

(*See* p. 114.)

Plate LXVIII

THE SMALL GOLDEN SHRINE

It is of naos shape upon a sled. The carved woodwork is overlaid with sheet gold upon which various scenes are chased.

(*See* Plate XXIX and pp. 46, 119-120.)

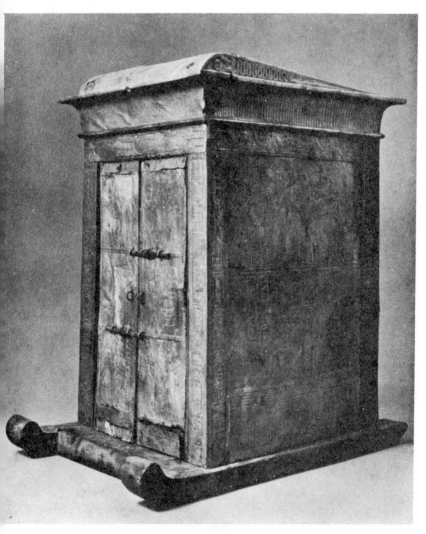

PLATE LXVIII

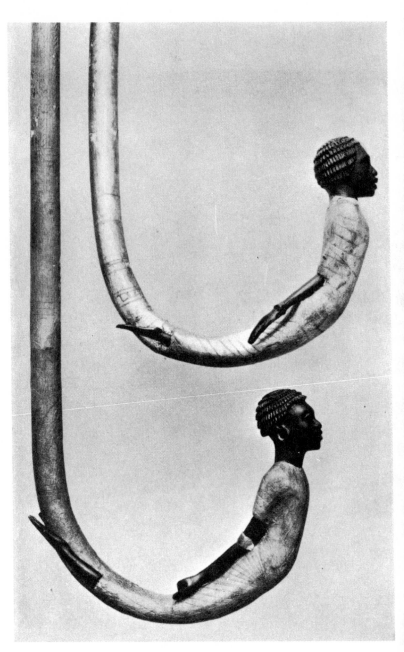

PLATE LXIX

Plate LXIX

TWO CEREMONIAL WALKING-STICKS COVERED WITH
THIN GOLD FOIL

The heads, arms and feet of the African prisoners are of ebony and are notable for their exquisite carving.

PLATE LXX

A CEREMONIAL WALKING-STICK

similar to those on the preceding Plate (LXIX). On this stick are represented the two foes of the king, symbolizing the Northern and Southern enemies of Egypt. The Asiatic type (A) is of ivory, the African type (B) is of ebony. They are unique in Egyptian art.

(*See* p. 115.)

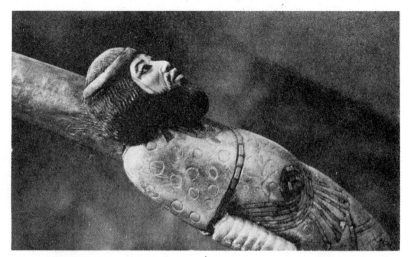

A

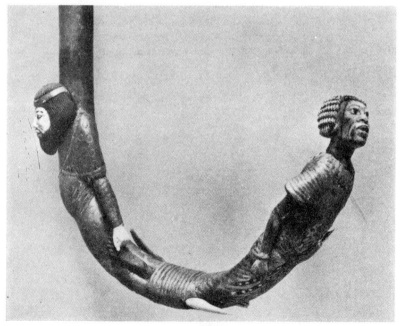

B

PLATE LXX

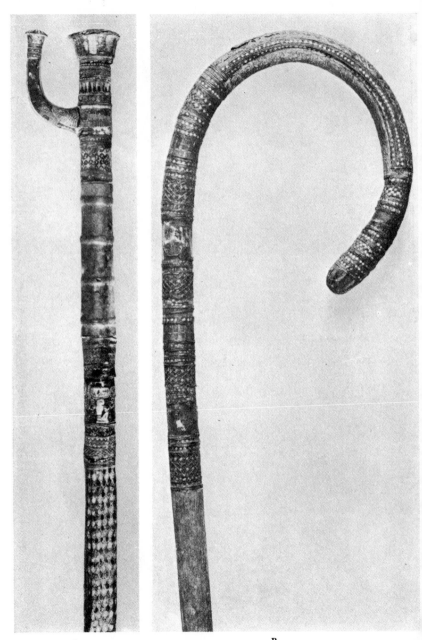

A B

PLATE LXXI

PLATE LXXI

A STAFF AND STICK

(A) This staff is decorated with ornamental barks and is inlaid with elytra of iridescent beetles.

(B) A curved-handled stick, gilt and elaborately decorated with coloured barks.

(*See* p. 115.)

PLATE LXXII

STICKS AND WHIPS WITH ORNAMENTAL HANDLES
IN GOLD-WORK

The first stick on the left is of gold. The second,
a whip, is of ivory and has a long hieroglyphic
inscription. The ornamentation of the third (centre)
stick is in granulated gold-work. The other two are
of wood embellished with gold foil.

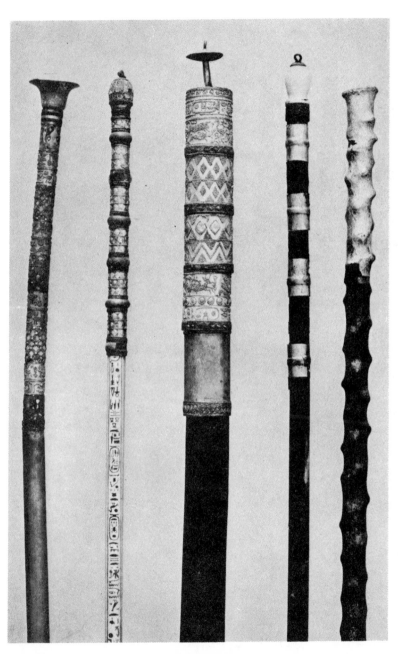

PLATE LXXII

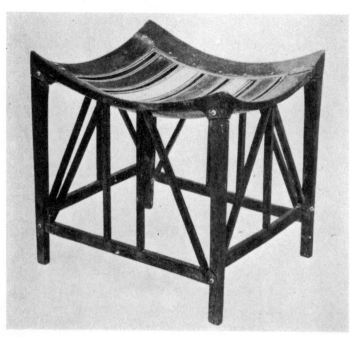

A

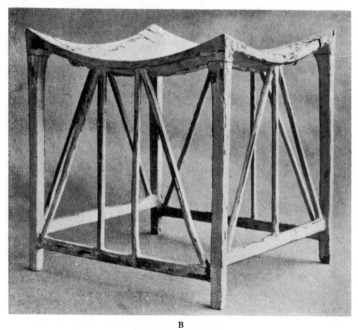

B

PLATE LXXIII

Plate LXXIII

TWO STOOLS

(A) Red-wood trellis-work stool inlaid with ivory and ebony.

(B) A wooden trellis-work stool painted white.

Plate LXXIV

TWO STOOLS

(A) An ornamental wooden stool painted white. The open-work device is symbolical of the " Union of the Two Kingdoms," Upper and Lower Egypt.

(B) An ebony stool richly inlaid with ivory and embellished with heavy gold mountings. The seat of the stool is devised to represent an animal's skin, and the legs terminate in ducks' heads.

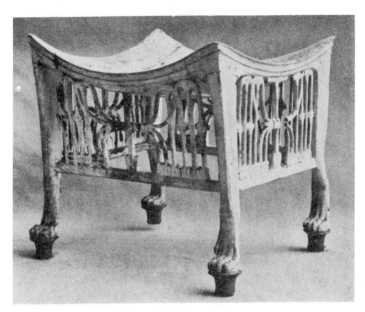

A

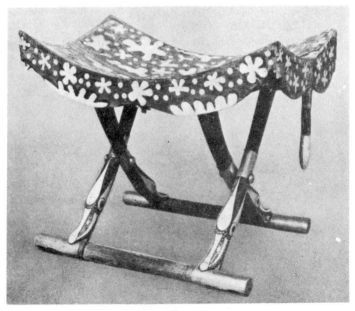

B

PLATE LXXIV

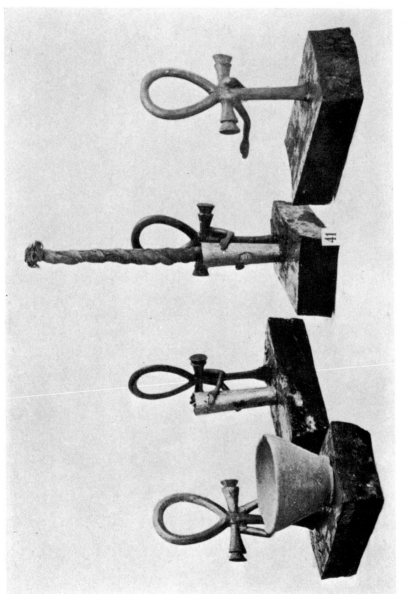

PLATE LXXV

PLATE LXXV

TORCH AND TORCH-HOLDERS OF BRONZE AND
GOLD UPON WOODEN PEDESTALS

These are absolutely new in type, and one of
them has still its torch of twisted linen in position
in the oil-cup. Two of them had bowls for floating
wicks, now missing. Probably these were of gold
and were stolen by the tomb-thieves. On the left
lamp a small pottery bowl serves to show what they
were probably like.

(*See* p. 113.)

PLATE LXXVI

THREE OF THE KING'S BOWS

This illustration shows only the detail of a section of the bows. The upper two double bows are of composite type and are decorated with ornamental barks. The lower bow is of heavy gold and is elaborately decorated with fine gold-work inlaid with coloured stones and glass.

(*See* p. 113.)

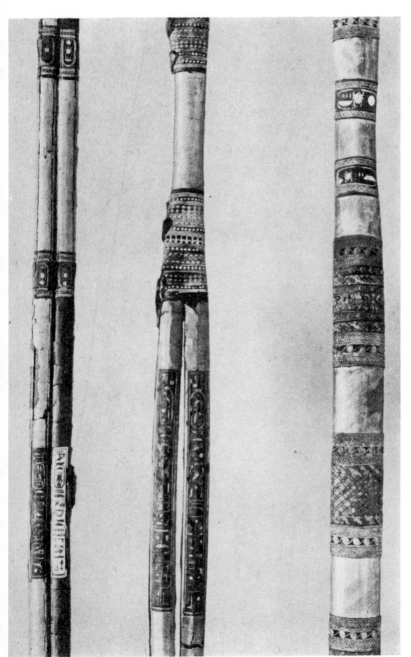

PLATE LXXVI

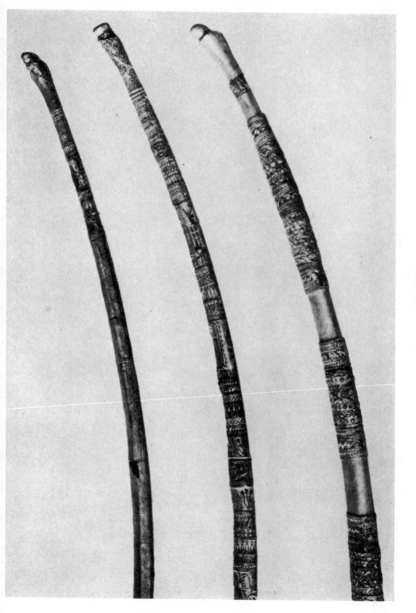

PLATE LXXVII

PLATE LXXVII

THREE OF THE KING'S BOWS

Details of the ends of the preceding bows shown on Plate LXXVI.

(*See* p. 171.)

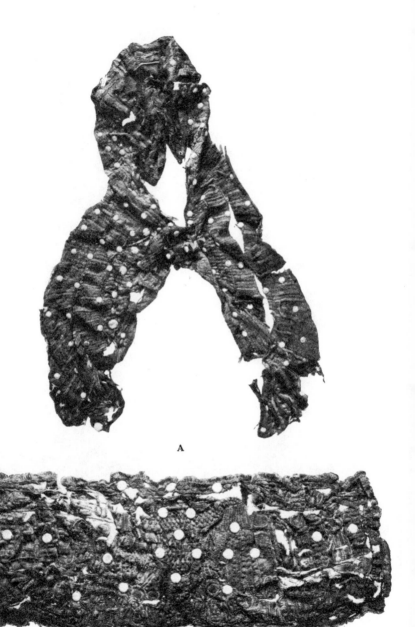

A

B

PLATE LXXVIII

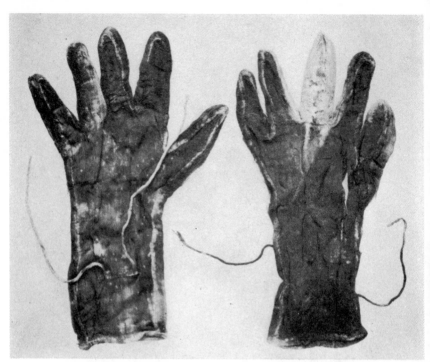

(A) A pair of linen gloves with tapes for tying at the wrist (No. 43, I and J).

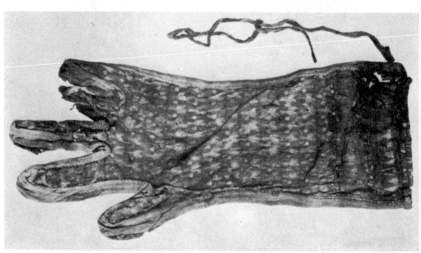

(B) Tapestry woven glove (No. 36, cc).

Plate LXXIX

EXAMPLES OF THE KING'S GLOVES.

(See p. 171)

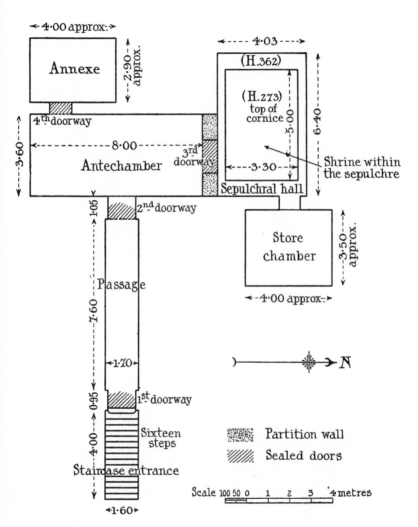

SKETCH-PLAN OF THE TOMB

INDEX

Index

Index

Index

Index

Index

Index

A CATALOG OF SELECTED
DOVER BOOKS
IN ALL FIELDS OF INTEREST

A CATALOG OF SELECTED DOVER
BOOKS IN ALL FIELDS OF INTEREST

CONCERNING THE SPIRITUAL IN ART, Wassily Kandinsky. Pioneering work by father of abstract art. Thoughts on color theory, nature of art. Analysis of earlier masters. 12 illustrations. 80pp. of text. 5⅜ x 8½. 23411-8 Pa. $4.95

ANIMALS: 1,419 Copyright-Free Illustrations of Mammals, Birds, Fish, Insects, etc., Jim Harter (ed.). Clear wood engravings present, in extremely lifelike poses, over 1,000 species of animals. One of the most extensive pictorial sourcebooks of its kind. Captions. Index. 284pp. 9 x 12. 23766-4 Pa. $14.95

CELTIC ART: The Methods of Construction, George Bain. Simple geometric techniques for making Celtic interlacements, spirals, Kells-type initials, animals, humans, etc. Over 500 illustrations. 160pp. 9 x 12. (USO) 22923-8 Pa. $9.95

AN ATLAS OF ANATOMY FOR ARTISTS, Fritz Schider. Most thorough reference work on art anatomy in the world. Hundreds of illustrations, including selections from works by Vesalius, Leonardo, Goya, Ingres, Michelangelo, others. 593 illustrations. 192pp. 7⅛ x 10¼. 20241-0 Pa. $9.95

CELTIC HAND STROKE-BY-STROKE (Irish Half-Uncial from "The Book of Kells"): An Arthur Baker Calligraphy Manual, Arthur Baker. Complete guide to creating each letter of the alphabet in distinctive Celtic manner. Covers hand position, strokes, pens, inks, paper, more. Illustrated. 48pp. 8¼ x 11. 24336-2 Pa. $3.95

EASY ORIGAMI, John Montroll. Charming collection of 32 projects (hat, cup, pelican, piano, swan, many more) specially designed for the novice origami hobbyist. Clearly illustrated easy-to-follow instructions insure that even beginning paper-crafters will achieve successful results. 48pp. 8¼ x 11. 27298-2 Pa. $3.50

THE COMPLETE BOOK OF BIRDHOUSE CONSTRUCTION FOR WOODWORKERS, Scott D. Campbell. Detailed instructions, illustrations, tables. Also data on bird habitat and instinct patterns. Bibliography. 3 tables. 63 illustrations in 15 figures. 48pp. 5¼ x 8½. 24407-5 Pa. $2.50

BLOOMINGDALE'S ILLUSTRATED 1886 CATALOG: Fashions, Dry Goods and Housewares, Bloomingdale Brothers. Famed merchants' extremely rare catalog depicting about 1,700 products: clothing, housewares, firearms, dry goods, jewelry, more. Invaluable for dating, identifying vintage items. Also, copyright-free graphics for artists, designers. Co-published with Henry Ford Museum & Greenfield Village. 160pp. 8¼ x 11. 25780-0 Pa. $10.95

HISTORIC COSTUME IN PICTURES, Braun & Schneider. Over 1,450 costumed figures in clearly detailed engravings—from dawn of civilization to end of 19th century. Captions. Many folk costumes. 256pp. 8⅜ x 11¾. 23150-X Pa. $12.95

STICKLEY CRAFTSMAN FURNITURE CATALOGS, Gustav Stickley and L. & J. G. Stickley. Beautiful, functional furniture in two authentic catalogs from 1910. 594 illustrations, including 277 photos, show settles, rockers, armchairs, reclining chairs, bookcases, desks, tables. 183pp. 6½ x 9¼. 23838-5 Pa. $11.95

AMERICAN LOCOMOTIVES IN HISTORIC PHOTOGRAPHS: 1858 to 1949, Ron Ziel (ed.). A rare collection of 126 meticulously detailed official photographs, called "builder portraits," of American locomotives that majestically chronicle the rise of steam locomotive power in America. Introduction. Detailed captions. xi + 129pp. 9 x 12. 27393-8 Pa. $13.95

AMERICA'S LIGHTHOUSES: An Illustrated History, Francis Ross Holland, Jr. Delightfully written, profusely illustrated fact-filled survey of over 200 American lighthouses since 1716. History, anecdotes, technological advances, more. 240pp. 8 x 10¾. 25576-X Pa. $12.95

TOWARDS A NEW ARCHITECTURE, Le Corbusier. Pioneering manifesto by founder of "International School." Technical and aesthetic theories, views of industry, economics, relation of form to function, "mass-production split" and much more. Profusely illustrated. 320pp. 6⅛ x 9¼. (USO) 25023-7 Pa. $9.95

HOW THE OTHER HALF LIVES, Jacob Riis. Famous journalistic record, exposing poverty and degradation of New York slums around 1900, by major social reformer. 100 striking and influential photographs. 233pp. 10 x 7⅞. 22012-5 Pa. $11.95

FRUIT KEY AND TWIG KEY TO TREES AND SHRUBS, William M. Harlow. One of the handiest and most widely used identification aids. Fruit key covers 120 deciduous and evergreen species; twig key 160 deciduous species. Easily used. Over 300 photographs. 126pp. 5⅜ x 8½. 20511-8 Pa. $3.95

COMMON BIRD SONGS, Dr. Donald J. Borror. Songs of 60 most common U.S. birds: robins, sparrows, cardinals, bluejays, finches, more—arranged in order of increasing complexity. Up to 9 variations of songs of each species. Cassette and manual 99911-4 $8.95

ORCHIDS AS HOUSE PLANTS, Rebecca Tyson Northen. Grow cattleyas and many other kinds of orchids—in a window, in a case, or under artificial light. 63 illustrations. 148pp. 5⅜ x 8½. 23261-1 Pa. $5.95

MONSTER MAZES, Dave Phillips. Masterful mazes at four levels of difficulty. Avoid deadly perils and evil creatures to find magical treasures. Solutions for all 32 exciting illustrated puzzles. 48pp. 8¼ x 11. 26005-4 Pa. $2.95

MOZART'S DON GIOVANNI (DOVER OPERA LIBRETTO SERIES), Wolfgang Amadeus Mozart. Introduced and translated by Ellen H. Bleiler. Standard Italian libretto, with complete English translation. Convenient and thoroughly portable—an ideal companion for reading along with a recording or the performance itself. Introduction. List of characters. Plot summary. 121pp. 5¼ x 8½. 24944-1 Pa. $3.95

TECHNICAL MANUAL AND DICTIONARY OF CLASSICAL BALLET, Gail Grant. Defines, explains, comments on steps, movements, poses and concepts. 15-page pictorial section. Basic book for student, viewer. 127pp. 5⅜ x 8½. 21843-0 Pa. $4.95

THE CLARINET AND CLARINET PLAYING, David Pino. Lively, comprehensive work features suggestions about technique, musicianship, and musical interpretation, as well as guidelines for teaching, making your own reeds, and preparing for public performance. Includes an intriguing look at clarinet history. "A godsend," The Clarinet, Journal of the International Clarinet Society. Appendixes. 7 illus. 320pp. 5⅜ x 8½. 40270-3 Pa. $9.95

HOLLYWOOD GLAMOR PORTRAITS, John Kobal (ed.). 145 photos from 1926-49. Harlow, Gable, Bogart, Bacall; 94 stars in all. Full background on photographers, technical aspects. 160pp. 8⅜ x 11¼. 23352-9 Pa. $12.95

THE ANNOTATED CASEY AT THE BAT: A Collection of Ballads about the Mighty Casey/Third, Revised Edition, Martin Gardner (ed.). Amusing sequels and parodies of one of America's best-loved poems: Casey's Revenge, Why Casey Whiffed, Casey's Sister at the Bat, others. 256pp. 5⅜ x 8½. 28598-7 Pa. $8.95

THE RAVEN AND OTHER FAVORITE POEMS, Edgar Allan Poe. Over 40 of the author's most memorable poems: "The Bells," "Ulalume," "Israfel," "To Helen," "The Conqueror Worm," "Eldorado," "Annabel Lee," many more. Alphabetic lists of titles and first lines. 64pp. 5³⁄₁₆ x 8¼. 26685-0 Pa. $1.00

PERSONAL MEMOIRS OF U. S. GRANT, Ulysses Simpson Grant. Intelligent, deeply moving firsthand account of Civil War campaigns, considered by many the finest military memoirs ever written. Includes letters, historic photographs, maps and more. 528pp. 6⅛ x 9¼. 28587-1 Pa. $12.95

ANCIENT EGYPTIAN MATERIALS AND INDUSTRIES, A. Lucas and J. Harris. Fascinating, comprehensive, thoroughly documented text describes this ancient civilization's vast resources and the processes that incorporated them in daily life, including the use of animal products, building materials, cosmetics, perfumes and incense, fibers, glazed ware, glass and its manufacture, materials used in the mummification process, and much more. 544pp. 6¹⁄₈ x 9¹⁄₄. (USO) 40446-3 Pa. $16.95

RUSSIAN STORIES/PYCCKNE PACCKA3bl: A Dual-Language Book, edited by Gleb Struve. Twelve tales by such masters as Chekhov, Tolstoy, Dostoevsky, Pushkin, others. Excellent word-for-word English translations on facing pages, plus teaching and study aids, Russian/English vocabulary, biographical/critical introductions, more. 416pp. 5⅜ x 8½. 26244-8 Pa. $9.95

PHILADELPHIA THEN AND NOW: 60 Sites Photographed in the Past and Present, Kenneth Finkel and Susan Oyama. Rare photographs of City Hall, Logan Square, Independence Hall, Betsy Ross House, other landmarks juxtaposed with contemporary views. Captures changing face of historic city. Introduction. Captions. 128pp. 8¼ x 11. 25790-8 Pa. $9.95

AIA ARCHITECTURAL GUIDE TO NASSAU AND SUFFOLK COUNTIES, LONG ISLAND, The American Institute of Architects, Long Island Chapter, and the Society for the Preservation of Long Island Antiquities. Comprehensive, well-researched and generously illustrated volume brings to life over three centuries of Long Island's great architectural heritage. More than 240 photographs with authoritative, extensively detailed captions. 176pp. 8¼ x 11. 26946-9 Pa. $14.95

NORTH AMERICAN INDIAN LIFE: Customs and Traditions of 23 Tribes, Elsie Clews Parsons (ed.). 27 fictionalized essays by noted anthropologists examine religion, customs, government, additional facets of life among the Winnebago, Crow, Zuni, Eskimo, other tribes. 480pp. 6⅛ x 9¼. 27377-6 Pa. $10.95

FRANK LLOYD WRIGHT'S DANA HOUSE, Donald Hoffmann. Pictorial essay of residential masterpiece with over 160 interior and exterior photos, plans, elevations, sketches and studies. 128pp. 9¼ x 10¾. 29120-0 Pa. $12.95

THE MALE AND FEMALE FIGURE IN MOTION: 60 Classic Photographic Sequences, Eadweard Muybridge. 60 true-action photographs of men and women walking, running, climbing, bending, turning, etc., reproduced from rare 19th-century masterpiece. vi + 121pp. 9 x 12. 24745-7 Pa. $10.95

1001 QUESTIONS ANSWERED ABOUT THE SEASHORE, N. J. Berrill and Jacquelyn Berrill. Queries answered about dolphins, sea snails, sponges, starfish, fishes, shore birds, many others. Covers appearance, breeding, growth, feeding, much more. 305pp. 5¼ x 8¼. 23366-9 Pa. $9.95

ATTRACTING BIRDS TO YOUR YARD, William J. Weber. Easy-to-follow guide offers advice on how to attract the greatest diversity of birds: birdhouses, feeders, water and waterers, much more. 96pp. 5³⁄₁₆ x 8¼. 28927-3 Pa. $2.50

MEDICINAL AND OTHER USES OF NORTH AMERICAN PLANTS: A Historical Survey with Special Reference to the Eastern Indian Tribes, Charlotte Erichsen-Brown. Chronological historical citations document 500 years of usage of plants, trees, shrubs native to eastern Canada, northeastern U.S. Also complete identifying information. 343 illustrations. 544pp. 6½ x 9¼. 25951-X Pa. $12.95

STORYBOOK MAZES, Dave Phillips. 23 stories and mazes on two-page spreads: Wizard of Oz, Treasure Island, Robin Hood, etc. Solutions. 64pp. 8¼ x 11. 23628-5 Pa. $2.95

AMERICAN NEGRO SONGS: 230 Folk Songs and Spirituals, Religious and Secular, John W. Work. This authoritative study traces the African influences of songs sung and played by black Americans at work, in church, and as entertainment. The author discusses the lyric significance of such songs as "Swing Low, Sweet Chariot," "John Henry," and others and offers the words and music for 230 songs. Bibliography. Index of Song Titles. 272pp. 6½ x 9¼. 40271-1 Pa. $9.95

MOVIE-STAR PORTRAITS OF THE FORTIES, John Kobal (ed.). 163 glamor, studio photos of 106 stars of the 1940s: Rita Hayworth, Ava Gardner, Marlon Brando, Clark Gable, many more. 176pp. 8⅜ x 11¼. 23546-7 Pa. $14.95

BENCHLEY LOST AND FOUND, Robert Benchley. Finest humor from early 30s, about pet peeves, child psychologists, post office and others. Mostly unavailable elsewhere. 73 illustrations by Peter Arno and others. 183pp. 5⅜ x 8½. 22410-4 Pa. $6.95

YEKL and THE IMPORTED BRIDEGROOM AND OTHER STORIES OF YIDDISH NEW YORK, Abraham Cahan. Film Hester Street based on Yekl (1896). Novel, other stories among first about Jewish immigrants on N.Y.'s East Side. 240pp. 5⅜ x 8½. 22427-9 Pa. $6.95

SELECTED POEMS, Walt Whitman. Generous sampling from *Leaves of Grass.* Twenty-four poems include "I Hear America Singing," "Song of the Open Road," "I Sing the Body Electric," "When Lilacs Last in the Dooryard Bloom'd," "O Captain! My Captain!"—all reprinted from an authoritative edition. Lists of titles and first lines. 128pp. 5³⁄₁₆ x 8¼. 26878-0 Pa. $1.00

THE BEST TALES OF HOFFMANN, E. T. A. Hoffmann. 10 of Hoffmann's most important stories: "Nutcracker and the King of Mice," "The Golden Flowerpot," etc. 458pp. 5⅜ x 8½. 21793-0 Pa. $9.95

FROM FETISH TO GOD IN ANCIENT EGYPT, E. A. Wallis Budge. Rich detailed survey of Egyptian conception of "God" and gods, magic, cult of animals, Osiris, more. Also, superb English translations of hymns and legends. 240 illustrations. 545pp. 5⅜ x 8½. 25803-3 Pa. $13.95

FRENCH STORIES/CONTES FRANÇAIS: A Dual-Language Book, Wallace Fowlie. Ten stories by French masters, Voltaire to Camus: "Micromegas" by Voltaire; "The Atheist's Mass" by Balzac; "Minuet" by de Maupassant; "The Guest" by Camus, six more. Excellent English translations on facing pages. Also French-English vocabulary list, exercises, more. 352pp. 5⅜ x 8½. 26443-2 Pa. $9.95

CHICAGO AT THE TURN OF THE CENTURY IN PHOTOGRAPHS: 122 Historic Views from the Collections of the Chicago Historical Society, Larry A. Viskochil. Rare large-format prints offer detailed views of City Hall, State Street, the Loop, Hull House, Union Station, many other landmarks, circa 1904-1913. Introduction. Captions. Maps. 144pp. 9⅜ x 12¼. 24656-6 Pa. $12.95

OLD BROOKLYN IN EARLY PHOTOGRAPHS, 1865-1929, William Lee Younger. Luna Park, Gravesend race track, construction of Grand Army Plaza, moving of Hotel Brighton, etc. 157 previously unpublished photographs. 165pp. 8⅞ x 11¾. 23587-4 Pa. $13.95

THE MYTHS OF THE NORTH AMERICAN INDIANS, Lewis Spence. Rich anthology of the myths and legends of the Algonquins, Iroquois, Pawnees and Sioux, prefaced by an extensive historical and ethnological commentary. 36 illustrations. 480pp. 5⅜ x 8½. 25967-6 Pa. $10.95

AN ENCYCLOPEDIA OF BATTLES: Accounts of Over 1,560 Battles from 1479 B.C. to the Present, David Eggenberger. Essential details of every major battle in recorded history from the first battle of Megiddo in 1479 B.C. to Grenada in 1984. List of Battle Maps. New Appendix covering the years 1967-1984. Index. 99 illustrations. 544pp. 6½ x 9¼. 24913-1 Pa. $16.95

SAILING ALONE AROUND THE WORLD, Captain Joshua Slocum. First man to sail around the world, alone, in small boat. One of great feats of seamanship told in delightful manner. 67 illustrations. 294pp. 5⅜ x 8½. 20326-3 Pa. $6.95

ANARCHISM AND OTHER ESSAYS, Emma Goldman. Powerful, penetrating, prophetic essays on direct action, role of minorities, prison reform, puritan hypocrisy, violence, etc. 271pp. 5⅜ x 8½. 22484-8 Pa. $7.95

MYTHS OF THE HINDUS AND BUDDHISTS, Ananda K. Coomaraswamy and Sister Nivedita. Great stories of the epics; deeds of Krishna, Shiva, taken from puranas, Vedas, folk tales; etc. 32 illustrations. 400pp. 5⅜ x 8½. 21759-0 Pa. $12.95

THE TRAUMA OF BIRTH, Otto Rank. Rank's controversial thesis that anxiety neurosis is caused by profound psychological trauma which occurs at birth. 256pp. 5⅜ x 8½. 27974-X Pa. $7.95

A THEOLOGICO-POLITICAL TREATISE, Benedict Spinoza. Also contains unfinished Political Treatise. Great classic on religious liberty, theory of government on common consent. R. Elwes translation. Total of 421pp. 5⅜ x 8½. 20249-6 Pa. $9.95

MY BONDAGE AND MY FREEDOM, Frederick Douglass. Born a slave, Douglass became outspoken force in antislavery movement. The best of Douglass' autobiographies. Graphic description of slave life. 464pp. 5⅜ x 8½. 22457-0 Pa. $8.95

FOLLOWING THE EQUATOR: A Journey Around the World, Mark Twain. Fascinating humorous account of 1897 voyage to Hawaii, Australia, India, New Zealand, etc. Ironic, bemused reports on peoples, customs, climate, flora and fauna, politics, much more. 197 illustrations. 720pp. 5⅜ x 8½. 26113-1 Pa. $15.95

THE PEOPLE CALLED SHAKERS, Edward D. Andrews. Definitive study of Shakers: origins, beliefs, practices, dances, social organization, furniture and crafts, etc. 33 illustrations. 351pp. 5⅜ x 8½. 21081-2 Pa. $8.95

THE MYTHS OF GREECE AND ROME, H. A. Guerber. A classic of mythology, generously illustrated, long prized for its simple, graphic, accurate retelling of the principal myths of Greece and Rome, and for its commentary on their origins and significance. With 64 illustrations by Michelangelo, Raphael, Titian, Rubens, Canova, Bernini and others. 480pp. 5⅜ x 8½. 27584-1 Pa. $9.95

PSYCHOLOGY OF MUSIC, Carl E. Seashore. Classic work discusses music as a medium from psychological viewpoint. Clear treatment of physical acoustics, auditory apparatus, sound perception, development of musical skills, nature of musical feeling, host of other topics. 88 figures. 408pp. 5⅜ x 8½. 21851-1 Pa. $11.95

THE PHILOSOPHY OF HISTORY, Georg W. Hegel. Great classic of Western thought develops concept that history is not chance but rational process, the evolution of freedom. 457pp. 5⅜ x 8½. 20112-0 Pa. $9.95

THE BOOK OF TEA, Kakuzo Okakura. Minor classic of the Orient: entertaining, charming explanation, interpretation of traditional Japanese culture in terms of tea ceremony. 94pp. 5⅜ x 8½. 20070-1 Pa. $3.95

LIFE IN ANCIENT EGYPT, Adolf Erman. Fullest, most thorough, detailed older account with much not in more recent books, domestic life, religion, magic, medicine, commerce, much more. Many illustrations reproduce tomb paintings, carvings, hieroglyphs, etc. 597pp. 5⅜ x 8½. 22632-8 Pa. $12.95

SUNDIALS, Their Theory and Construction, Albert Waugh. Far and away the best, most thorough coverage of ideas, mathematics concerned, types, construction, adjusting anywhere. Simple, nontechnical treatment allows even children to build several of these dials. Over 100 illustrations. 230pp. 5⅜ x 8½. 22947-5 Pa. $8.95

THEORETICAL HYDRODYNAMICS, L. M. Milne-Thomson. Classic exposition of the mathematical theory of fluid motion, applicable to both hydrodynamics and aerodynamics. Over 600 exercises. 768pp. 6⅛ x 9¼. 68970-0 Pa. $20.95

SONGS OF EXPERIENCE: Facsimile Reproduction with 26 Plates in Full Color, William Blake. 26 full-color plates from a rare 1826 edition. Includes "TheTyger," "London," "Holy Thursday," and other poems. Printed text of poems. 48pp. 5¼ x 7. 24636-1 Pa. $4.95

OLD-TIME VIGNETTES IN FULL COLOR, Carol Belanger Grafton (ed.). Over 390 charming, often sentimental illustrations, selected from archives of Victorian graphics—pretty women posing, children playing, food, flowers, kittens and puppies, smiling cherubs, birds and butterflies, much more. All copyright-free. 48pp. 9¼ x 12¼. 27269-9 Pa. $7.95

PERSPECTIVE FOR ARTISTS, Rex Vicat Cole. Depth, perspective of sky and sea, shadows, much more, not usually covered. 391 diagrams, 81 reproductions of drawings and paintings. 279pp. 5⅜ x 8½. 22487-2 Pa. $7.95

DRAWING THE LIVING FIGURE, Joseph Sheppard. Innovative approach to artistic anatomy focuses on specifics of surface anatomy, rather than muscles and bones. Over 170 drawings of live models in front, back and side views, and in widely varying poses. Accompanying diagrams. 177 illustrations. Introduction. Index. 144pp. 8⅜ x11¼. 26723-7 Pa. $8.95

GOTHIC AND OLD ENGLISH ALPHABETS: 100 Complete Fonts, Dan X. Solo. Add power, elegance to posters, signs, other graphics with 100 stunning copyright-free alphabets: Blackstone, Dolbey, Germania, 97 more–including many lower-case, numerals, punctuation marks. 104pp. 8¼ x 11. 24695-7 Pa. $8.95

HOW TO DO BEADWORK, Mary White. Fundamental book on craft from simple projects to five-bead chains and woven works. 106 illustrations. 142pp. 5⅜ x 8. 20697-1 Pa. $5.95

THE BOOK OF WOOD CARVING, Charles Marshall Sayers. Finest book for beginners discusses fundamentals and offers 34 designs. "Absolutely first rate . . . well thought out and well executed."–E. J. Tangerman. 118pp. 7¾ x 10⅝. 23654-4 Pa. $7.95

ILLUSTRATED CATALOG OF CIVIL WAR MILITARY GOODS: Union Army Weapons, Insignia, Uniform Accessories, and Other Equipment, Schuyler, Hartley, and Graham. Rare, profusely illustrated 1846 catalog includes Union Army uniform and dress regulations, arms and ammunition, coats, insignia, flags, swords, rifles, etc. 226 illustrations. 160pp. 9 x 12. 24939-5 Pa. $10.95

WOMEN'S FASHIONS OF THE EARLY 1900s: An Unabridged Republication of "New York Fashions, 1909," National Cloak & Suit Co. Rare catalog of mail-order fashions documents women's and children's clothing styles shortly after the turn of the century. Captions offer full descriptions, prices. Invaluable resource for fashion, costume historians. Approximately 725 illustrations. 128pp. 8⅜ x 11¼. 27276-1 Pa. $11.95

THE 1912 AND 1915 GUSTAV STICKLEY FURNITURE CATALOGS, Gustav Stickley. With over 200 detailed illustrations and descriptions, these two catalogs are essential reading and reference materials and identification guides for Stickley furniture. Captions cite materials, dimensions and prices. 112pp. 6½ x 9¼. 26676-1 Pa. $9.95

EARLY AMERICAN LOCOMOTIVES, John H. White, Jr. Finest locomotive engravings from early 19th century: historical (1804–74), main-line (after 1870), special, foreign, etc. 147 plates. 142pp. 11⅜ x 8¼. 22772-3 Pa. $10.95

THE TALL SHIPS OF TODAY IN PHOTOGRAPHS, Frank O. Braynard. Lavishly illustrated tribute to nearly 100 majestic contemporary sailing vessels: Amerigo Vespucci, Clearwater, Constitution, Eagle, Mayflower, Sea Cloud, Victory, many more. Authoritative captions provide statistics, background on each ship. 190 black-and-white photographs and illustrations. Introduction. 128pp. 8⅞ x 11¾. 27163-3 Pa. $14.95

LITTLE BOOK OF EARLY AMERICAN CRAFTS AND TRADES, Peter Stockham (ed.). 1807 children's book explains crafts and trades: baker, hatter, cooper, potter, and many others. 23 copperplate illustrations. 140pp. 4⅝ x 6.
23336-7 Pa. $4.95

VICTORIAN FASHIONS AND COSTUMES FROM HARPER'S BAZAR, 1867–1898, Stella Blum (ed.). Day costumes, evening wear, sports clothes, shoes, hats, other accessories in over 1,000 detailed engravings. 320pp. 9⅜ x 12¼.
22990-4 Pa. $15.95

GUSTAV STICKLEY, THE CRAFTSMAN, Mary Ann Smith. Superb study surveys broad scope of Stickley's achievement, especially in architecture. Design philosophy, rise and fall of the Craftsman empire, descriptions and floor plans for many Craftsman houses, more. 86 black-and-white halftones. 31 line illustrations. Introduction 208pp. 6½ x 9¼.
27210-9 Pa. $9.95

THE LONG ISLAND RAIL ROAD IN EARLY PHOTOGRAPHS, Ron Ziel. Over 220 rare photos, informative text document origin (1844) and development of rail service on Long Island. Vintage views of early trains, locomotives, stations, passengers, crews, much more. Captions. 8⅞ x 11¾.
26301-0 Pa. $13.95

VOYAGE OF THE LIBERDADE, Joshua Slocum. Great 19th-century mariner's thrilling, first-hand account of the wreck of his ship off South America, the 35-foot boat he built from the wreckage, and its remarkable voyage home. 128pp. 5⅜ x 8½.
40022-0 Pa. $4.95

TEN BOOKS ON ARCHITECTURE, Vitruvius. The most important book ever written on architecture. Early Roman aesthetics, technology, classical orders, site selection, all other aspects. Morgan translation. 331pp. 5⅜ x 8½. 20645-9 Pa. $8.95

THE HUMAN FIGURE IN MOTION, Eadweard Muybridge. More than 4,500 stopped-action photos, in action series, showing undraped men, women, children jumping, lying down, throwing, sitting, wrestling, carrying, etc. 390pp. 7⅞ x 10⅝.
20204-6 Clothbd. $27.95

TREES OF THE EASTERN AND CENTRAL UNITED STATES AND CANADA, William M. Harlow. Best one-volume guide to 140 trees. Full descriptions, woodlore, range, etc. Over 600 illustrations. Handy size. 288pp. 4½ x 6⅜.
20395-6 Pa. $6.95

SONGS OF WESTERN BIRDS, Dr. Donald J. Borror. Complete song and call repertoire of 60 western species, including flycatchers, juncoes, cactus wrens, many more–includes fully illustrated booklet. Cassette and manual 99913-0 $8.95

GROWING AND USING HERBS AND SPICES, Milo Miloradovich. Versatile handbook provides all the information needed for cultivation and use of all the herbs and spices available in North America. 4 illustrations. Index. Glossary. 236pp. 5⅜ x 8½.
25058-X Pa. $7.95

BIG BOOK OF MAZES AND LABYRINTHS, Walter Shepherd. 50 mazes and labyrinths in all–classical, solid, ripple, and more–in one great volume. Perfect inexpensive puzzler for clever youngsters. Full solutions. 112pp. 8⅛ x 11.
22951-3 Pa. $5.95

PIANO TUNING, J. Cree Fischer. Clearest, best book for beginner, amateur. Simple repairs, raising dropped notes, tuning by easy method of flattened fifths. No previous skills needed. 4 illustrations. 201pp. 5⅜ x 8½. 23267-0 Pa. $6.95

HINTS TO SINGERS, Lillian Nordica. Selecting the right teacher, developing confidence, overcoming stage fright, and many other important skills receive thoughtful discussion in this indispensible guide, written by a world-famous diva of four decades' experience. 96pp. 5³/₈ x 8¹/₂. 40094-8 Pa. $4.95

THE COMPLETE NONSENSE OF EDWARD LEAR, Edward Lear. All nonsense limericks, zany alphabets, Owl and Pussycat, songs, nonsense botany, etc., illustrated by Lear. Total of 320pp. 5⅜ x 8½. (USO) 20167-8 Pa. $7.95

VICTORIAN PARLOUR POETRY: An Annotated Anthology, Michael R. Turner. 117 gems by Longfellow, Tennyson, Browning, many lesser-known poets. "The Village Blacksmith," "Curfew Must Not Ring Tonight," "Only a Baby Small," dozens more, often difficult to find elsewhere. Index of poets, titles, first lines. xxiii + 325pp. 5⅜ x 8¼. 27044-0 Pa. $8.95

DUBLINERS, James Joyce. Fifteen stories offer vivid, tightly focused observations of the lives of Dublin's poorer classes. At least one, "The Dead," is considered a masterpiece. Reprinted complete and unabridged from standard edition. 160pp. 5³/₁₆ x 8¼. 26870-5 Pa. $1.00

GREAT WEIRD TALES: 14 Stories by Lovecraft, Blackwood, Machen and Others, S. T. Joshi (ed.). 14 spellbinding tales, including "The Sin Eater," by Fiona McLeod, "The Eye Above the Mantel," by Frank Belknap Long, as well as renowned works by R. H. Barlow, Lord Dunsany, Arthur Machen, W. C. Morrow and eight other masters of the genre. 256pp. 5⅜ x 8½. (USO) 40436-6 Pa. $8.95

THE BOOK OF THE SACRED MAGIC OF ABRAMELIN THE MAGE, translated by S. MacGregor Mathers. Medieval manuscript of ceremonial magic. Basic document in Aleister Crowley, Golden Dawn groups. 268pp. 5⅜ x 8½.
23211-5 Pa. $9.95

NEW RUSSIAN-ENGLISH AND ENGLISH-RUSSIAN DICTIONARY, M. A. O'Brien. This is a remarkably handy Russian dictionary, containing a surprising amount of information, including over 70,000 entries. 366pp. 4½ x 6⅛.
20208-9 Pa. $10.95

HISTORIC HOMES OF THE AMERICAN PRESIDENTS, Second, Revised Edition, Irvin Haas. A traveler's guide to American Presidential homes, most open to the public, depicting and describing homes occupied by every American President from George Washington to George Bush. With visiting hours, admission charges, travel routes. 175 photographs. Index. 160pp. 8¼ x 11. 26751-2 Pa. $11.95

NEW YORK IN THE FORTIES, Andreas Feininger. 162 brilliant photographs by the well-known photographer, formerly with *Life* magazine. Commuters, shoppers, Times Square at night, much else from city at its peak. Captions by John von Hartz. 181pp. 9¼ x 10¾. 23585-8 Pa. $13.95

INDIAN SIGN LANGUAGE, William Tomkins. Over 525 signs developed by Sioux and other tribes. Written instructions and diagrams. Also 290 pictographs. 111pp. 6⅛ x 9¼. 22029-X Pa. $3.95

ANATOMY: A Complete Guide for Artists, Joseph Sheppard. A master of figure drawing shows artists how to render human anatomy convincingly. Over 460 illustrations. 224pp. 8⅜ x 11¼. 27279-6 Pa. $11.95

MEDIEVAL CALLIGRAPHY: Its History and Technique, Marc Drogin. Spirited history, comprehensive instruction manual covers 13 styles (ca. 4th century thru 15th). Excellent photographs; directions for duplicating medieval techniques with modern tools. 224pp. 8⅜ x 11¼. 26142-5 Pa. $12.95

DRIED FLOWERS: How to Prepare Them, Sarah Whitlock and Martha Rankin. Complete instructions on how to use silica gel, meal and borax, perlite aggregate, sand and borax, glycerine and water to create attractive permanent flower arrangements. 12 illustrations. 32pp. 5⅜ x 8½. 21802-3 Pa. $1.00

EASY-TO-MAKE BIRD FEEDERS FOR WOODWORKERS, Scott D. Campbell. Detailed, simple-to-use guide for designing, constructing, caring for and using feeders. Text, illustrations for 12 classic and contemporary designs. 96pp. 5⅜ x 8½. 25847-5 Pa. $3.95

SCOTTISH WONDER TALES FROM MYTH AND LEGEND, Donald A. Mackenzie. 16 lively tales tell of giants rumbling down mountainsides, of a magic wand that turns stone pillars into warriors, of gods and goddesses, evil hags, powerful forces and more. 240pp. 5⅜ x 8½. 29677-6 Pa. $6.95

THE HISTORY OF UNDERCLOTHES, C. Willett Cunnington and Phyllis Cunnington. Fascinating, well-documented survey covering six centuries of English undergarments, enhanced with over 100 illustrations: 12th-century laced-up bodice, footed long drawers (1795), 19th-century bustles, 19th-century corsets for men, Victorian "bust improvers," much more. 272pp. 5⅜ x 8¼. 27124-2 Pa. $9.95

ARTS AND CRAFTS FURNITURE: The Complete Brooks Catalog of 1912, Brooks Manufacturing Co. Photos and detailed descriptions of more than 150 now very collectible furniture designs from the Arts and Crafts movement depict davenports, settees, buffets, desks, tables, chairs, bedsteads, dressers and more, all built of solid, quarter-sawed oak. Invaluable for students and enthusiasts of antiques, Americana and the decorative arts. 80pp. 6½ x 9¼. 27471-3 Pa. $8.95

WILBUR AND ORVILLE: A Biography of the Wright Brothers, Fred Howard. Definitive, crisply written study tells the full story of the brothers' lives and work. A vividly written biography, unparalleled in scope and color, that also captures the spirit of an extraordinary era. 560pp. 6⅛ x 9¼. 40297-5 Pa. $17.95

THE ARTS OF THE SAILOR: Knotting, Splicing and Ropework, Hervey Garrett Smith. Indispensable shipboard reference covers tools, basic knots and useful hitches; handsewing and canvas work, more. Over 100 illustrations. Delightful reading for sea lovers. 256pp. 5⅜ x 8½. 26440-8 Pa. $8.95

FRANK LLOYD WRIGHT'S FALLINGWATER: The House and Its History, Second, Revised Edition, Donald Hoffmann. A total revision—both in text and illustrations—of the standard document on Fallingwater, the boldest, most personal architectural statement of Wright's mature years, updated with valuable new material from the recently opened Frank Lloyd Wright Archives. "Fascinating"—*The New York Times*. 116 illustrations. 128pp. 9¼ x 10¾. 27430-6 Pa. $12.95

PHOTOGRAPHIC SKETCHBOOK OF THE CIVIL WAR, Alexander Gardner. 100 photos taken on field during the Civil War. Famous shots of Manassas Harper's Ferry, Lincoln, Richmond, slave pens, etc. 244pp. 10⅝ x 8¼. 22731-6 Pa. $10.95

FIVE ACRES AND INDEPENDENCE, Maurice G. Kains. Great back-to-the-land classic explains basics of self-sufficient farming. The one book to get. 95 illustrations. 397pp. 5⅜ x 8½. 20974-1 Pa. $7.95

SONGS OF EASTERN BIRDS, Dr. Donald J. Borror. Songs and calls of 60 species most common to eastern U.S.: warblers, woodpeckers, flycatchers, thrushes, larks, many more in high-quality recording. Cassette and manual 99912-2 $9.95

A MODERN HERBAL, Margaret Grieve. Much the fullest, most exact, most useful compilation of herbal material. Gigantic alphabetical encyclopedia, from aconite to zedoary, gives botanical information, medical properties, folklore, economic uses, much else. Indispensable to serious reader. 161 illustrations. 888pp. 6½ x 9¼. 2-vol. set. (USO) Vol. I: 22798-7 Pa. $9.95
Vol. II: 22799-5 Pa. $9.95

HIDDEN TREASURE MAZE BOOK, Dave Phillips. Solve 34 challenging mazes accompanied by heroic tales of adventure. Evil dragons, people-eating plants, blood-thirsty giants, many more dangerous adversaries lurk at every twist and turn. 34 mazes, stories, solutions. 48pp. 8¼ x 11. 24566-7 Pa. $2.95

LETTERS OF W. A. MOZART, Wolfgang A. Mozart. Remarkable letters show bawdy wit, humor, imagination, musical insights, contemporary musical world; includes some letters from Leopold Mozart. 276pp. 5⅜ x 8½. 22859-2 Pa. $7.95

BASIC PRINCIPLES OF CLASSICAL BALLET, Agrippina Vaganova. Great Russian theoretician, teacher explains methods for teaching classical ballet. 118 illustrations. 175pp. 5⅜ x 8½. 22036-2 Pa. $5.95

THE JUMPING FROG, Mark Twain. Revenge edition. The original story of The Celebrated Jumping Frog of Calaveras County, a hapless French translation, and Twain's hilarious "retranslation" from the French. 12 illustrations. 66pp. 5⅜ x 8½. 22686-7 Pa. $3.95

BEST REMEMBERED POEMS, Martin Gardner (ed.). The 126 poems in this superb collection of 19th- and 20th-century British and American verse range from Shelley's "To a Skylark" to the impassioned "Renascence" of Edna St. Vincent Millay and to Edward Lear's whimsical "The Owl and the Pussycat." 224pp. 5⅜ x 8½. 27165-X Pa. $5.95

COMPLETE SONNETS, William Shakespeare. Over 150 exquisite poems deal with love, friendship, the tyranny of time, beauty's evanescence, death and other themes in language of remarkable power, precision and beauty. Glossary of archaic terms. 80pp. 5³⁄₁₆ x 8¼. 26686-9 Pa. $1.00

BODIES IN A BOOKSHOP, R. T. Campbell. Challenging mystery of blackmail and murder with ingenious plot and superbly drawn characters. In the best tradition of British suspense fiction. 192pp. 5⅜ x 8½. 24720-1 Pa. $6.95

CATALOG OF DOVER BOOKS

THE WIT AND HUMOR OF OSCAR WILDE, Alvin Redman (ed.). More than 1,000 ripostes, paradoxes, wisecracks: Work is the curse of the drinking classes; I can resist everything except temptation; etc. 258pp. 5⅜ x 8½. 20602-5 Pa. $6.95

SHAKESPEARE LEXICON AND QUOTATION DICTIONARY, Alexander Schmidt. Full definitions, locations, shades of meaning in every word in plays and poems. More than 50,000 exact quotations. 1,485pp. 6½ x 9¼. 2-vol. set.
Vol. 1: 22726-X Pa. $17.95
Vol. 2: 22727-8 Pa. $17.95

SELECTED POEMS, Emily Dickinson. Over 100 best-known, best-loved poems by one of America's foremost poets, reprinted from authoritative early editions. No comparable edition at this price. Index of first lines. 64pp. 5³⁄₁₆ x 8¼.
26466-1 Pa. $1.00

THE INSIDIOUS DR. FU-MANCHU, Sax Rohmer. The first of the popular mystery series introduces a pair of English detectives to their archnemesis, the diabolical Dr. Fu-Manchu. Flavorful atmosphere, fast-paced action, and colorful characters enliven this classic of the genre. 208pp. 5³⁄₁₆ x 8¼. 29898-1 Pa. $2.00

THE MALLEUS MALEFICARUM OF KRAMER AND SPRENGER, translated by Montague Summers. Full text of most important witchhunter's "bible," used by both Catholics and Protestants. 278pp. 6⅝ x 10. 22802-9 Pa. $12.95

SPANISH STORIES/CUENTOS ESPAÑOLES: A Dual-Language Book, Angel Flores (ed.). Unique format offers 13 great stories in Spanish by Cervantes, Borges, others. Faithful English translations on facing pages. 352pp. 5⅜ x 8½.
25399-6 Pa. $8.95

GARDEN CITY, LONG ISLAND, IN EARLY PHOTOGRAPHS, 1869–1919, Mildred H. Smith. Handsome treasury of 118 vintage pictures, accompanied by carefully researched captions, document the Garden City Hotel fire (1899), the Vanderbilt Cup Race (1908), the first airmail flight departing from the Nassau Boulevard Aerodrome (1911), and much more. 96pp. 8⅞ x 11¾. 40669-5 Pa. $12.95

OLD QUEENS, N.Y., IN EARLY PHOTOGRAPHS, Vincent F. Seyfried and William Asadorian. Over 160 rare photographs of Maspeth, Jamaica, Jackson Heights, and other areas. Vintage views of DeWitt Clinton mansion, 1939 World's Fair and more. Captions. 192pp. 8⅞ x 11. 26358-4 Pa. $12.95

CAPTURED BY THE INDIANS: 15 Firsthand Accounts, 1750-1870, Frederick Drimmer. Astounding true historical accounts of grisly torture, bloody conflicts, relentless pursuits, miraculous escapes and more, by people who lived to tell the tale. 384pp. 5⅜ x 8½. 24901-8 Pa. $8.95

THE WORLD'S GREAT SPEECHES (Fourth Enlarged Edition), Lewis Copeland, Lawrence W. Lamm, and Stephen J. McKenna. Nearly 300 speeches provide public speakers with a wealth of updated quotes and inspiration–from Pericles' funeral oration and William Jennings Bryan's "Cross of Gold Speech" to Malcolm X's powerful words on the Black Revolution and Earl of Spenser's tribute to his sister, Diana, Princess of Wales. 944pp. 5⅜ x 8⅜. 40903-1 Pa. $15.95

THE BOOK OF THE SWORD, Sir Richard F. Burton. Great Victorian scholar/adventurer's eloquent, erudite history of the "queen of weapons"–from prehistory to early Roman Empire. Evolution and development of early swords, variations (sabre, broadsword, cutlass, scimitar, etc.), much more. 336pp. 6⅛ x 9¼.
25434-8 Pa. $9.95

AUTOBIOGRAPHY: The Story of My Experiments with Truth, Mohandas K. Gandhi. Boyhood, legal studies, purification, the growth of the Satyagraha (nonviolent protest) movement. Critical, inspiring work of the man responsible for the freedom of India. 480pp. 5⅜ x 8½. (USO) 24593-4 Pa. $8.95

CELTIC MYTHS AND LEGENDS, T. W. Rolleston. Masterful retelling of Irish and Welsh stories and tales. Cuchulain, King Arthur, Deirdre, the Grail, many more. First paperback edition. 58 full-page illustrations. 512pp. 5⅜ x 8½. 26507-2 Pa. $9.95

THE PRINCIPLES OF PSYCHOLOGY, William James. Famous long course complete, unabridged. Stream of thought, time perception, memory, experimental methods; great work decades ahead of its time. 94 figures. 1,391pp. 5⅜ x 8½. 2-vol. set.
Vol. I: 20381-6 Pa. $13.95
Vol. II: 20382-4 Pa. $14.95

THE WORLD AS WILL AND REPRESENTATION, Arthur Schopenhauer. Definitive English translation of Schopenhauer's life work, correcting more than 1,000 errors, omissions in earlier translations. Translated by E. F. J. Payne. Total of 1,269pp. 5⅜ x 8½. 2-vol. set.
Vol. 1: 21761-2 Pa. $12.95
Vol. 2: 21762-0 Pa. $12.95

MAGIC AND MYSTERY IN TIBET, Madame Alexandra David-Neel. Experiences among lamas, magicians, sages, sorcerers, Bonpa wizards. A true psychic discovery. 32 illustrations. 321pp. 5⅜ x 8½. (USO) 22682-4 Pa. $9.95

THE EGYPTIAN BOOK OF THE DEAD, E. A. Wallis Budge. Complete reproduction of Ani's papyrus, finest ever found. Full hieroglyphic text, interlinear transliteration, word-for-word translation, smooth translation. 533pp. 6½ x 9¼.
21866-X Pa. $11.95

MATHEMATICS FOR THE NONMATHEMATICIAN, Morris Kline. Detailed, college-level treatment of mathematics in cultural and historical context, with numerous exercises. Recommended Reading Lists. Tables. Numerous figures. 641pp. 5⅜ x 8½.
24823-2 Pa. $11.95

PROBABILISTIC METHODS IN THE THEORY OF STRUCTURES, Isaac Elishakoff. Well-written introduction covers the elements of the theory of probability from two or more random variables, the reliability of such multivariable structures, the theory of random function, Monte Carlo methods of treating problems incapable of exact solution, and more. Examples. 502pp. $5^{3}/_{8}$ x $8^{1}/_{2}$. 40691-1 Pa. $16.95

THE RIME OF THE ANCIENT MARINER, Gustave Doré, S. T. Coleridge. Doré's finest work; 34 plates capture moods, subtleties of poem. Flawless full-size reproductions printed on facing pages with authoritative text of poem. "Beautiful. Simply beautiful."—*Publisher's Weekly.* 77pp. 9¼ x 12. 22305-1 Pa. $7.95

NORTH AMERICAN INDIAN DESIGNS FOR ARTISTS AND CRAFTSPEOPLE, Eva Wilson. Over 360 authentic copyright-free designs adapted from Navajo blankets, Hopi pottery, Sioux buffalo hides, more. Geometrics, symbolic figures, plant and animal motifs, etc. 128pp. 8⅜ x 11. (EUK) 25341-4 Pa. $8.95

SCULPTURE: Principles and Practice, Louis Slobodkin. Step-by-step approach to clay, plaster, metals, stone; classical and modern. 253 drawings, photos. 255pp. 8⅜ x 11.
22960-2 Pa. $11.95

THE INFLUENCE OF SEA POWER UPON HISTORY, 1660–1783, A. T. Mahan. Influential classic of naval history and tactics still used as text in war colleges. First paperback edition. 4 maps. 24 battle plans. 640pp. 5⅜ x 8½. 25509-3 Pa. $14.95

THE STORY OF THE TITANIC AS TOLD BY ITS SURVIVORS, Jack Winocour (ed.). What it was really like. Panic, despair, shocking inefficiency, and a little heroism. More thrilling than any fictional account. 26 illustrations. 320pp. 5⅜ x 8½.
20610-6 Pa. $8.95

FAIRY AND FOLK TALES OF THE IRISH PEASANTRY, William Butler Yeats (ed.). Treasury of 64 tales from the twilight world of Celtic myth and legend: "The Soul Cages," "The Kildare Pooka," "King O'Toole and his Goose," many more. Introduction and Notes by W. B. Yeats. 352pp. 5⅜ x 8½. 26941-8 Pa. $8.95

BUDDHIST MAHAYANA TEXTS, E. B. Cowell and Others (eds.). Superb, accurate translations of basic documents in Mahayana Buddhism, highly important in history of religions. The Buddha-karita of Asvaghosha, Larger Sukhavativyuha, more. 448pp. 5⅜ x 8½. 25552-2 Pa. $12.95

ONE TWO THREE . . . INFINITY: Facts and Speculations of Science, George Gamow. Great physicist's fascinating, readable overview of contemporary science: number theory, relativity, fourth dimension, entropy, genes, atomic structure, much more. 128 illustrations. Index. 352pp. 5⅜ x 8½. 25664-2 Pa. $8.95

EXPERIMENTATION AND MEASUREMENT, W. J. Youden. Introductory manual explains laws of measurement in simple terms and offers tips for achieving accuracy and minimizing errors. Mathematics of measurement, use of instruments, experimenting with machines. 1994 edition. Foreword. Preface. Introduction. Epilogue. Selected Readings. Glossary. Index. Tables and figures. 128pp. $5^{3}/_{8}$ x $8^{1}/_{2}$.
40451-X Pa. $6.95

DALÍ ON MODERN ART: The Cuckolds of Antiquated Modern Art, Salvador Dalí. Influential painter skewers modern art and its practitioners. Outrageous evaluations of Picasso, Cézanne, Turner, more. 15 renderings of paintings discussed. 44 calligraphic decorations by Dalí. 96pp. 5⅜ x 8½. (USO) 29220-7 Pa. $5.95

ANTIQUE PLAYING CARDS: A Pictorial History, Henry René D'Allemagne. Over 900 elaborate, decorative images from rare playing cards (14th–20th centuries): Bacchus, death, dancing dogs, hunting scenes, royal coats of arms, players cheating, much more. 96pp. 9¼ x 12¼. 29265-7 Pa. $12.95

MAKING FURNITURE MASTERPIECES: 30 Projects with Measured Drawings, Franklin H. Gottshall. Step-by-step instructions, illustrations for constructing handsome, useful pieces, among them a Sheraton desk, Chippendale chair, Spanish desk, Queen Anne table and a William and Mary dressing mirror. 224pp. 8⅛ x 11¼.
29338-6 Pa. $13.95

THE FOSSIL BOOK: A Record of Prehistoric Life, Patricia V. Rich et al. Profusely illustrated definitive guide covers everything from single-celled organisms and dinosaurs to birds and mammals and the interplay between climate and man. Over 1,500 illustrations. 760pp. 7½ x 10⅛. 29371-8 Pa. $29.95